Record of Significant Family Events

Date Event

_____ _____

_____ _____

_____ _____

_____ _____

_____ _____

_____ _____

_____ _____

_____ _____

_____ _____

_____ _____

_____ _____

_____ _____

_____ _____

_____ _____

_____ _____

_____ _____

_____ _____

Date

Event

_____ _____

_____ _____

_____ _____

_____ _____

_____ _____

_____ _____

_____ _____

_____ _____

_____ _____

_____ _____

_____ _____

_____ _____

_____ _____

_____ _____

_____ _____

_____ _____

_____ _____

_____ _____

_____ _____

_____ _____

_____ _____

FOLLOWING PAGE: *The Menorah in Zechariah's Vision* from the *Cervera Bible*

(Ms. 72, fol. 316v), 1300. Biblioteca Nacional, Lisbon.

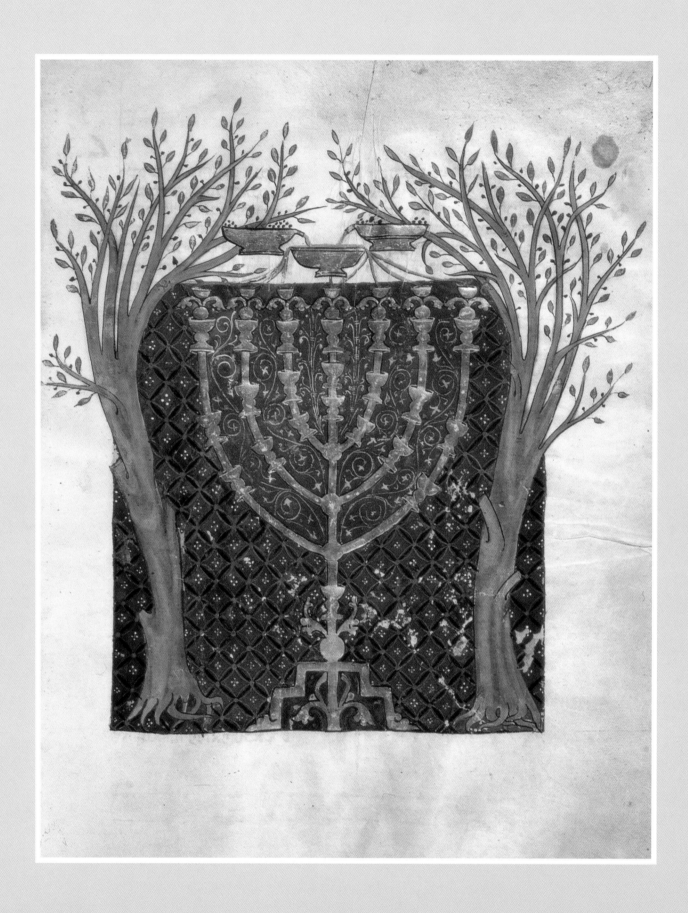

התנ״ך המצויר

THE ILLUSTRATED HEBREW BIBLE

75 Selected Stories

Adapted by Ellen Frankel

A FAIR STREET/WELCOME BOOK

STEWART, TABORI & CHANG

NEW YORK

8

Introduction

What Is the Bible?

WHEN THE ANCIENT GREEKS GAVE the Bible its name—from *biblos*, meaning "book"—the Hebrew Bible was already an ancient text, its origins lost in mythic memory. In fact, the oldest parts of the Bible arose before books were even invented, emerging as spoken stories transmitted over generations by the ancestors of the Jewish people. In time, these foundational stories were collected in a sacred anthology known as the **Torah**, derived from the Hebrew word meaning "teaching," and inscribed on parchment scrolls made of animal skin. Over the next thousand years, other elements were added to this treasury of national lore: chronicles, poems and laments, legal and ritual manuals, wisdom literature (collections of ethical and philosophical reflections), prophecies, parables, and folktales. These too became part of the library of sacred Jewish books. Then, in the early centuries of the common era, when Roman occupation and sectarian strife threatened the very survival of the Jewish people, two dozen of these "books" were selected and canonized as *The Book*—that is, the Bible. As the Jewish people began their two-thousand-year diaspora, the Bible accompanied them into exile and sustained them—their spiritual home away from home.

Who Wrote the Bible?

FOR MANY WHO HOLD THE BIBLE sacred, even to ask this question verges on blasphemy; until modern times, only heretics questioned the divine authorship of scripture. In both Jewish and Christian traditions, the Bible was regarded literally as the "word of God," dictated to Moses on Mount Sinai. Any contradiction, redundancy, anachronism, or error was considered intentional, an opportunity for inspired "decoding." In fact, interpreters through the ages have delighted in untangling these knots and trying to tie the loose ends up into a neat bow. If only reading the Bible were so straightforward!

With the dawning of the Age of Reason, in the eighteenth century, this traditional approach to scripture came under attack. Christian scholars began to question the notion that the Bible was a seamless whole, claiming instead that it was a collection of documents spanning many centuries. They believed that the many errors and inconsistencies in the Hebrew text were evidence of this *Documentary Hypothesis*, as it came to be known, rather than divine mysteries inviting inspired solutions. Other scientific findings— new dating techniques, the discovery of dinosaur bones, Charles Darwin's evolutionary theories, Albert Einstein's radical notions about time, energy, and relativity—further shook the foundations of Orthodox Bible interpretation. In many circles, fundamentalism became synonymous with backwardness: Those who stubbornly clung to the notion that God wrote the Bible were considered naive.

In the Jewish world, the debate over the authorship of the Bible precipitated a crisis that continues to this day. Liberal Judaism emerged when its proponents embraced the

9

Documentary Hypothesis; Orthodoxy continues to be committed to the idea of the Torah's divine source. Yet despite this major difference, the Jewish community managed to avoid an irrevocable schism—largely because the ancient rabbis had prepared the ground for this debate. In reality, Jews have never been fundamentalists in the modern sense of the word. For two thousand years, rabbinic tradition has filtered the reading of the Bible through the interpretive lens called *midrash* (meaning *to search out*, an intermediary process between close reading and reimagining), thereby keeping the text flexible enough to accommodate the changing needs of the times. Although the rabbis never acknowledged their creative rereadings (perhaps not even to themselves), the precedents they set have enabled us, their modern descendants, to reconcile religious and scientific worldviews—and thereby to hold fast to the Bible.

What's in the Bible?

THE HEBREW BIBLE CONSISTS OF twenty-four books, divided into three major sections: *Torah*, *Prophets* (*Nevi'im*), and *Writings* (*Kethuvim*). The acronym formed from the first letters of these three Hebrew words yields the traditional Jewish name for the Bible: **TaNaKH**. (The more familiar title, the **Old Testament**, reflects Christianity's reinterpretation of the Hebrew Bible as the **prelude** to its own sacred scripture, the **New Testament**.) *The Illustrated Hebrew Bible* comprises seventy-five stories drawn from the Tanakh—forty from the Torah, thirty-five from Prophets and Writings.

The **Torah**, known also as the Five Books of Moses or the Pentateuch (Greek for "five books"), begins at the very beginning, the creation of the world, and ends with the death of Moses, as the Israelites stand poised to enter the Promised Land. The stories in this section—about the Garden of Eden, the Great Flood, the first Jewish family, the exodus from Egypt, the revelation at Sinai, the wanderings in the desert—have been told and retold for generations in religious school, in synagogue, and at home. Each year at the Passover seder, Jews reexperience the miraculous redemption from Egypt, and fifty days later, on the holiday of Shavuot, they receive the Torah anew.

Prophets, the middle division of the Bible, consists of four historical and four prophetic "books." First come the histories—Joshua, chronicling the Israelites' conquest of Canaan; Judges, describing the consolidation of national identity in the new land; and Samuel and Kings, documenting the ill-fated fortunes of the northern and southern kingdoms of Israel. Following these are the prophetic books: the three major prophets—Isaiah, Jeremiah, and Ezekiel—and the minor prophets, known in Hebrew as "the Twelve"—Hosea, Joel, Amos, Obadiah, Jonah, Micah, Nahum, Habakkuk, Zephaniah, Haggai, Zechariah, and Malachi. These prophetic writings, focusing primarily on Israel's flawed moral conduct and tragic destiny, contain some of the most inspiring poetry and prose in western literature.

Finally, we come to the eleven remaining books, known collectively as the **Writings**, an eclectic anthology of wisdom literature, poetry, and narrative. In the ancient world, wisdom literature was a common literary form, whose classic texts, such as Plato's *Dialogues* and the *Tao te Ching*, remain popular and pertinent to this day. The three wisdom books in this biblical section—Job, Proverbs, and Ecclesiastes—similarly strive to teach us how to live our lives with understanding, integrity, and peace of mind. Another unit in this section, known collectively as the Scrolls, (*megillot* in Hebrew), contains five books—Song of Songs, Ruth,

Lamentations, Ecclesiastes, and Esther. Together they constitute a liturgical cycle associated with five Jewish festivals. Standing by itself is the Book of Psalms, a collection of 150 poems traditionally attributed to King David. In Jewish, Christian, and secular tradition, these powerful prayer-poems have long been regarded as exceptional models of lyrical expression. Finally, the last three historical books complete the story of ancient Israel. The Book of Daniel, set in Babylonia after the Destruction of the First Temple, gives us a legendary glimpse of one of the first Jewish communities in diaspora. The double Book of Ezra/Nehemiah finishes this story by recounting the Jews' redemption from that exile and return to their homeland. And Chronicles is the grand reprise, recapping the history of Israel from its entry into the Promised Land until its conquest and exile by Babylonia.

From the stories, poetry, and wisdom of this sprawling anthology of ancient Hebrew literature, written over the course of a millennium, has arisen much of our contemporary culture; from the Bible's teachings, many of us have framed the guideposts for our lives. How apt is the metaphor that Jewish tradition has applied to this extraordinary book: "It is a Tree of Life to all who hold fast to it."

A Note about Art and Translation

NO OTHER WORK OF LITERATURE has inspired more artistic expression than the Bible. From ancient synagogue mosaics to contemporary paintings and sculpture, biblical themes have held pride of place in the art of every western nation. To these biblical stories each artist brings his or her own personal interpretation—just as each viewer adds yet another interpretive spin.

In addition to considering the differing perspectives of individual artists, we should note the differences between Jewish and Christian aesthetic traditions. Because of Judaism's traditional prohibition of representational art (a ban not always observed with strict vigilance), the history of Jewish art includes certain centuries of blank canvas. Although there have been exceptions especially under the influence of Hellenism, and Christian iconography, premodern Jewish art has focused primarily on synagogue decoration, manuscript illumination, calligraphy, and ceremonial art.

The opposite is true of Christian art. The stories of the Hebrew Bible, together with those of the New Testament, have inspired thousands of paintings, sculptures, and decorative works. Almost every Renaissance artist depicted biblical subjects; almost every church in Christendom, old or new, displays scenes and portraits from the Hebrew Bible. And although they no longer dominate the fine arts, biblical themes still command their share of admirers.

The art illustrating this volume honors the Hebrew Bible on its own terms. Each work of art should be considered as commentary, intended to enrich and deepen our understanding of the biblical text.

Similarly, these seventy-five stories have been retold in a style and language meant to make them as accessible as possible to contemporary readers. Inspired by the new translation published by the Jewish Publication Society, the narratives have been simplified and adapted for ease of reading and understanding. In addition, the language has been rendered with as much gender-sensitivity as possible. More material has been left out than included; missing are the laws, rituals, genealogies, prophecies, and other non-narrative portions that compose much of the Bible. Instead, this volume presents the essential stories of our collective spiritual biography. Taken together, they recount the greatest story ever told.

I.
The Beginning
of the World

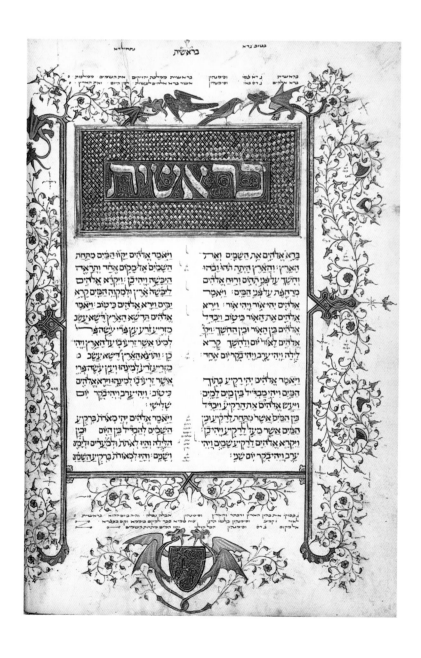

EVERY CULTURE HAS STORIES explaining the world's origins: how heaven and earth emerged from primal chaos, how life sprang forth, how people came to rule and misrule themselves. In such tales of beginnings resides the ethos of a community. Through them we discover how a particular tradition comes to terms with the imponderables of life—death, evil, moral fallibility, and grace.

In the not-so-distant past, those who studied the ancient stories regarded them as mere myths, quaint fabrications of the pre-civilized mind. With an arrogance typical of each reigning generation, scholars assumed that these early storytellers were naive literalists, simpletons ignorant of even the most basic laws of nature. But is judging a society by the tales it tells its children really fair? What might our descendants conclude about our own time if all that survived were our bedtime stories?

As you read these opening accounts from Genesis, put aside your preconceptions and meet the stories on their own terms. Understand that the questions they pose are not cosmological, but rather theological. Remember that the narrative voice presenting these dramas is much more concerned with why these events happen than with *how* they happen.

Read carefully: Very little that transpires at the world's beginning is represented as morally neutral. The Bible tells us that everything God creates is good, and that human beings are "very good." Human creatures were created to be companionable, because "it is not good for Adam to be alone." Moral knowledge exacts a price;

suffering is consequential, not random. Through the moral fable of Abel and Cain, we are warned that "sin crouches in the doorway," but assured that we can be its master. In the parable of the Flood, we realize that the agency of divine wrath, the floodgates of heaven, can also redeem as an agency of covenant, through the sign of the rainbow. The Tower of Babel story warns us not to let our hubris exceed our humanity.

We need not read these stories only as moral fables—they are also deliciously playful. Many previous generations of Bible readers have admired the serpent's wiliness and giggled at Adam and Eve's flimsy fig leaves. They have noted the preposterousness of Noah's floating zoo and made fun of Babel's follies. In fact, the mystery plays of medieval Europe presented the Genesis stories as farce!

In these first universal tales, the Bible portrays its world through the broad strokes of caricature, dramatizing the best and worst in human nature. And astonishingly, the beauty and truth these old stories convey have only improved with age.

OPPOSITE: *Genesis Page,* **Provence, probably Avignon (G. 4848, fol. 17v), ca. 1422. The Pierpont Morgan Library, NY/Art Resource, NY.**
OVERLEAF: *Paradise* **(detail), Peter Paul Rubens and Jan Breughel, ca. 1610–1620. Mauritshuis, The Hague/Art Resource, NY.**

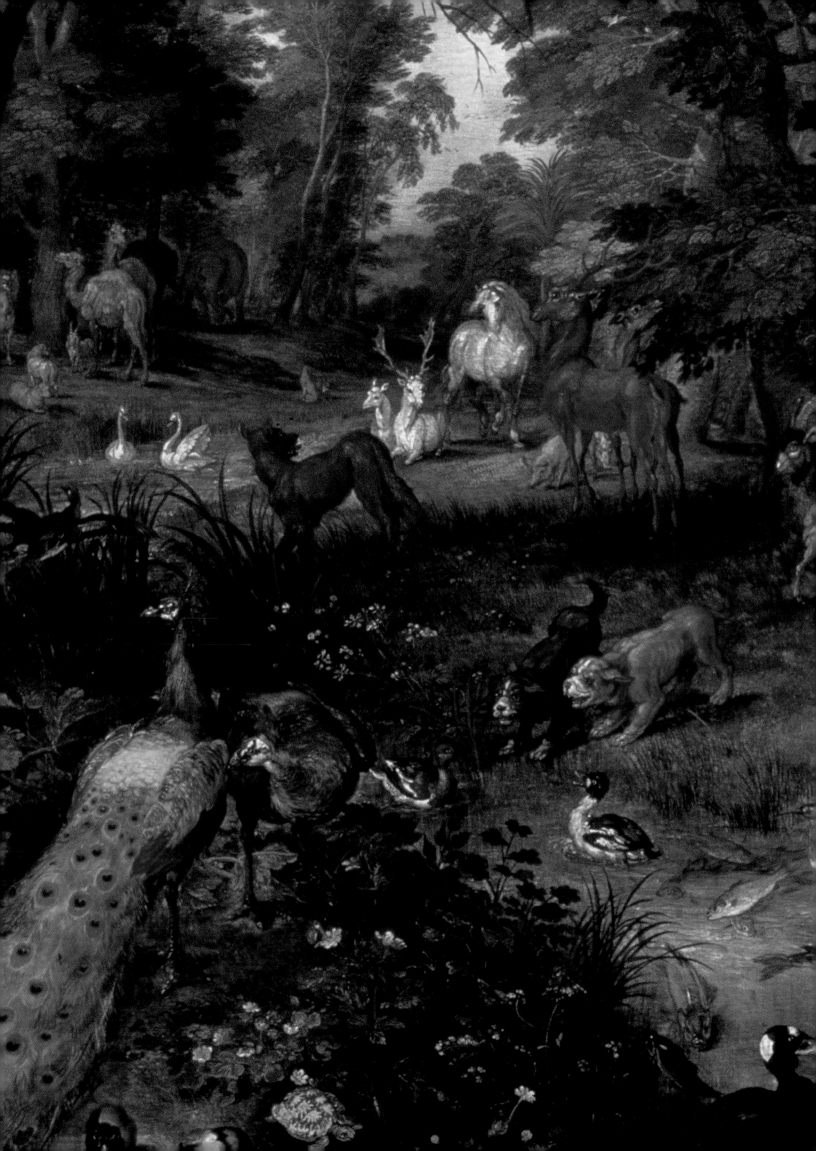

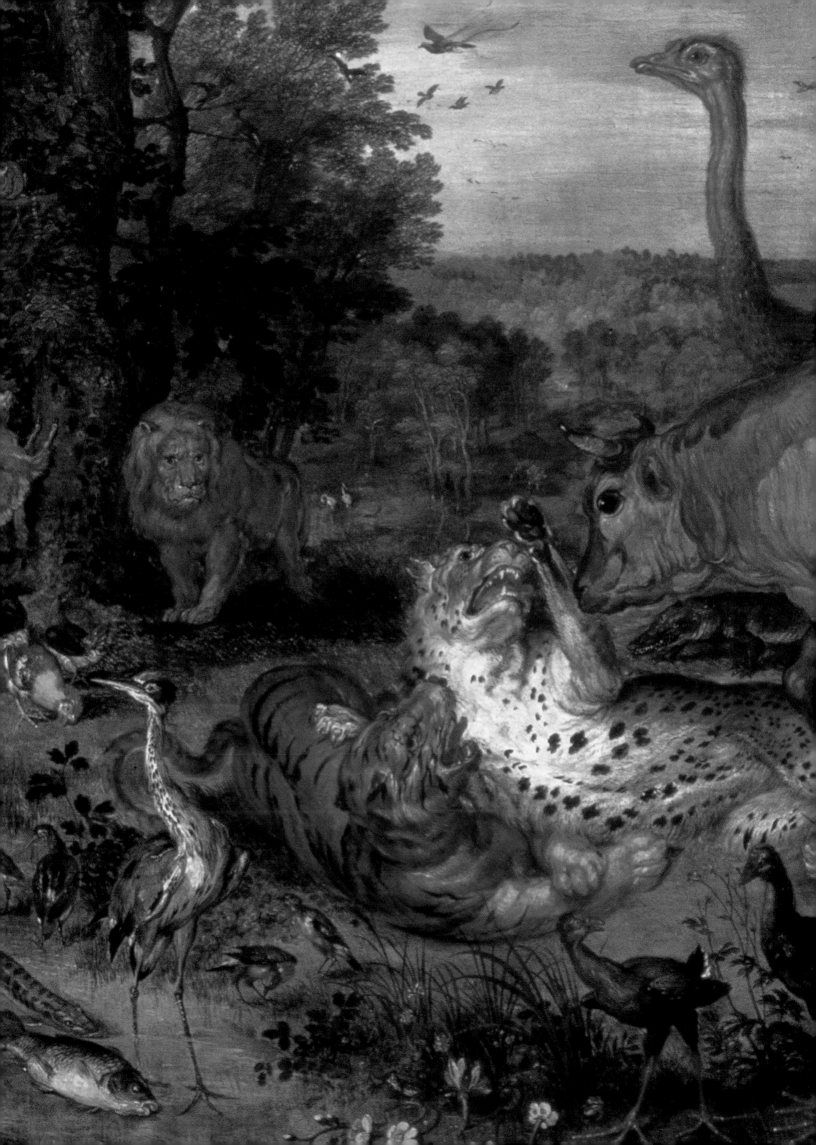

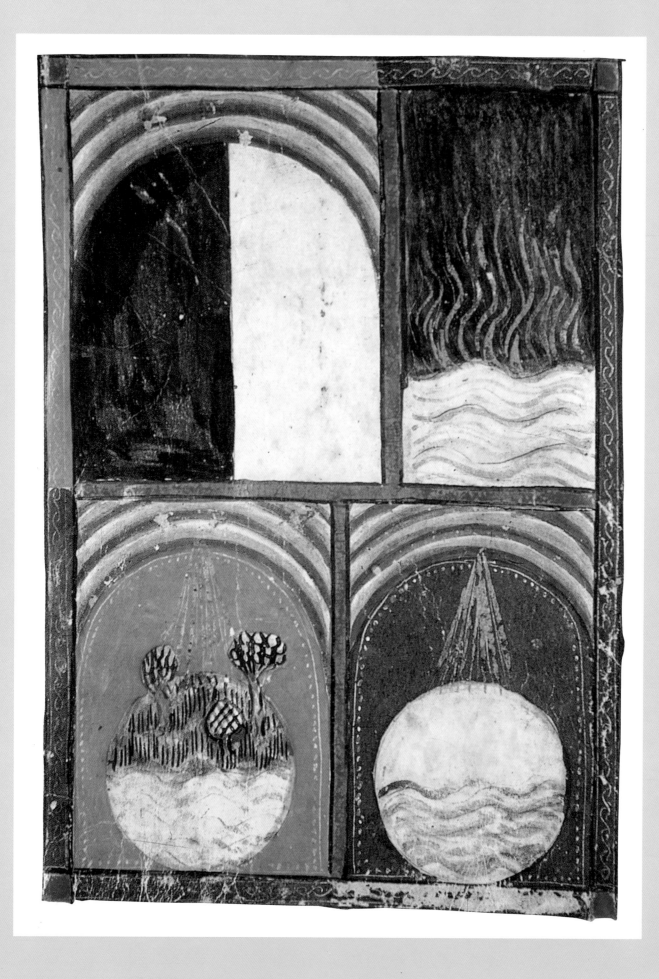

Genesis 1:1–2:4

In the Beginning

IN THE VERY BEGINNING, GOD CREATED A WORLD—THE HEAVENS AND THE EARTH—OUT OF NOTHING. BUT THIS WORLD WAS WITHOUT RHYME OR REASON. DARKNESS COVERED THE FACE OF THE DEEP, AND THE BREATH OF GOD GLIDED OVER THE WATERS.

Then God said, "Let there be light!"
And there was light.

God saw that the light was good. Then God separated the light from the darkness. God called the light "Day," and the darkness "Night."

And so there was evening and there was morning: one day.

Then God said, "Let there be a great space in the middle of the waters, separating them." God made this great space, separating the water above from the water below. God called this great space "Sky."

And there was evening and there was morning: a second day.

Then God said, "Let the water below the sky be gathered into one place, so that dry land can appear." And so it came to pass. God called the dry land "Earth," and the gathering together of the waters "Oceans." And God saw that this was good.

Then God said, "Let the earth give birth to green growing things—seed-bearing plants of every kind, and trees of every kind bearing fruit with seeds." And God saw that this was good.

And there was evening and there was morning: a third day.

Then God said, "Let there be lights in the sky to separate day from night. They will serve as signs of time: of days and of years." And so it came to pass.

Then God made the two great lights: the greater light—the Sun—to rule the day, and the lesser light—the Moon—to rule the night, as well as the stars. And God saw that this was good.

And there was evening and there was morning: a fourth day.

Then God said, "Let the waters overflow with life, and let flying creatures soar above the earth across the open space of sky." Then God created the great sea monsters, and creeping creatures of every kind, and winged creatures of every kind. And God saw that this was good.

God blessed them, saying, "Be fruitful and multiply! Fill the oceans, and let winged creatures spread over the earth."

And there was evening and there was morning: a fifth day.

Then God said, "Let the earth give rise to every kind of living creature—herd animals, creeping things, and wild beasts of every kind." And so it came to pass. God made wild beasts of every kind and herd animals of every kind,

OPPOSITE: *The First Three Days of Creation* from the *Sarajevo Haggadah*, Spain, 14th century. The National Museum of Bosnia Herzegovina, Sarajevo.

17

and all kinds of creeping things on the earth. And God saw that this was good.

Then God said, "Let us make a human being in our image, who is like us. They will rule the fish of the sea, the birds of the sky, the herd animals, the whole earth, and all the creeping things that creep on earth."

So God created a human being—Adam—molded in the divine image, both male and female at the same time. God blessed them and said to them, "Be fruitful and multiply, fill the earth and tame it, and rule over the fish of the sea, the birds of the sky, and all the living things that creep on the earth. And I give to you every seed-bearing plant that is on the earth, and every tree that has seed-bearing fruit as food. Likewise, I give the green plants for food to all the animals on the land, to all the birds in the sky, and to everything that creeps on the earth that breathes the breath of life." And so it came to pass.

And looking over all that had been made, God found it all very good.

And there was evening and there was morning: the sixth day.

Then the heavens and earth were finished, and all their company. God finished the work on the seventh day, and rested on the seventh day from all that work. God blessed the seventh day and declared it holy, because on it God rested from all the work of creation.

Such is the story of heaven and earth when they were created.

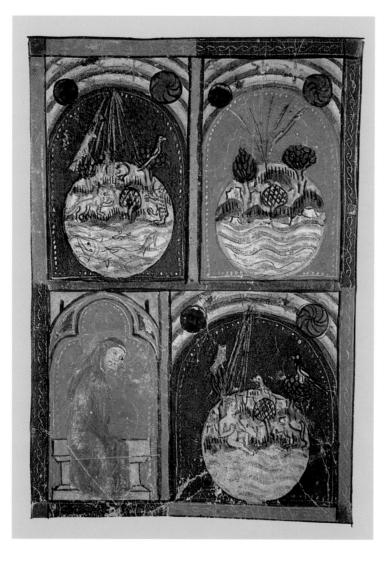

The Last Days of Creation from the *Sarajevo Haggadah*, Spain, 14th century. The National Museum of Bosnia Herzegovina, Sarajevo.

18

The Creation of Adam and Eve

אלה תולדות השמים בהבראם

These are the stories of heaven and earth when they were created.

WHEN GOD MADE EARTH AND HEAVEN, NO BUSH-ES GREW, NO GRASSES SPROUTED FROM THE FIELDS, BECAUSE GOD HAD NOT YET SENT RAIN UPON THE EARTH, AND THERE WAS NO one to work the soil. Instead a mist rose up from the ground and watered the face of the earth.

Then God formed a man, Adam, from the dust of the earth, and blew the breath of life into his nostrils, and Adam came to life.

Then God planted a garden in Eden in the east and placed the new-made man there. And from the ground God made trees grow, every kind of tree that was pleasant to look at and good to eat. And in the middle of the garden grew the Tree of Life and the Tree of Knowing Good and Evil.

God placed the man in the Garden of Eden to till and tend it. And God commanded him: "Of every tree in the garden you may eat, but you may not eat from the Tree of Knowing Good and Evil, for as soon as you eat from it you will surely die."

Then God said, "It is not good for Adam to be alone. I will make a companion for him."

So out of the earth God made all the wild animals and all the birds of the sky and brought them to Adam to see what he would call them. Whatever he called each living creature, that was to be its name. So Adam gave names to all the field animals and to the birds of the sky and to all the wild beasts. But still Adam had no companion.

Then God cast Adam into a deep sleep, and while he was asleep, took one of his ribs and sealed up the flesh at that place. And God shaped the rib into a woman and brought her to Adam.

Then Adam said, "This one at last is bone of my bones and flesh of my flesh. She will be called woman, *isha*, because she was taken out of man, *ish*."

That is why a man leaves his mother and father and clings to his wife, so that they become one flesh.

Adam Naming the Beasts, **William Blake, 1810.**
Glasgow Museums: The Stirling Maxwell
Collection, Pollok House.

19

Genesis 3a

The Serpent in the Garden

באחר ממנו לדעת טוב ורע

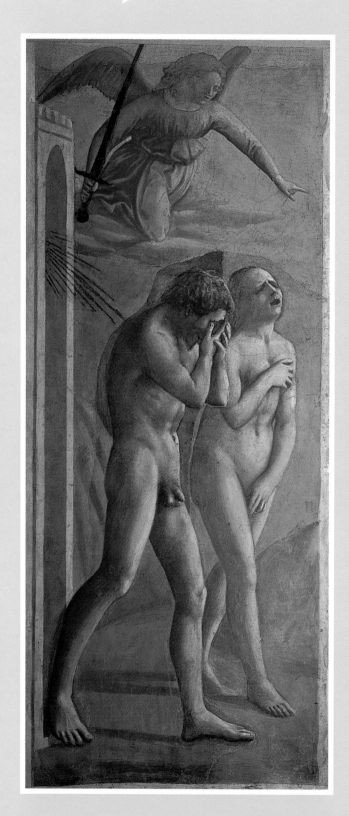

Adam and Eve Banished from Paradise, Tommaso Masaccio, early 15th century. The Brancacci Chapel, S. Maria del Carmine, Florence/ Bridgeman Art Library, London/New York.

THE MAN AND THE WOMAN WERE BOTH NAKED, YET THEY FELT NO SHAME.

THEN THE SERPENT, THE CRAFTIEST OF ALL THE WILD ANIMALS THAT GOD HAD MADE, SAID TO THE WOMAN, "DID GOD REALLY SAY, 'YOU SHALL NOT EAT FROM *ANY* TREE IN THE GARDEN'?"

"We may eat fruit from all the trees," answered the woman, "except the one that grows in the middle of the garden. About that one God said, 'Do not eat it or touch it, or you might die.'"

"You are not going to die!" cried the serpent. "You see, God knows that as soon as you eat this fruit, your eyes will be opened and you will be like God, who understands good and evil."

And when the woman noticed how tasty the fruit looked, and how pleasing it appeared, and when she imagined how wise it might make her, she took some fruit and ate it. She also gave some to her husband, which he ate.

Then suddenly their eyes were opened. As soon as they realized they were naked, they sewed fig leaves together and covered themselves. No sooner had they done so than they heard the voice of God moving through the garden. Quickly they hid from God among the trees.

God called out to Adam, "Where are you?"

"I heard your voice in the garden," answered Adam. "I was afraid because I was naked, so I hid."

"Who told you that you were naked?" asked God. "Did you eat from the forbidden tree?"

"The woman you set beside me—she gave me some fruit from the tree, and I ate it."

"What have you done?" God asked the woman.

"The serpent tricked me, so I ate," she replied.

"Because you did this," God said to the serpent, "you will be more cursed than all the other tame and wild beasts! You will crawl on your belly and eat dirt all the days of your life. I will sow hatred between you and the woman, between her children and yours. They will strike at your head, and you will strike at their heel."

To the woman God said, "I will make it painful for you to give birth to children. Yet despite that, you will still desire your husband, and he will rule over you."

And to Adam God said, "Because you obeyed your wife and ate from the forbidden tree, the ground will be cursed because of you. It will sprout thorns and thistles, and only through hard labor will you make it yield food. Your diet will be the lowly grasses of the field. By the sweat of your brow you will earn your bread, until you return to the ground from which you were taken. For you are only dust, and to dust you shall return."

Adam gave his wife the name Eve, <u>H</u>ava, because she was the mother of all living things, <u>h</u>ai.

God then made garments of skin for Adam and Eve, and clothed them.

Then God said, "Now that human beings have become like one of us, understanding good and evil, what if they should take fruit from the Tree of Life as well and live forever!"

So God banished them from the Garden of Eden, so that they would have to work the ground from which human beings were taken. After they were driven out, God stationed east of Eden the cherubim and the flaming ever-turning sword, to guard the way back to the Tree of Life.

21

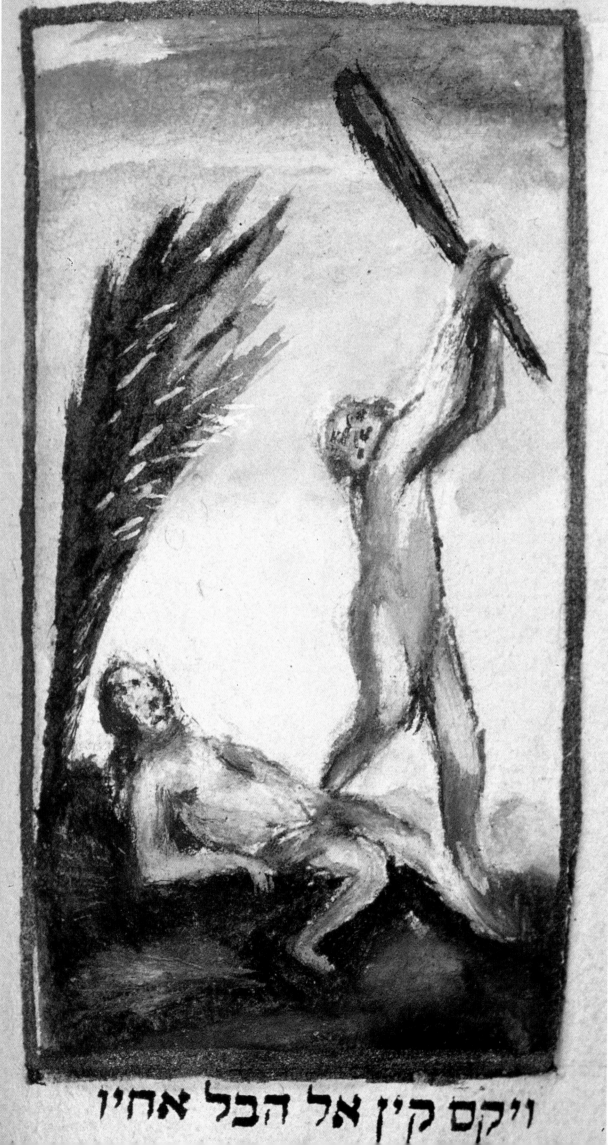

ויקס קין אל הכל אחיו

The Story of the First Murder

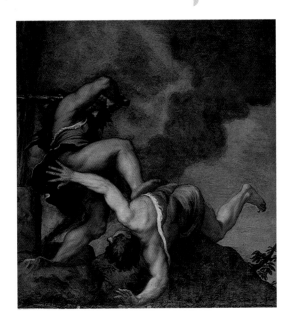

ADAM KNEW HIS WIFE, EVE, AND SHE BECAME PREGNANT AND GAVE BIRTH TO CAIN. "WITH GOD'S HELP," SHE DECLARED, "I HAVE GAINED, *KANITI*, A BOY CHILD."

Then she gave birth to his brother, Abel.

Abel became a shepherd, and Cain became a farmer.

Cain brought God an offering from what he grew in the ground. Abel brought the best of the firstborn animals of his flock. God took notice of Abel and his offering, but did not take notice of Cain and his offering.

Cain was very angry.

"Why are you so angry," God asked Cain, "and why do you look so sad? If you do what is right, you will be accepted. If you do not, sin crouches in the doorway calling to you—but you can master it!"

When they were together in the field, Cain rose up against his brother, Abel, and killed him.

"Where is your brother, Abel?" God asked Cain.

"I do not know," Cain replied. "Am I my brother's keeper?"

"What have you done?" God said to him. "Listen, your brother's blood cries out to Me from the ground! Now you shall be more cursed than the ground, which opened its mouth to receive your brother's blood from your hand. When you work the soil, it will no longer yield up its strength to you. You will become a rootless wanderer on the earth."

"My punishment is too much for me to bear!" cried Cain. "Now that You have banished me from the soil, and from Your presence, anyone who meets me may kill me!"

"I promise," said God, "that anyone who kills Cain will suffer not one but seven deaths." And God put a mark on Cain, in case anyone should meet him and want to kill him.

Then Cain left God's presence and settled in the land of Nod, east of Eden.

OPPOSITE: *Omer Book*, **Italy, ca. 1800–1810. The Jewish Museum, NY. Coll. Feffer, NY/Art Resource, NY.** ABOVE: *Cain and Abel*, **Titian, 16th century. S. Maria della Salute, Venice/ Erich Lessing/Art Resource, NY.**

23

The Great Flood

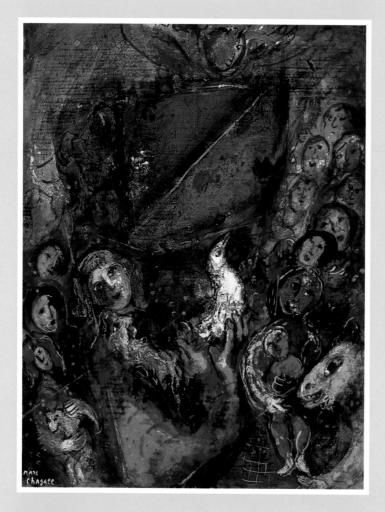

Noah's Ark, Marc Chagall, 1943. Christie's Images. © 1999 Artists Rights Society (ARS), New York/ADAGP, Paris.

HEN GOD SAW HOW MUCH HUMAN WICKEDNESS WAS ON EARTH, AND HOW PEOPLE'S MINDS WERE ALWAYS BENT ON EVIL, GOD REGRETTED CREATING HUMAN BEINGS AND WAS HEARTSICK. "I WILL WIPE OUT THESE HUMAN BEINGS I HAVE MADE," GOD DECLARED, "together with the beasts, creeping things, and birds, for I am sorry that I made them."

But Noah found favor in God's eyes.

THIS IS THE STORY OF NOAH'S family. Noah was a righteous man, whole-hearted in his own time. Noah walked with God. He had three sons: Shem, Ham, and Japhet.

Now the earth was filled with violence and lawlessness. When God saw how spoiled the earth was, because living things had perverted their own natures, God said to Noah, "I have decided to put an end to all flesh on earth. The earth is filled with violence because of them, so I am going to destroy them with the earth.

"Make yourself an ark of gopher wood, with compartments, covered inside and outside with pitch. Make it four hundred fifty

feet long, seventy-five feet wide, and forty-five feet high. Make a window in the roof to let the daylight in, and a door in the side. Fashion within it bottom, second, and third decks.

"For I am about to bring a flood upon the earth to destroy all living things under the sky: Everything on earth shall perish.

"But I will establish my covenant with you. You will come into the ark with your sons and your wife, and your sons' wives. From all living things—birds, cattle, and creeping things—take two of each into the ark to keep alive with you, a male and a female. For yourselves, take some of everything edible and store it away, as food for you and for them."

Noah did just as God commanded him.

Then God told Noah, "Go into the ark with your whole household. You are the only righteous one I have found in this generation. Take seven pairs of every permitted animal, male and female, and one pair of every forbidden animal, to keep their kind alive on the earth. In seven days I will bring rain upon the earth, for forty days and forty nights, and I will wipe out from the earth all life that I have created."

And Noah did just as God commanded him.

Noah was six hundred years old when the Flood came. He went into the ark with his sons, his wife, his sons' wives, the permitted animals and the forbidden ones, the birds, and everything that creeps on the ground. They came to Noah two by two, a male and a female, as God had commanded. On that same day, Noah, his family, and all the animals with them went into the ark, two of every living thing that breathed life. And

God shut Noah in.

And on the seventh day the waters of the Flood rained down upon the earth.

In the six-hundredth year of Noah's life, in the second month, on the seventeenth day of the month, "All the fountains of the great deep burst apart.

And the windows of the sky broke open."

THE FLOOD CONTINUED forty days on the earth. The waters swelled and raised the ark above the earth, so that it drifted upon the waters. Then the waters surged higher, covering all the tallest mountains and rising above the mountain tops. And all that breathed the breath of life—everything on dry land—all perished. Everything alive on earth—people, cattle, creeping things, birds of the sky—all were blotted out.

Only Noah and those who were with him remained alive in the ark.

Then, after one hundred fifty days, God remembered Noah and all the animals with him in the ark and caused a wind to blow across the earth, so that the fountains of the deep and the windows of the sky were sealed up, and the rain was held back. Then the waters steadily retreated from the earth.

In the seventh month, on the seventeenth day of the month, the ark came to rest on the mountains of Ararat. The waters kept going down until the tenth month. On the first day of that month, the tops of the mountains could be seen.

At the end of forty days, Noah opened the window and sent out the raven, who flew to and fro until the waters had dried up from the earth.

Then he sent out the dove to see whether the waters had subsided. But the dove could not find a resting place for her foot, so she came back to the ark, and Noah took her in.

25

He waited another seven days and again sent out the dove. When the dove returned toward evening, there in her beak was a plucked-off olive leaf! Then Noah knew that the waters had subsided. He waited another seven days and sent out the dove again. This time she did not return.

In his six-hundred-first year, in the first month, on the first day of the month, Noah removed the ark's covering and saw that the ground was drying. In the second month, on the twenty-seventh day of the month, the earth was dry.

God then spoke to Noah, "Come out of the ark, with your wife, your sons, and their wives. Bring out with you all the living things that are with you—birds, animals, and everything that creeps on the earth—and let them swarm over the earth and multiply."

So Noah came out with his family. And all the animals came out of the ark by families.

Then Noah built an altar to God and offered upon it sacrifices from every permitted animal and bird.

Smelling the pleasing odor, God thought, "Never again will I doom the earth because of human beings, because from its youthful days the human heart inclines toward evil. Nor will I ever again destroy every living thing as I have done. So long as the earth lasts, seedtime and harvest, cold and heat, summer and winter, day and night, will never end."

God blessed Noah and his children and said to them, "Increase and fill the earth. All beasts of the earth, birds of the sky, and fish of the sea will fear you. They are given into your hands. Every creature that lives shall be yours to eat, as well as all the green grasses. But you must not eat meat with its lifeblood still in it. Of your own lifeblood and of every beast, I will demand an accounting: Whoever sheds human blood, by human beings his blood will be shed, for God made human beings in the divine image."

God said to Noah and his children, "I now establish My covenant with you and your descendants, and with every living thing with you—birds, cattle, and all wild beasts—every living thing on earth. Never again will all flesh be cut off by the waters of a flood, and never again will a flood destroy the earth.

"This is the sign of the covenant I set between Me and you, and every living creature with you, for all time to come. I have set My rainbow in the clouds, and it shall serve as a covenant-sign between Me and the earth. When I bring clouds over the earth, and the rainbow appears in the clouds, I will remember My everlasting covenant with all living creatures on earth, so that the waters never again become a flood to destroy all flesh."

Noah's three sons who came out of the ark were Shem, Ham, and Japhet. From these three sons, the whole world branched out.

Then Noah, a farmer, planted a vineyard. He drank of the wine, became drunk, and uncovered himself in his tent. His youngest son, Ham, the father of Canaan, saw his father's nakedness and told his brothers about it. Shem and Japhet took a cloth, and walking backward, covered their father, their faces turned away so as not to see his nakedness.

When Noah awoke and heard what had happened, he said:

Blessed be the God of Shem!
May God enlarge Japhet,
and let him dwell in the tents
of Shem!
But let Canaan be a slave to them!

Noah lived three hundred fifty years after the Flood and died at the age of nine hundred fifty.

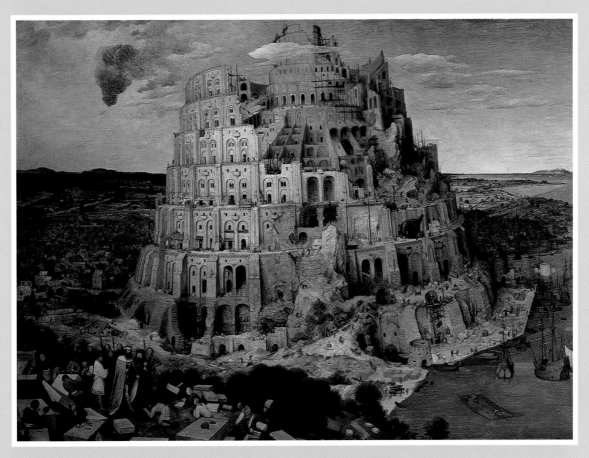

The Tower of Babel, Pieter Brueghel, the Elder, 1563.
Kunsthistorisches Museum, Vienna/Erich Lessing/Art Resource, NY.

The Tower of Babel

NOW EVERYONE ON EARTH SPOKE THE SAME LANGUAGE. AND AS THEY TRAVELED FROM THE EAST, THEY CAME UPON A VALLEY IN THE LAND OF SHINAR AND SETTLED THERE.

"COME, LET US MAKE BRICKS AND BURN THEM HARD," THEY SAID TO ONE ANOTHER.

"Let us build a city, with a tower reaching up into the sky, so that we can make a name for ourselves. Otherwise, we will be scattered all over the world."

Then God came down to look at the city and tower that human beings had built.

"If they have begun to act this way because they are one people speaking one language," God said, "then there is nothing to stop them from doing whatever they wish. Let us go down and mix up their speech, so that they will not understand one another's language."

So from there God scattered them across the face of the earth, and they stopped building the city. That is why the place is called Babel, *Bavel*, because there God babbled the speech of the whole earth and scattered its inhabitants over the face of the earth.

II.
The First
Jewish Family

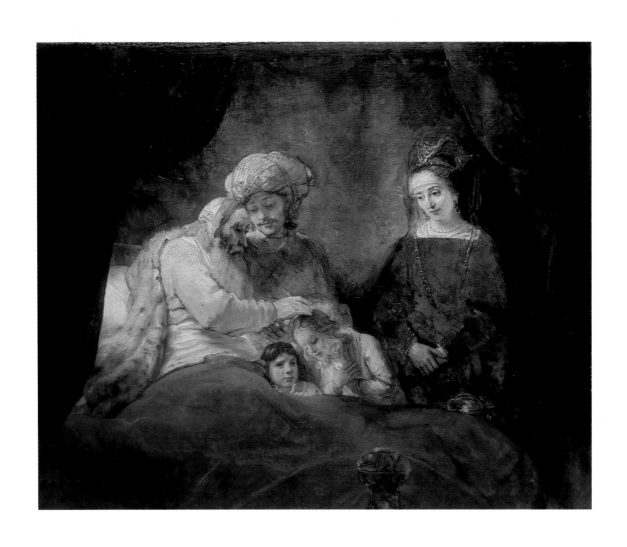

THE STORIES AT THE BEGINNING of Genesis span twenty generations—ten leading up to Noah, then ten more, culminating with Abraham and Sarah. In this next section the tales cover much less ground, only four generations—but how much more is packed into this shorter span!

A major theme running through the stories in this section is exile—the perennial lot of the Jewish people. We first encounter it with Abraham and Sarah, who leave their native country of Ur (present-day Iraq), their language, culture, gods, and families to settle in the foreign land of Canaan. Famine then drives them to Egypt, to which they return at the end of this four-generation cycle. Soon after Abraham and Sarah set down roots in their new homeland, they send Ishmael, Abraham's firstborn son, into exile with his mother, Hagar. Abraham later dispatches his servant to bring home a bride for Isaac, and Rebecca is thus exiled from her family. After stealing his brother's birthright, Rebecca's son Jacob flees back to his mother's homeland, thus completing the circle and remaining an outcast for twenty years. On their way back home, Jacob's beloved wife Rachel dies in childbirth and is buried along the road, outside the family's burial cave. Finally, Rachel's son Joseph is sold into bondage in Egypt, where he is eventually joined by his brothers, his father, and his whole clan in what ultimately becomes the first long diaspora of the Jewish people.

The other significant thread in these narratives is family rivalry. The importance of this theme comes as no surprise in a social system based on *primogeniture*, where the eldest son takes all. Yet in these stories, primogeniture is turned on its head: The *youngest* son is always the heir, not his older brother. Perhaps these accounts are meant as allegories about the Israelites, who appeared on the ancient Near Eastern stage long after the emergence of the great civilizations of the region—Babylonia, Egypt, and Assyria. Perhaps they present a lesson about the possibilities of prevailing—with God's help and human cunning—over the accident of one's birth. Whatever the moral, the Jewish line initially descends through a string of youngest sons: Isaac, Jacob, and Joseph. The firstborn sons, Ishmael and Esau, are cut off entirely. Joseph's eleven older brothers become the ancestors of Israel's tribes, but Joseph receives a double portion through his two sons, Ephraim and Manasseh.

Not only the men of these first families, but the women too, must vie for power. The barren Sarah ousts her rival, Hagar, when the latter gives birth to a potential heir for Abraham. The most poignant rivalry occurs between two sisters, Rachel and Leah, who are yoked together in marriage by their father's greed and deceit and then locked in a bitter breeding competition, together with their handmaids, to win their husband's divided love. Their rivalry no doubt provides the model for their sons, whose quarrels foreshadow the divided nation.

OPPOSITE: *Jacob Blessing the Children of Joseph*, **Rembrandt Harmensz van Rijn, 17th century. Gemäldegalerie, Kassel/Bridgeman Art Library, London/New York.**
OVERLEAF: *Abraham Expelling Hagar and Ishmael*, **Guercino, 1657. Pinacoteca di Brera, Milan/Scala/Art Resource, NY.**

Abram and Sarai Leave Their Native Land

THIS IS THE LINE OF TERA<u>H</u>: NOAH, SHEM, ARPAKHSHAD, SHELAH, EBER, PELEG, REU, SERUG, NA<u>H</u>OR, TERA<u>H</u>. TERA<u>H</u> HAD THREE SONS, ABRAM, NA<u>H</u>OR, AND HARAN. HARAN DIED IN UR. THEN TERA<u>H</u> LEFT FOR THE LAND OF CANAAN, TAKING WITH HIM ABRAM AND HIS WIFE, SARAI, NA<u>H</u>OR AND HIS WIFE, MILCAH, AND HARAN'S son, Lot. They did not reach Canaan but settled in <u>H</u>aran, where Tera<u>h</u> died.

THEN GOD SAID TO ABRAM, "GO forth from your native land, from your father's house, to the land that I will show you. I will make of you a great nation and make your name great. You shall be a blessing. I will bless those who bless you, and curse those who curse you. And all the families on earth will bless themselves by you."

So Abram went forth as God had commanded him. Abram was seventy-five years old when he left <u>H</u>aran. He took with him his wife, Sarai, and his nephew Lot, and all the wealth they had gathered, and the souls they had inspired in <u>H</u>aran, and they set out for the land of Canaan.

When they arrived there, Abram settled in Shechem, at the oak tree of Mamre. The Canaanites were then in the land.

God appeared to Abram and said, "I will give this land to your descendants."

Abram built an altar to God, who had appeared to him.

Then he traveled to the hill country east of Bethel, pitched his tent there, and built another altar to God. From there he traveled south toward the Negev.

33

OPPOSITE: *One God*, Harry Lieberman, ca. 1971. Private Collection. Courtesy Museum of American Folk Art, New York.
RIGHT: *God Appearing to Abraham at Sichem*, Paulus Potter, 17th century. Christie's Images.

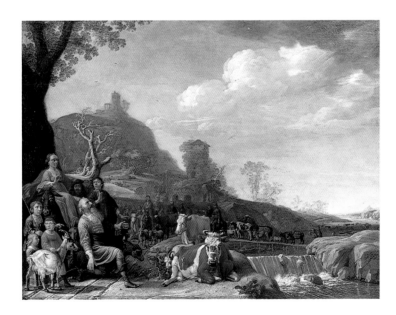

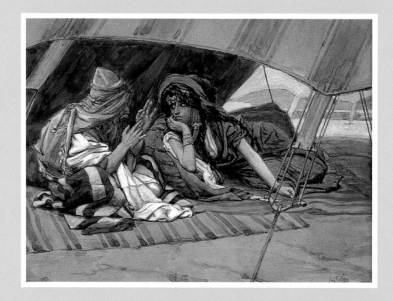

Abram's Counsel to Sarah, James Jacques Joseph Tissot, 19th century. The Jewish Museum, NY/Art Resource, NY.

The Birth of Ishmael

34

NOW SARAI, ABRAM'S WIFE, HAD GIVEN BIRTH TO NO CHILDREN. SHE HAD AN EGYPTIAN MAID NAMED HAGAR. ONE DAY SARAI SAID TO ABRAM, "GOD HAS KEPT ME FROM HAVING CHILDREN. TAKE MY maid. Perhaps you will have a son through her."

Abram listened to Sarai, taking Hagar as a wife. But when she learned that she was going to bear Abram's child, she began to look down upon her mistress, Sarai.

"This is your fault!" Sarai said to Abram. "I myself gave you Hagar, and now that she sees she is pregnant, she looks down upon me. Let God decide between you and me!"

"Your maid is in your hands," Abram said to Sarai. "Do with her what you think is right."

Sarai dealt harshly with her, and she ran away. An angel of God found her by a spring in the wilderness and said, "Hagar, slave of Sarai, where have you come from and where are you going?"

"I am running away from my mistress, Sarai," she said.

"Go back to your mistress," the angel said, "and submit to her." And the angel added, "I will greatly increase your children, and they shall be too many to count. Behold, you are to have a son, and you shall call him Ishmael, 'God listens,' for God has listened to your suffering. Your son will be a wild ass of a man, his hand against everyone, and everyone's hand against him. He will live alongside all his kinsmen."

Then Hagar called to God, who spoke to her. "You are *El-Ro'ee*, 'God-of-Seeing,' because 'I have gone on seeing even after God saw me!" Therefore the well was called *Be'er-la-hai-Ro'ee*, "Well of the Living One Who Sees Me."

When Hagar gave birth to a son, Abram named him Ishmael. Abram was eighty-six years old when his son was born.

The Visit of the Three Angels

*When Abram was ninety-nine years old, God appeared to him and made
a covenant with him. He changed his name to Abraham, and Sarai's
name to Sarah. And God promised to make of them a great nation.*

GOD APPEARED TO ABRAHAM BY THE OAK TREES OF MAMRE, WHERE ABRAHAM WAS SITTING IN FRONT OF HIS TENT IN THE HEAT OF THE DAY. WHEN HE LOOKED UP, HE SAW THREE MEN STANDING NEARBY. AS SOON AS HE SAW THEM, HE RAN TO MEET THEM AND

bowed. "My lords, do not pass by!" he said to them. "Let me have some water brought to you. Wash your feet and rest under the tree.

Abraham and the Three Angels, **Bohemian
glass tumbler, ca. 1850. Coll. Max Berger,
Vienna/Erich Lessing/Art Resource, NY.**

And let me give you a little bread to eat so that you can regain your strength before going on."

Then Abraham hurried into the tent and said to Sarah, "Quick, knead some flour and make cakes!"

Then he ran to the herd, chose a tender calf, and gave it to a servant boy to cook. He took the cooked meat, together with milk and butter, and served it to his guests.

"Where is your wife, Sarah?" they asked.

"There, in the tent," he replied.

"I will come back next year," said one of the guests, "and your wife, Sarah, will have a son!"

At that moment, Sarah was behind Abraham, listening at the tent flap. Now Abraham and Sarah were very old, and Sarah no longer menstruated like younger women. Sarah laughed to herself and thought, "Now that I am dried up, am I going to enjoy myself—with such an old man for a husband!"

"Why did Sarah laugh?" God asked Abraham. "Does she doubt that she could have a child at such an age? Is anything too amazing for God? I will come back to you at this time next year, and Sarah will have a son."

Sarah was afraid, so she lied. "No," she protested, "I did not laugh!"

God said to her, "But you did laugh."

35

Genesis 18:16–19:38

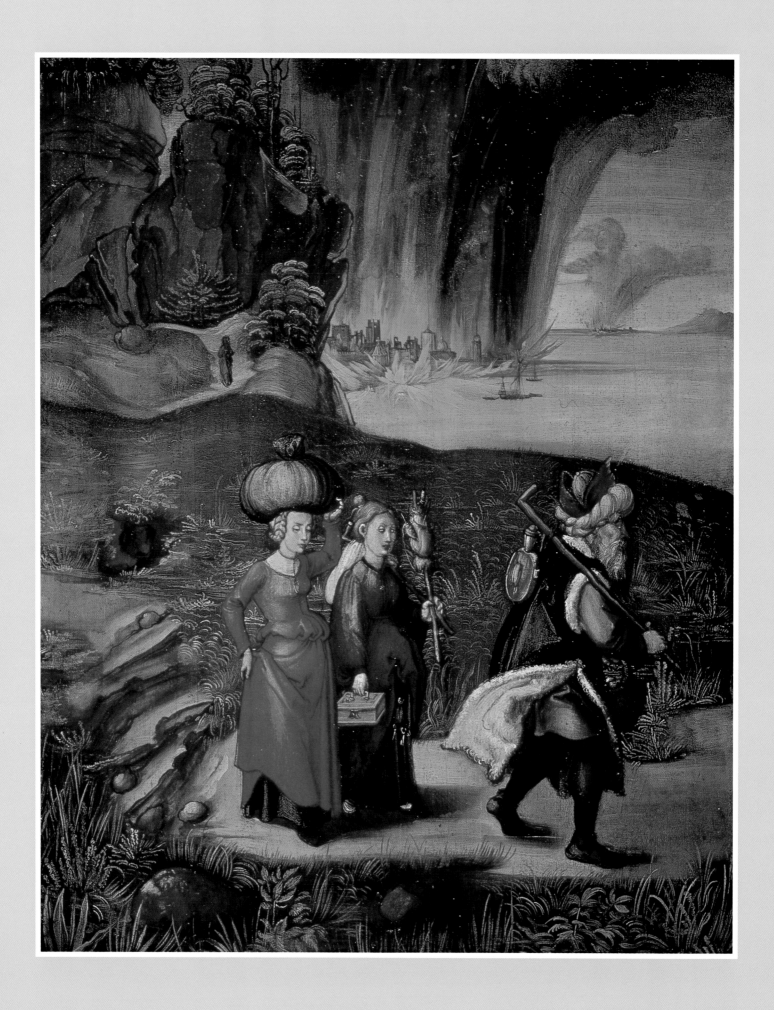

Sodom and Gomorrah

אלי והאנשים אשר באו אליך

THE MEN NOW HEADED TOWARD SODOM. AS ABRAHAM WALKED WITH THEM, GOD WONDERED, "SHOULD I HIDE FROM ABRAHAM WHAT I AM ABOUT TO DO? FOR I HAVE SINGLED HIM OUT TO TEACH HIS CHILDREN WHAT IS RIGHT, SO THAT HE MIGHT RECEIVE WHAT I HAVE PROMISED HIM."

"The sins of Sodom and Gomorrah are so great!" God now declared to Abraham. "I will go there to see if what I have heard is true."

So while Abraham remained talking with God, the other two men continued on down to Sodom.

"Will you destroy the righteous together with the guilty?" Abraham asked. "What if there are fifty righteous people in the city—will you destroy the place? Will you not pardon it for the sake of the fifty righteous who live there? Should not the Judge of the World act justly!"

"If I find there fifty righteous ones," God answered, "I will forgive the whole place on their account."

"Although I am only dust and ashes," continued Abraham, "let me speak further, my Lord. What if the righteous are five short? Will you destroy the whole city because five are missing?"

"I will not destroy it if I find forty-five."

OPPOSITE: *Lot and His Daughters*, **Albrecht Dürer, early 16th century. National Gallery of Art, Washington, DC/Bridgeman Art Library, London/New York.**

"What if only forty can be found?" asked Abraham.

"For the sake of forty, I will not do it," God answered.

"Do not be angry, my Lord," said Abraham, "if I ask for the sake of thirty."

"Very well, for the sake of thirty," God replied.

"What if only twenty can be found?"

"I will not destroy it for the sake of twenty."

"I will speak one last time, my Lord," Abraham said. "Please do not be angry. What if only ten are found?"

"I will not destroy it for the sake of ten," God said.

Then God left after speaking to Abraham, and Abraham returned to his place.

IN THE EVENING, THE TWO ANGELS came to Sodom and met Lot at the city gate. He rose to greet them, bowed, and said to them, "Please spend the night in my house, and then you can go on your way early."

"No," they said, "we will spend the night in the town square."

But Lot persuaded them to stay with him, so they came to his house, where he served them a feast. Before they went to sleep, every man of Sodom, young and old, surrounded the house and shouted to Lot, "Where are those men who came to you tonight? Bring them out so that we can be intimate with them!"

37

Genesis 22:1–19

The Binding of Isaac

ויעקד את־יצחק בנו

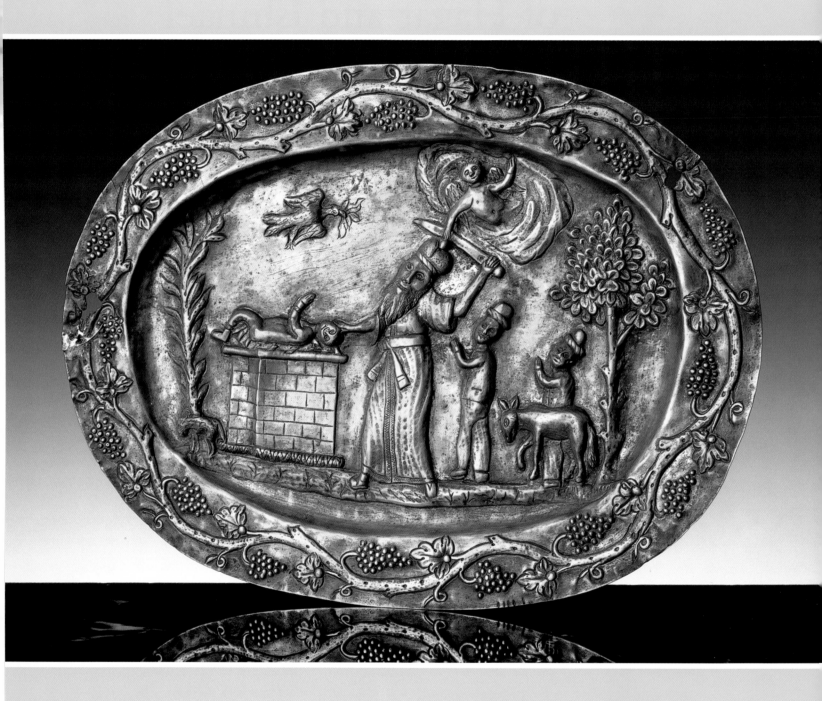

AFTER A TIME, GOD TESTED ABRAHAM.

"ABRAHAM!"

"HERE I AM," ANSWERED ABRAHAM.

"TAKE YOUR SON, YOUR ONLY SON, THE ONE YOU LOVE, ISAAC, AND GO TO THE LAND OF MORIAH. SACRIFICE HIM THERE ON ONE OF THE MOUNTAINS I WILL SHOW YOU."

SO EARLY THE NEXT MORNING, ABRAHAM SADDLED HIS DONKEY AND

took with him two of his servants and his son, Isaac. He split the wood for the sacrifice and headed toward the place God had told him to go.

On the third day Abraham looked up and saw the mountain in the distance.

"Stay here with the donkey," Abraham told his servants. "The boy and I will go up there. We will worship and then return to you."

Abraham took the wood for the sacrifice and bound it to his son, Isaac. In his own hand he took the firestone and the knife, and the two of them walked off together.

Then Isaac said to Abraham, "Father!"

"Here I am, my son," Abraham answered.

"Here are the firestone and the wood, but where is the sheep for the sacrifice?"

"God will see to the sheep for the sacrifice, my son," Abraham replied.

OPPOSITE: *Ceremonial Plate,* **Galicia, 19th century. From the Collection of The Jewish Museum, NY/HUC Skirball Cultural Center, Museum Collection, Los Angeles.**

Then the two of them walked off together.

They came to the place God had told Abraham about. There Abraham built an altar and arranged the wood on it. Then he bound up his son, Isaac, and laid him on the altar on top of the wood.

Abraham reached out his hand and took the knife to kill his son. But an angel of God called to him from heaven, "Abraham! Abraham!"

"Here I am," said Abraham.

"Do not raise your hand against the boy or do anything to hurt him; now I know that you fear God, because you have not held back your son, your only son, from Me."

Then Abraham looked up and saw a ram caught in a thornbush by its horns. He took the ram and sacrificed it instead of his son.

Abraham named the place *Adonai yireh,* "God will see." And so they say even today, "On the mountain of God is vision."

Then the angel of God called to Abraham a second time from heaven and said, "I will swear by My own name,' says God, 'that because you have done this, because you have not held back your son, your only son, I will give you My blessing, and make your children as countless as the stars of heaven and the sands of the seashore. Your descendants will triumph over their enemies. And all the nations of the earth will bless themselves by your descendants, because you have listened to My voice.'"

Abraham then went back to his servants, and they left together for Beersheba, where Abraham lived.

41

Eliezer Seeks a Wife for Isaac

בראה את עיניה

ABRAHAM WAS NOW OLD, BLESSED BY GOD IN ALL THINGS. ABRAHAM CALLED HIS SENIOR SERVANT, WHO RAN ABRAHAM'S HOUSEHOLD AND ALL THAT HE OWNED, AND SAID TO HIM, "SWEAR BY THE GOD OF HEAVEN AND EARTH THAT YOU WILL NOT FIND A WIFE FOR MY SON, ISAAC, FROM AMONG the Canaanites, but will go to the land of my birth to find a wife for him."

"But what if the woman refuses to come with me?" the servant asked. "Shall I take your son back there?"

"No, you must not take him back there! God who took me from my native land and promised this new land to me and my offspring will send an angel before you, and you will find a wife there for my son. And if the woman does not agree to follow you, then you are released from your oath to me. But do not take my son there."

And the servant swore to do what Abraham had asked of him.

So the servant set out with ten camels and many gifts and traveled to Aram-Nahara'im, where Nahor, Abraham's brother,

OPPOSITE: *Rebecca at the Well*, **Thomas Rossiter, 1852. In the Collection of the Corcoran Gallery of Art, Washington, DC. Gift of William Wilson Corcoran.**

lived. Arriving at the well outside the city at evening time, when the women came to draw water, he made his camels kneel down by the well, and he prayed, "God of my master, Abraham, grant me good fortune and be gracious to my master. When the daughters of the city come here, give me a sign. When I say, 'Please lower your jar so that I may drink,' let the one who answers, 'Drink, and I will also water your camels' be the one whom You have chosen for Isaac."

As soon as he had finished speaking, Rebecca—daughter of Bethuel, son of Milcah, wife of Abraham's brother Nahor (that is, Abraham's great-niece)—came to the well. She was very beautiful and not yet married. She went down to the spring and returned, bearing her jar on her shoulder. The servant ran to her and asked her for water.

She quickly lowered her jar and said, "Drink, my lord." When he had drunk his fill, she said, "I will also draw enough for your camels." She emptied the water into the trough and then returned to the well to draw water for all the camels.

Then the servant gave the young woman a gold nose ring and two golden armbands and said to her, "Whose daughter are you? Is there room tonight in your father's house?"

"I am Bethuel's daughter, granddaughter of Milcah and Nahor," she said. "We have room for you and plenty of straw for your camels."

The servant bowed before God and offered thanksgiving. "God has guided me

43

on my errand," he declared, "leading me to the house of my master's kinsmen."

Rebecca ran ahead and told her family all that had happened. When her brother Laban saw the gold jewelry she was wearing, he went to the well and said to the servant, who was still standing there with his camels, "Why are you still outside? Come in! I have made everything ready for you and your camels."

So the camels were unloaded and fed, and water was brought to wash the feet of the servant and his men. But the servant refused to eat anything until he had told his story.

"I am Abraham's servant," he began. "God has blessed my master so that he has become very rich. In their old age, Abraham and his wife, Sarah, have had a son, who will inherit everything when Abraham dies. My master made me swear to find a wife for his son from among his kinsmen, and God sent me a sign and guided me to your daughter. Now tell me if you will treat my master kindly."

Laban and his father, Bethuel, answered, "The matter was ordained by God. Take Rebecca to be the wife of your master's son, as God has spoken."

The servant gave Rebecca many gifts of silver and gold, as well as clothing, and also gave presents to her brother and mother. Then the servant and his men had dinner and spent the night. The next day, the servant said, "Let me return home to my master."

But Laban and Rebecca's mother asked him to remain with them ten more days.

"Do not make me wait," he said. "Let me go."

"Let us ask Rebecca," they said. And when they asked her, "Will you go with this man?" she replied, "I will."

So they sent Rebecca and her nurse, Deborah, with Abraham's servant and his men, and they traveled back to Canaan.

Isaac was walking in the field at twilight when he saw camels approaching. As soon as Rebecca saw him, she dismounted from her camel and put on her veil. The servant then told Isaac all that had happened.

Isaac brought Rebecca into his mother Sarah's tent, and she became his wife. Isaac loved her, and was comforted after his mother's death.

Persian Vessel, **Luristan, possibly Amlash, date unknown. HUC Skirball Cultural Center, Museum Collection, Los Angeles. Gift of Ruth K. March from the Estate of A. L. and Ida Koolish.**

44

Jacob Steals the Birthright

בכורתי את בכרתך לי

Isaac Blessing Jacob **from the**
Golden Haggadah **(Add. Ms.**
27210, fol. 4v), ca. 1320. © The
British Library, London.

second child came out grasping his brother's heel, so they named him Jacob, "heel." Esau grew up to be a hunter, an outdoorsman; Jacob was a mild man, and stayed close to camp. Isaac, because he fancied game, favored Esau, but Rebecca loved Jacob.

Once when Jacob was cooking a lentil stew, Esau came home famished. He said to his brother, "Give me some of that red stuff!" (That is why he is also named Edom, which means "red.")

Jacob said, "First sell me your birthright."

Esau replied, "What good is my birthright to me if I die?"

But only after Esau had sworn his birthright over to his brother did Jacob give him bread and lentil stew to eat. After he had eaten, Esau went on his way. And so he spurned his birthright.

When Isaac was old and blind, he said to his older son, Esau, "Who knows how soon I may die? Go hunt me some game and prepare it the way I like, so that I can give you my blessing before I die."

45

ISAAC WAS FORTY WHEN HE MARRIED REBECCA, AND THEY WERE WITHOUT CHILDREN FOR TWENTY YEARS. ISAAC PRAYED TO GOD ON HIS WIFE'S BEHALF, AND SHE CONCEIVED TWINS, WHO STRUGGLED WITH EACH OTHER IN HER WOMB. "WHY THIS?" SHE CRIED OUT TO GOD. "WHY ME?"

"Two nations are in your womb," God answered her, "one mightier than the other, and the older shall serve the younger."

When she gave birth, the first twin emerged covered all over with red hair, so they named him Esau, "hairy one." The

Rebecca had been listening to their conversation, and now she said to her son Jacob, "I overheard your father tell your brother, 'Hunt and prepare some game for me, so that I may bless you before I die.' Now listen to me, and do as I say. Fetch me two choice kids from the flock, and I will prepare them just the way your father likes. Then bring the dish to your father, so that he can bless you before he dies."

Jacob protested, "But Esau is a hairy man, and my skin is smooth! If my father touches me and discovers my deceit, he will curse me, not bless me."

His mother replied, "Your curse will be on my head, my son! Just do as I say."

So Rebecca cooked the goats and then dressed Jacob in Esau's best clothes, covering his neck and hands with the goatskins. Then she gave Jacob the meat and bread she had prepared, and he took them in to his father.

"Father," he said.

"Which of my sons are you?" Isaac asked.

"I am Esau, your firstborn," Jacob said. "Here is the game you requested. Please sit up and eat, and then bless me."

"How did you succeed so quickly?"

"God granted me good fortune."

"Come closer, my son," Isaac said to Jacob, "so that I can touch you, to see whether you are really my son Esau or not." And when he touched him, he said, "The voice is the voice of Jacob, but the hands are the hands of Esau." And because

Jacob's hands were hairy, Isaac did not recognize him and so blessed him.

He asked him again, "Are you really my son Esau?" and Jacob answered, "I am." And after Jacob had served him the meat and given him wine to drink, Isaac said to him, "Come close and kiss me, my son." He kissed him and smelled his clothes, and then he blessed him.

As soon as Jacob had gone, Esau returned from his hunting. He prepared a dish and took it in to his father, saying, "Sit up and eat, and give me your blessing."

Isaac said to him, "Who are you?"

He answered, "I am your son Esau, your firstborn!"

Isaac began to tremble and asked, "Then who was it who brought game to me before? Because I blessed him, he must remain blessed!"

When Esau heard this, he wept wildly and bitterly and cried, "Bless me too, Father!"

"Your brother took away your blessing with guile," Isaac said.

"So he has earned his name, Jacob, 'heel,' for he has swindled me out of both my birthright and my blessing! Do you not have a blessing left for me?"

"I have named him your master and blessed him with grain and wine," Isaac replied. "What have I left for you, my son?"

"Surely, you have something," he cried. "Bless me too, Father!" And he wept aloud.

Isaac said, "By your sword you shall live, and you shall serve your brother. But when you grow restless, you will throw off his yoke."

After this, Esau bore a grudge against his brother and swore to himself, "When my father dies and I have mourned him, I will kill my brother, Jacob." As soon as Rebecca learned of Esau's plans, she called Jacob and told him to flee to her brother Laban's house in Haran. "Stay with him awhile until your brother's anger cools," she said to him, "and then I will send for you. Let me not lose you both in one day!"

So Jacob left his parents' house and journeyed to Paddan-Aram, to stay with his uncle Laban.

Jacob's Dream of the Ladder

וְהִנֵּה סֻלָּם מֻצָּב אַרְצָה

JACOB LEFT BEERSHEBA AND JOURNEYED TOWARD HARAN. WHEN THE SUN SET THAT NIGHT, HE STOPPED AT A CERTAIN PLACE AND LAY DOWN FOR THE NIGHT, PLACING ONE OF THE STONES THERE UNDER HIS HEAD. HE DREAMED OF A LADDER REACHING FROM THE GROUND UP TO THE SKY, with angels going up and down on it. Beside him stood God, who said to him, "I am the God of your father Abraham and the God of Isaac. This ground upon which you are lying I give to you and your descendants, who will spread out to the west, east, north, and south. I am with you and will protect you wherever you go, and I will bring you back here to this land."

Jacob woke from his sleep and said, "Surely God is here in this place, and I did not know it! This is none other than God's house, the gateway to heaven." Jacob took the stone that he had used as a pillow and poured oil upon it. He named that place Bethel, "the house of God," and swore a vow, "If You protect and sustain me on this journey and return me safe to my father's house, You will be my God and this stone shall be Your dwelling place. And I will give You one-tenth of all that You give me."

Then Jacob resumed his journey.

47

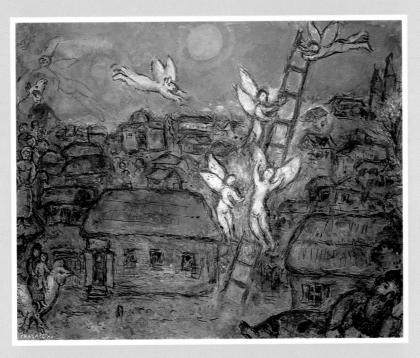

Jacob's Ladder, Marc Chagall, 1973. Coll. Chagall/Scala/Art Resource, NY.

THE FIRST JEWISH FAMILY

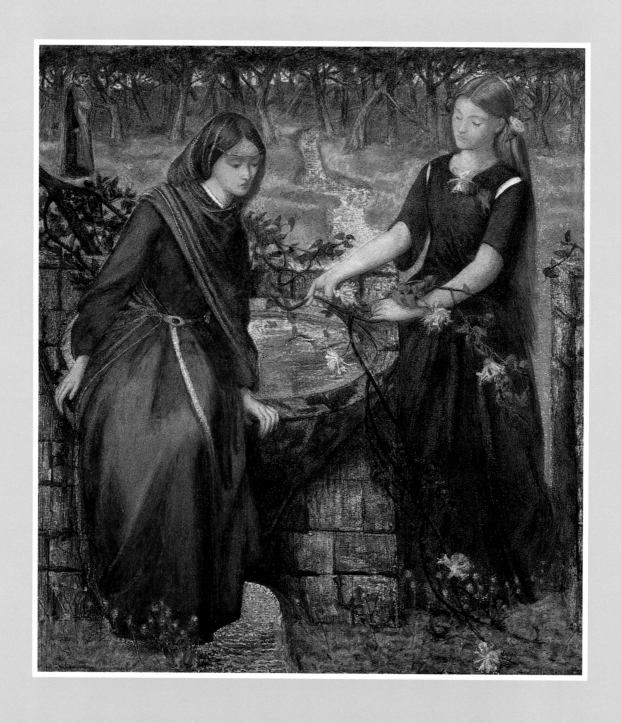

Jacob Marries Leah and Rachel

JACOB REACHED THE LAND OF THE EASTERNERS AND CAME TO A WELL COVERED BY A LARGE STONE. WHEN HE LEARNED THAT THE SHEPHERDS GATHERED THERE WITH THEIR FLOCKS WERE FROM HARAN,

he asked them if they knew Laban, son of Nahor. "Yes, we do," they replied, "and there is his daughter Rachel, coming with her flock." But when Jacob asked the other shepherds to roll off the stone covering the mouth of the well, they refused, so he rolled it off himself and watered Rachel's flock. He then kissed Rachel and burst into tears, telling her that he was her cousin, Rebecca's son. She went and told her father, Laban, who ran to greet his nephew Jacob and bring him home.

After a month's time, Laban said to Jacob, "Just because you are my bone and flesh, why should you work for nothing? Tell me what your wages should be."

"I will serve you seven years for your younger daughter, Rachel," Jacob replied. Laban had two daughters—Leah, the elder, had tender eyes; Rachel was beautiful, and Jacob loved her.

Laban said, "Better that I should marry her to you than to a stranger."

So Jacob served seven years for Rachel, but they seemed to him only a few days because of his love for her.

Jacob now asked Laban for his wife, because he had kept his promise. Laban made a feast for all the people of that place, and when it was evening, brought Leah to Jacob, and

OPPOSITE: *Dante's Vision of Rachel and Leah,* Dante Gabriel Rossetti, 1855. Tate Gallery, London/Art Resource, NY.

he lay with her. And when morning came, there was Leah!

"Why did you trick me?" Jacob asked Laban. "I served you for Rachel!"

"It is not our custom to marry the younger daughter before the elder," Laban replied. "At the end of the bridal week, I will give you her sister as well—if you will serve me yet another seven years." And so, at the end of the week, Jacob married Rachel, and lay with her, and loved her more than Leah. And Jacob served Laban another seven years.

When God saw that Leah was unloved, God opened her womb—but Rachel was barren. Leah bore a son and named him Reuben, meaning "See, a son," for she said, "God has seen—*ra'ah*—my suffering," and also, "Now my husband will love me—*ye'ehavani*." She bore a second son, Simeon, meaning "God heard—*shama*—that I was unloved and gave me this one too." She gave birth again to a son and named him Levi, saying, "My husband will become attached—*yillaveh*—to me." Then she bore a fourth son, whom she named Judah, declaring, "this time I will praise—*odeh*—God."

Because she had borne no children, Rachel envied

49

her sister, and she said to Jacob, "Give me children, or I shall die!"

Jacob chastised Rachel, "God is the one who has denied you children. Can I play God?"

Rachel now gave Jacob Bilhah, whom Laban had given her as a maidservant, and she said, "Sleep with her, so that I can have children through her." Bilhah conceived and gave Jacob a son. Rachel named him Dan, saying, "God has vindicated me—*danani*—and given me a son." Then Bilhah gave birth to a second son, whom Rachel named Naftali, declaring, "I have waged a fateful contest—*naftule naftalti*—with my sister and have won."

Leah now gave Jacob, as a concubine, Zilpah, whom Laban had given her as a maidservant, and she gave birth to a son, whom Leah named Gad, meaning "What luck!" And she gave birth to a second son, whom Leah named Asher, saying, "What good fortune—*b'oshri!*"

Once when Leah's son Reuben returned home with some mandrakes and gave them to his mother, Rachel asked her sister for them (for they were known to promote conception). Leah protested, "Was it not enough to take away my husband! Now you want my son's mandrakes too!"

Rachel said, "I promise that Jacob will sleep with you tonight in exchange for the mandrakes."

And when Jacob came home that night, Leah said to him, "I have hired you with my son's mandrakes," and she

conceived and bore a fifth son, whom she named Issachar, which means "God has given me my reward—*sekhari*—for giving my maid to my husband." Then she bore a sixth son, whom she called Zebulun, saying, "God has given me a special gift—*zebadani*—and my husband will praise me—*yizbeleni*." She then gave birth to a daughter, Dinah.

Then God remembered Rachel and opened her womb. She gave birth to a son, whom she named Joseph, declaring, "God has removed—*asaf*—my disgrace," and also, "May God add—*yosef*—another son for me."

Jacob had now spent twenty years serving Laban, and God had blessed Jacob and multiplied his flocks. Then God said to him, "Return to the land of your fathers, and I will be with you." But Laban did not want to let Jacob go. So

Jacob fled with his wives and concubines, his children and his flocks, and came to the hill country of Gilead. Laban pursued Jacob and overtook him, and demanded from him his household gods; for Rachel had stolen them, but had not told Jacob. When Laban could not find his gods, he left Jacob and his camp in peace and returned home to Haran.

And Jacob journeyed toward Canaan to meet his brother, Esau.

Wedding Rings, **Italy, 17th century. Collection Israel Museum, Jerusalem.**

Jacob Wrestles with the Angel

אם ברכתני

לא אשלחך כי

JACOB SENT MESSENGERS AHEAD TO HIS BROTHER, ESAU, AND THEY RETURNED, SAYING, "YOUR BROTHER IS COMING TO MEET YOU, AND WITH HIM ARE FOUR HUNDRED MEN." AND JACOB WAS VERY MUCH afraid, and he divided his family, servants, and flocks into two camps, so that he would not lose all that he had if his brother attacked. He prayed to God to protect him from the hand of his brother, recalling God's promise to make Jacob's descendants as numerous as the sands of the sea. The next morning he sent many animals from his flocks as gifts to his brother Esau, hoping thereby to soften his anger.

That night he forded the River Jabbok with his two wives, his two maidservants, and his children, and all his possessions. Then Jacob was left alone on the other bank.

And a man wrestled with him until the break of day. When he saw that he was not able to overpower Jacob, he pulled Jacob's hip out of its socket, and he said, "Let me go, for the day is breaking." But Jacob answered, "I will not let you go until you bless me."

"What is your name?"

"Jacob."

"Your name will no longer be Jacob, but Israel, *Yisrael*, for you have wrestled—*sareeta*—with God and with human beings, and you have triumphed."

"Please tell me your name," said Jacob.

"You must not ask my name!" And he left him there.

Jacob named the place Peni'el, meaning "I have seen a godly being face to face—*panim el panim*—and my life has been spared." And as the sun rose, he went on his way, limping on his hip. To this day, in remembrance of Jacob's wrestling that night, the children of Israel do not eat the thigh muscle attached to the hip socket.

51

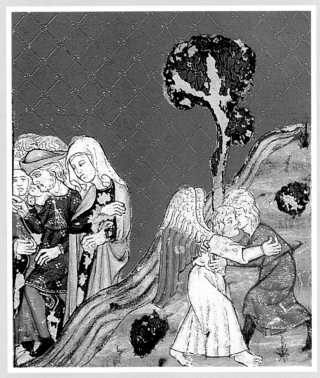

Jacob Taking His Family Across the Jabbok from the *Golden Haggadah* (Add. Ms. 27210, fol. 15r), ca. 1320. © The British Library, London.

The Rape of Dinah

שכב אתה ויענה

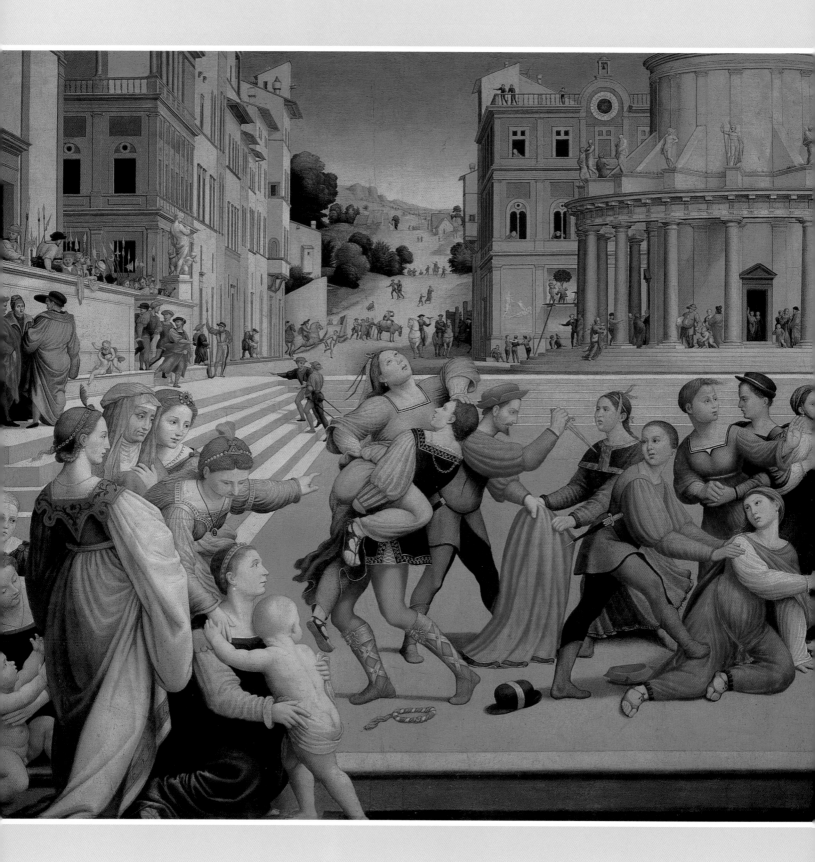

OW DINAH, THE DAUGHTER LEAH HAD BORNE TO JACOB, WENT OUT TO VISIT THE DAUGHTERS OF THE LAND. AND SHECHEM, SON OF HAMOR, THE CHIEF OF THAT LAND, SAW HER AND SEIZED HER AND LAY WITH HER AND RAPED HER. CAPTIVATED BY DINAH AND IN LOVE WITH HER, HE SPOKE TENDERLY TO THE YOUNG WOMAN.

Then Shechem said to his father, Hamor, "Get me this girl as a wife."

Jacob heard that Shechem had raped his daughter, but because his sons were out in the field tending the herds, he said nothing until they came home. And Shechem's father, Hamor, went to speak with Jacob.

When Jacob's sons came in from the field and heard the news, they were heartbroken and angry, because Shechem had done an unspeakable thing. Hamor said to them, "My son Shechem yearns for your daughter. Please give her to him in marriage. Intermarry with us—our sons will marry your daughters, and our daughters will marry your sons. You will live among us and settle down in this land and have a share in it."

Shechem added, "I will pay whatever bride-price you ask, however high. Only give me the girl as a wife."

Jacob's sons answered Shechem and his father with cunning, because he had violated their sister, Dinah: "We cannot do what you ask, because to give our sister to a man who is

OPPOSITE: *The Rape of Dinah, Daughter of Jacob and Leah*, Fra Bartolomeo, ca. 1531. Kunsthistorisches Museum, Vienna/Erich Lessing/Art Resource, NY.

uncircumcised would be a disgrace among us. Only on one condition will we give her to you: Every male among you must be circumcised so that you become like us. Then we will intermarry with you and dwell among you and become one people. But if you will not do this, we will take our daughter and go."

Their words pleased Hamor and Shechem, and Shechem lost no time doing what they asked, for he desired Jacob's daughter. Then Hamor and his son Shechem—who was the most respected son in his father's house—went to the town gate and said to their fellow townsmen, "These people are our friends. Let them settle here and marry with us, for the land has room enough for all of us. However, they will agree to join with us only on one condition—that all our men become circumcised as they are circumcised. Let us agree to these terms, for then their cattle and all that they have will become ours, and they will live among us." And all the males of the town listened to their words and were circumcised.

On the third day, when Hamor and his people were in pain, Simeon and Levi, Dinah's brothers, took their swords, came unchallenged into the town, and slaughtered all the males. They killed Hamor and his son Shechem, took Dinah out of Shechem's house, and left. Then Jacob's other sons came upon the slain and plundered the town, because their sister had been violated. They seized everything—the flocks and herds and asses, the wealth and children and wives, everything that was in the houses, inside the city, and in the fields outside.

"What trouble you have caused me!" Jacob said to Simeon and Levi. "You have made me despicable to those who live in this land, the Canaanites and Perizzites. My men are few; if these others join together to attack me, I and my household will be destroyed."

And they answered him, "Shall our sister be treated like a whore?"

53

Then Joseph told them about a second dream: "In this dream, the sun, the moon, and eleven stars were bowing down to me."

When he told this dream to his father and his brothers, his father rebuked him, saying, "What is this that you have dreamed? That I and your mother and your brothers are to bow down to you?" His brothers resented him, but his father took the matter to heart.

Once, when his brothers had taken their father's flock to pasture at Shechem, Jacob said to Joseph, "Go see how your brothers are and how the flocks are doing, and bring me back word."

When Joseph reached Shechem, he met a man wandering in the fields. The man asked him, "What are you looking for?"

Joseph answered, "I am looking for my brothers. Can you tell me where they are herding their flock?"

"They have left here," the man said, "for I heard them say, 'Let us go to Dothan.'" So Joseph went and found them at Dothan.

When they saw him coming in the distance, they conspired to kill him. "Here comes that dreamer!" they said to one another. "Let us kill him and throw him into one of the pits. Then we can say, 'A wild beast has devoured him.' So much for his dreams!"

But Reuben, when he heard what they were saying, tried to save Joseph. "Let us not take his life," he said. "Do not spill any blood! Throw him into this pit in the wilderness, but do not raise a hand against him," for he intended to save his brother from their hands and return him to his father.

When Joseph came to his brothers, they stripped him of his coat of many colors and threw him into the pit. The pit was empty; there was no water in it. Then they sat down to eat. When they looked up, they saw a caravan of Ishmaelites coming from Gilead, carrying spices down to Egypt. Judah said to his brothers, "What do we gain by killing our brother and

hiding his blood? Let us sell him to these Ishmaelites, instead of raising our own hands against him. For he is our brother, our own flesh and blood." And his brothers agreed. They sold him to the Ishmaelites for twenty pieces of silver, and they took Joseph to Egypt.

When Reuben returned to the pit and found Joseph gone, he tore his clothes. He returned to his brothers and said, "The boy is gone! What shall I do?"

They took Joseph's coat, slaughtered a kid, and dipped the coat in its blood. Then they sent the coat of many colors to their father and said, "We found this. Do you recognize it? Is this your son's coat?"

When Jacob recognized it, he cried, "My son's coat! A wild beast has devoured him! It has torn Joseph to pieces!" And Jacob tore his clothes and put on sackcloth and mourned his son for many days. And all his sons and daughters rose up to comfort him, but he refused to be comforted, saying, "I will go down to my grave mourning my son." And his father wept for him.

And Joseph was sold in Egypt to Potiphar, Pharaoh's chief steward.

56

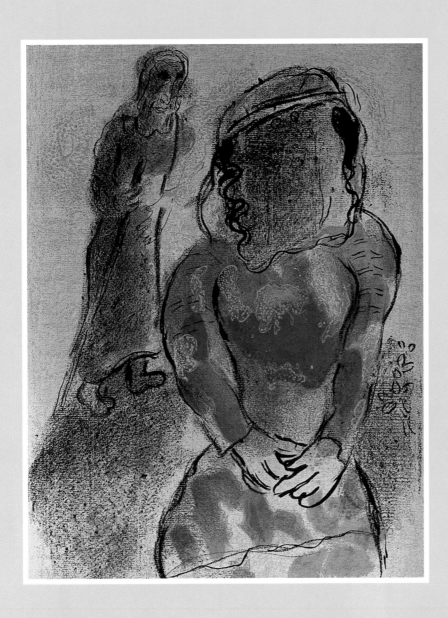

Tamar, Daughter-in-Law of Judah, **Marc Chagall, 1960. Musée Message Biblique-Chagall, Nice/Photo © RMN. © 1999 Artists Rights Society (ARS), New York/ADAGP, Paris.**

Judah and Tamar

JUDAH MARRIED THE DAUGHTER OF A CANAANITE, WHO BORE HIM THREE SONS: ER, ONAN, AND SHELAH. JUDAH FOUND A WIFE NAMED TAMAR FOR HIS FIRSTBORN SON, ER. BUT ER DISPLEASED GOD, AND GOD TOOK his life. Then Judah said to Onan, "Do your duty as a brother-in-law and marry your brother's widow to give him an heir." But because he knew that Tamar's seed would not count as his own, he spilled his seed upon the ground whenever he lay with Tamar. This displeased God, and God took his life also. Then Judah said to his daughter-in-law Tamar, "Return as a widow to your father's house until my son Shelah grows up." For Judah worried, "He might also die like his brothers." So Tamar returned to her father's house.

In the course of time, Judah's wife, the daughter of

Shua, died. When Judah got up from mourning, he went with his friend Hirah the Adullamite to the sheepshearing at Timnah. When Tamar was told of this, she took off her widow's clothes, put on a veil, and sat down along the road to Timnah. For though Tamar knew that Shelah had grown up, she had not been summoned to marry him. Seeing her, Judah took her for a prostitute (for her face was veiled). He turned aside and said to her, "Sleep with me"(he did not recognize her as his daughter-in-law).

"What will you pay me?" she asked.

"I will send a kid from my flock," he replied.

"You must give me a pledge until you send it."

"What pledge shall I give you?" he asked.

"Your seal and cord, and the staff you carry."

He gave them to her, and slept with her, and she became pregnant. Then she went on her way, took off her veil, and put back on her widow's clothes.

Judah sent his friend Hirah to redeem the pledge with a kid from Judah's flock, but Hirah could not find the woman. "Where is the prostitute who sits by the road?" he asked the people of the town.

"There has been no such woman here," they told him.

When Hirah related this to Judah, he said, "Let her keep my pledge, for if we continue asking about it, we will look like fools. I kept my word, but she did not allow herself to be found."

Three months later, Judah was told, "Your daughter-in-law Tamar is pregnant; she has played the whore."

Judah declared, "Bring her out and let her be burned."

Tamar then sent a message to her father-in-law, "I have conceived by the man to whom these belong. Do you know whose seal and cord and staff these are?"

Recognizing these items as his, Judah said, "How much more in the right is she than I! For I did not give her to my son Shelah." And Judah never slept with her again.

When the time came for her to give birth, behold, there were twins in Tamar's womb! When one put out his hand, the midwife tied a red thread around him to mark this one as the firstborn. But the child pulled back his hand, and his brother was born first. "Look how you have broken through!" the midwife declared. So he was called Peretz, "breakthrough." Then his brother came out, his hand bound with the red thread. He was therefore named Zerah, "radiance."

Joseph in Egypt

ווישב אבי חי (decorative Hebrew)

WHEN JOSEPH ARRIVED IN EGYPT, THE ISHMAELITES SOLD HIM TO POTIPHAR, PHARAOH'S CHIEF STEWARD. GOD WAS WITH JOSEPH, AND HE PROSPERED IN POTIPHAR'S HOUSE. AND WHEN

Potiphar saw that God was with Joseph, so that he succeeded in everything he did, Potiphar put Joseph in charge of his entire household and all that he owned, inside and outside. And for Joseph's sake, God blessed Potiphar and all that he owned. So Potiphar left Joseph in charge of everything, except the food that he ate.

Now Joseph was quite good-looking. Potiphar's wife had her eye on Joseph, and one day she said to him, "Lie with me."

But he refused. "See, my master has entrusted me with everything he has," he said to his master's wife, "so that he does not even know what is in his own house. He has no more authority in his house than I. He has withheld nothing from me—except you. How could I act so basely, and sin before God?" And though she implored him every day, he refused to lie with her.

One day he came into the house to do his work when no other household staff were present.

Joseph Fleeing Potiphar's Wife, **Raphael, early 16th century. Logge, Vatican Palace, Vatican State/Scala/Art Resource, NY.**

59

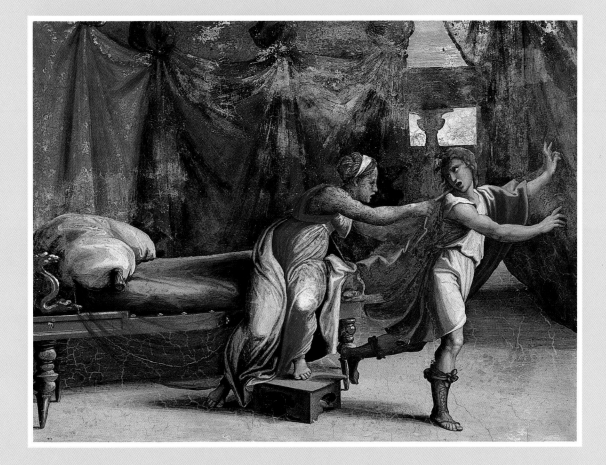

Potiphar's wife grabbed hold of his garment and demanded, "Lie with me!" Joseph fled outside, leaving his garment in her hand.

Then she called to her servants, "See, he had to bring a Hebrew here to toy with us! He tried to lie with me, but I screamed aloud. And when he heard me screaming, he left his garment in my hand and fled."

She kept his garment close at hand until her husband came home. And she told him the same story. When he heard what his servant had done, Potiphar was furious. He had Joseph locked up in the place where the king's prisoners were kept.

But God was with Joseph there and showed him kindness. The warden took a liking to him and put him in charge of all the prisoners and all that happened at the prison. The warden gave Joseph a free hand. Everything Joseph did, God caused to prosper.

Some time afterward, the king's cupbearer and baker offended the king, and he put them in the custody of his chief steward, who assigned them to the prison under Joseph's charge. After they had been in custody for a while, they each dreamed a dream on the same night, each with its own meaning. When Joseph came to them the next morning, he saw that they were troubled. "Why are you so downcast today?" he asked them.

"We dreamed a dream," they told him, "and there is no one to interpret it."

Joseph said to them, "God can interpret—tell them to me."

So the cupbearer told Joseph: "In my dream there was a vine with three branches. And though the vine was barely in bud, blossoms suddenly appeared, and the clusters ripened into grapes. Pharaoh's cup was in my hand, and I took the grapes, pressed them into the cup, and handed the cup to Pharaoh."

"Here is the meaning of your dream,"

Pharaoh's Dream **from the** *Golden Haggadah* **(Add. Ms. 27210, fol. 7r), ca. 1320. © The British Library, London.**

Joseph said to him. "The three branches are three days. Three days from now, Pharaoh will pardon you and restore you to your former position as his cupbearer. But when all is well with you again," Joseph added, "please remember to tell Pharaoh about me so that I can be freed from this place. For I was abducted from the land of the Hebrews, and I have done nothing wrong that I should have been cast in this pit."

When the chief baker saw how well the interpretation had turned out, he said to Joseph: "In my dream, there were three baskets on my head, and in the top basket were all kinds of baked goods prepared for Pharaoh, and the birds were eating these from the basket on my head."

Joseph said to him, "Here is the meaning of your dream: The three baskets are three days. Three days from now, Pharaoh will

60

hang you from a tree, and the birds will eat your flesh."

The third day was Pharaoh's birthday, and he gave a banquet for all his servants, singling out the chief cupbearer and chief baker from among all his servants. He restored the chief cupbearer to his former position; the chief baker he hanged—just as Joseph had foretold.

However, the chief cupbearer did not remember Joseph, but forgot him.

Two years later, Pharaoh dreamed a dream: As he stood by the Nile, out of the river came seven beautiful, healthy cows, and they grazed among the reeds. Soon after, out of the Nile came seven ugly, lean other cows, and these stood next to the first cows on the riverbank. Then the ugly, lean cows ate up the seven beautiful, healthy cows. And then Pharaoh awoke.

Pharaoh fell asleep and dreamed again: Seven healthy, sound ears of grain grew on a single stalk. And seven other ears, lean and withered by the east wind, sprouted behind them. Then the seven lean ears swallowed up the seven full, healthy ears. And then Pharaoh awoke—and behold, it was a dream.

The next morning, waking up with a troubled spirit, Pharaoh sent for all the magicians and wise men of Egypt. He told them his dreams, but no one could interpret them. Then the chief cupbearer spoke up: "Today I recall my wrongdoing! Pharaoh once became angry with me and the chief baker and imprisoned us. While we were in prison, each of us dreamed a dream on the same night, each with its own meaning. When we told our dreams to a young Hebrew prisoner there, a servant of the chief steward, he interpreted our dreams for us. And his interpretations came to pass: I was restored to my position, and the baker was hanged."

So Pharaoh sent for Joseph. He was hurriedly shaved and dressed and brought before Pharaoh. "I have dreamed a dream," Pharaoh said to him, "and no one can interpret it. I have heard that you can interpret dreams."

"Not I," Joseph replied, "but God will look after Pharaoh's welfare."

So Pharaoh told Joseph his two dreams of the seven cows and the seven ears of grain. "This is but a single dream," Joseph said. "God has told Pharaoh what will come to pass. The seven good cows and the seven good ears together are seven years. And the seven lean cows and seven lean ears are seven years of famine. God has revealed to Pharaoh what is about to happen: First, seven years of great prosperity will come to the land of Egypt. But they will be followed by seven years of famine so severe that the good years will be forgotten. Because Pharaoh has had the same dream twice, it is certain that this matter has been ordained by God and will soon come to pass. Therefore, let Pharaoh find a wise man, and put him in charge of the land of Egypt. And let him appoint overseers who will see that sufficient food is stored in reserve for the years of famine."

Joseph's plan pleased Pharaoh and his officials. "Could we find another man like this," Pharaoh declared, "filled with the spirit of God?" So Pharaoh said to Joseph, "Because God has made all this known to you, there is none as wise as you! You shall be in charge of my household, and at your command shall my people be directed. Only with respect to my throne will I be superior to you. Behold, I am giving you the entire land of Egypt."

Then Pharaoh took off his signet ring

61

and placed it on Joseph's hand. He had Joseph clothed in fine linen robes and hung a golden chain around his neck. Joseph rode in the chariot of his second-in-command, and all the people acclaimed him. Pharaoh said to him, "I remain Pharaoh, but only at your word will anyone in Egypt lift hand or foot."

Then Pharaoh gave Joseph a new name—*Zaphenat-paneah*—meaning "God speaks; he lives." He gave him as a wife Asenat, daughter of Potiphera, priest of On. Joseph was thirty years old when he entered Pharaoh's service.

During the seven years of plenty, Joseph gathered all the abundant grain that the land produced and stored it in the cities closest to the fields where it grew. So plentiful was the grain that it outnumbered the sands of the sea, so that Joseph stopped measuring it. And before the years of famine began, Asenat gave Joseph two sons. Joseph named the firstborn Manasseh, meaning "God has made me forget my suffering and my father's house." And he named the second son Ephraim, meaning "God has made me fruitful in the land of my affliction."

Then the seven years of abundance came to an end, and seven years of famine began. There was famine in all lands, but in Egypt alone there was bread. And when the whole land of Egypt felt the famine and cried out to Pharaoh for bread, he said to them, "Go to Joseph, and he will tell you what to do."

When the famine became severe in Egypt, Joseph opened the storehouses and rationed out grain to the Egyptians. And when the famine spread over the whole world, all came to Joseph in Egypt for rations.

When Jacob saw that there was food in Egypt, he said to his sons, "Go down to Egypt and get rations for us, so that we may live and not die." So ten of Joseph's brothers went down to Egypt, because the famine extended to the land of Canaan. But Jacob did not send Joseph's brother Benjamin with them, for he feared that some disaster might befall him.

Joseph's brothers came before Joseph, vizier of Egypt, and bowed low before him. Joseph recognized his brothers, but they did not recognize him. He acted like a stranger and spoke harshly to them. "Where do you come from?" he asked.

"From the land of Canaan, to obtain food," they replied.

Then Joseph remembered the dreams he had had about them. "You are spies!" he said to them. "You have come to see the land in its nakedness."

"No, my lord," they said, "your servants have come only to obtain food. We are honest men, not spies."

"No, you are spies!" Joseph repeated. "This is how I will test you: Bring your youngest brother here, or as Pharaoh lives, you will not leave here. Send one among you to fetch your brother here; the rest of you will remain captive. Thus I will test whether you are telling the truth or are indeed spies." And he locked them up for three days.

On the third day, Joseph said to them, "Do this and you shall live, for I am a God-fearing man. If you are indeed honest men, let one of your brothers remain in custody while the rest of you take home rations, and bring your youngest brother back to me. Then I will believe your story, and you shall not die."

"We are now bearing our guilt because of what we did to our brother," they said to one another, "for we witnessed his ordeal and did not help him. Now we face our own ordeal."

"Did I not say to you," Reuben reminded them, "'Do not do wrong by the boy?'

62

But you would not listen to me, and now we must pay for his blood."

Now they did not know that Joseph was listening, because there was an interpreter between them and him. Hearing their words, he turned away and wept. Then he turned back and spoke with them, and he had Simeon bound before them. Then Joseph ordered food placed in their sacks, returned their money to them, and gave them food for their journey. They loaded up their donkeys and went on their way.

That night when they reached a resting place, one of them opened his sack to feed his donkey and found his money inside. "My money has been returned!" he said to his brothers. "Here it is in my sack!"

Then they all lost heart and began to tremble. "What has God done to us?" they cried.

When they returned to their father, Jacob, in Canaan, they told him all that had happened: "The lord of that land spoke harshly to us and accused us of being spies. We told him, 'We are honest men, not spies. We are twelve brothers, son of one father. One of us is gone, and the littlest one is with our father in Canaan.' But he said to us, 'I will know that you are honest men only if you leave one of your brothers with me and return here with your youngest brother. Then I will release your brother to you, and you shall be free.'"

"You are always bereaving me!" Jacob said to them. "Joseph is gone and so is Simeon, and now you would take Benjamin away!"

"Kill my own two sons if I do not bring Benjamin back to you," Reuben said to his father. "Entrust him to me, and I will return him to you."

"No, my son will not go down with you," Jacob said, "for his brother is dead, and he is all I have left. If he meets with misfortune on the way, you will send my

Joseph Ordering to Store Grain in the Granaries, **Mosaic, 13th century. S. Marco, Venice/ Cameraphoto/Art Resource, NY.**

white head down in grief to the grave."

But the famine was very severe in Canaan. When they had consumed all the food that they had brought from Egypt, their father said to them, "Go back and obtain more food for us."

"The man warned us," Judah said, "'Do not show me your faces again unless you bring your brother with you.' If you will send our brother with us, we will go down and obtain food. But if not, we will not go, for the man said that he would not see us without him."

"Why did you do this evil to me," Jacob asked, "to tell the man that you had one more brother?"

"The man kept asking us about ourselves and our family," they told him, "wanting to know: 'Is your father still alive? Do you have another brother?' We answered the questions he put to us. How were we to

63

64

know that he would then say to us, 'Bring your brother down here'?"

"Send the boy with me," Judah said to his father, Jacob. "We will go down and thus remain alive—ourselves, you, and our little ones. I myself will be responsible for him. If I do not bring him back to you, I will stand guilty before you forever."

"If it must be, then take some of the choicest products of the land—balm and honey, gum, ladanum, pistachios, and almonds," their father, Jacob, said to them. "Also take with you double the money, so that you can return the money put back into your sacks. Perhaps it was a mistake. Take your brother with you, and go back at once to the man. May God Almighty dispose him to be merciful toward you so that he releases both your other brother and Benjamin. As for me, if I am to be bereaved, then I will be bereaved."

So they took with them the gifts, the double measure of money, and Benjamin, and they went down to Egypt. When Joseph saw Benjamin with them, he said to his house steward, "Slaughter an animal, for these men will dine with me this afternoon." The man did as he was told, and

Joseph and His Brothers, **Tony Siani, 1995. Courtesy Harriette Siani.**

he brought the men to Joseph's house. They were frightened to be brought to Joseph's house, for they thought, "It is because of the money we found in our sacks. He has brought us here to seize us as slaves, together with our animals." So they said to the house steward, "My lord, we came down once before to obtain food rations. But on our way home, when we looked in our sacks, we found all our money returned to us, and we do not know who put it there. Now we have come down again, ready to repay what was returned to us and to pay additional money for more food."

"All is well," he said to them. "Do not be afraid. Your God and the God of your fathers must have put treasure in your sacks. For I

already received your money." Then Simeon was brought out to them.

They were given water and had their feet washed, and their animals fed. Then they laid out their gifts and waited for Joseph. When he came home, they presented their gifts to him and bowed before him. "How is your old father that you spoke about?" he asked them. "Is he still alive?"

"Yes, he is well," they answered, and they bowed again.

Then he looked up and saw his brother Benjamin, his mother's son, and he said, "Is this your little brother whom you told me about? May God be gracious to you, my son."

Then Joseph hurried out, because he was filled with such tender feeling toward his brother that he was near tears. He went into another room and wept there. Then he washed his face and returned. "Serve the meal," he ordered. They served Joseph and his brothers apart from the Egyptians, who did not eat with the Hebrews, because to do so would be abhorrent to the Egyptians. To the brothers' astonishment, Joseph arranged for them to be seated in their correct birth order, from the youngest brother to the oldest. They all received portions from Joseph's table, but Benjamin's portion was several times that of anyone else's. And they ate and drank their fill.

Then Joseph instructed his house steward: "Fill the men's sacks with food, as much as they can carry, and put their money back in their sacks. And in the sack of the youngest one put my silver goblet, together with his money."

Early the next morning, the brothers were sent off, but they had not gone far before Joseph said to his steward, "Go after these men! And when you catch up with them, say to them, 'Why have you repaid good with evil? This is the very cup from which my master drinks and which he uses for divining. You have done an evil thing!'"

When the steward caught up with them and accused them, they answered him, "Why does my lord say such things? Far be it from us to act in this way! See, we returned the money that we found in our bags. How could we have stolen silver or gold from your master's house? The one whose sack contains it shall die, and the rest of us shall be your master's servants."

"Only the one who has it will be my master's slave," he said to them. "The rest of you shall go free."

So each one opened his sack, and the goblet was found in Benjamin's sack. Seeing this, they tore their clothes. Then they mounted their donkeys and returned to the city.

When Judah and his brothers came to Joseph's house and found him still at home, they bowed low before him. "What have you done?" Joseph said to them. "Do you not realize that a man like myself practices divination?"

"What can we say, my lord?" Judah replied. "God has found out our sin, and indeed we are now your servants, each of us as much as he in whose hand the goblet was found."

"No, declared Joseph. "Only the one in whose hand the goblet was found shall be my slave. As for the rest of you, go home in peace to your father."

Then Judah drew near to him and said, "Please, my lord, you who are the equal of Pharaoh, do not be angry with your servant when I speak with you now. My lord asked his servants: 'Have you a father or another brother?' We told my lord, 'We have an old father and a little brother, the son of his old age, whose other brother has died, so that only he is left of his mother, and his father

65

adores him.' And you said to your servant, 'Bring him down to me so that I may lay eyes upon him.' We said to my lord, 'The boy cannot leave his father, for if he does, our father will surely die.' But you said to us, 'If he does not come down, you will not see my face again.' When we told this to our father, he said to us, 'You know that my wife bore me only two sons, and one was torn by wild beasts and I have not seen him since. If you take this other one from me and he meets with disaster, my white head will go down in sorrow to the grave.'

"If your servant returns home without the boy, my father—whose soul is bound up with the boy—will go down in sorrow to the grave. For I have declared myself responsible for the boy, and if I do not bring him back, I will remain guilty before my father forever. Therefore, please take me as your servant in place of the boy, and let the boy go back with his brothers. For how can I return to my father without the boy? Let me not see evil befall my father!"

Joseph could no longer contain himself before his attendants, and he ordered them out of the room. His weeping was so loud that the Egyptians could hear, and word was brought to Pharaoh. Then Joseph declared to his brothers, "I am Joseph. Does my father yet live?"

But his brothers were unable to respond, for they were struck dumb.

Then Joseph said to his brothers, "Come close." And when they drew near, he said to them, "I am your brother Joseph whom you sold into Egypt. Do not reproach yourselves for selling me, for it was to save lives that God sent me here ahead of you. It is

Joseph Making Himself Known to His Brethren,
William Blake, ca. 1785. Fitzwilliam Museum, University of Cambridge.

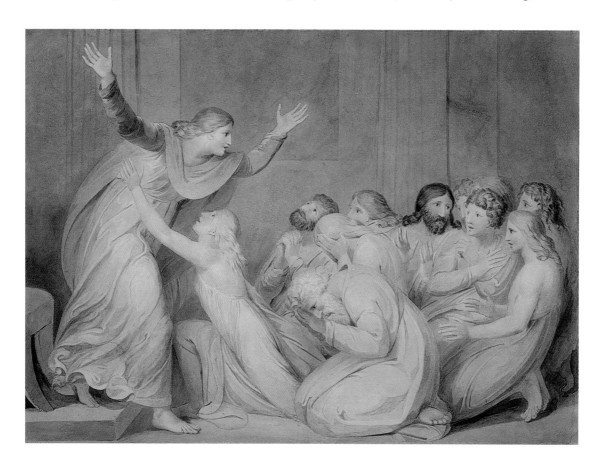

now the second year of the famine; for five more years, there will be no harvest. God has sent me ahead to save you and to redeem you through a great deliverance. Indeed, it was not you who sent me here, but God, who has made me second to Pharaoh and lord of all his house and ruler over the land of Egypt. Hurry home to my father and tell him: 'So says your son Joseph: "God has made me lord over Egypt. Come down to me without delay. You will live in the land of Goshen and be near me—you, your children, your grandchildren, and your sheep and cattle and all that you have. There I will provide for you during the remaining five years of famine, so you shall not starve."' You can see for yourselves that it is indeed I, Joseph, who am speaking to you. Now go to my father and tell him everything you have seen here, and bring my father here as soon as possible."

Then he embraced his brother Benjamin and wept. He kissed all his brothers and embraced them, weeping. And at last, they were able to talk with him.

Pharaoh was told that Joseph's brothers had come. The news pleased Pharaoh and his servants, and he said to Joseph, "Tell your brothers: 'Load up your animals and go to the land of Canaan at once. Bring your father and your households to Egypt, and I will give you the best of the land of Egypt. Bring with you wagons for your children and wives, but never mind your possessions, for the best of the land shall be yours.'"

So Joseph gave them wagons and food for the journey. He also provided them with a change of clothing, and to Benjamin he gave three hundred pieces of silver and several changes of clothing. He sent abundant provisions to his father for the journey. And as he sent his brothers on their way, he told them, "Do not quarrel on the journey."

When they came to their father, Jacob, and told him, "Joseph is still alive, and he rules over the whole land of Egypt," Jacob's heart went numb, for he did not believe them. But when they told him all that Joseph had said to them and when he saw the wagons Joseph had sent, his spirit revived.

"My son Joseph is still alive," Jacob said. "I will go to see him before I die."

So Jacob and all that he had went down to Beersheba and sacrificed there. And God came to him in a night vision and called, "Jacob! Jacob!"

"Here I am," he answered.

"I am the God of your father," God said. "Do not be afraid to go down to Egypt, for I will make you a great nation there. I will go down with you to Egypt and I will bring you back, and Joseph's hand will close your eyes."

So Jacob and his family, numbering seventy souls, went down to Egypt. Jacob lived seventeen years in the land of Egypt, and when he died, Joseph closed his eyes and carried him back to Canaan, to the cave of Makhpelah, and laid him to rest beside his ancestors, Abraham and Sarah, Rebecca and Isaac, and his wife Leah.

Just before Joseph died at the age of one hundred ten years, he said to his brothers: "God will surely take notice of you and bring you up from here to the land promised to Abraham, Isaac, and Jacob. And when God does take notice of you, you shall carry my bones from here."

Then Joseph died and was embalmed and placed in a coffin in Egypt.

III.
Slaves in the
Land of Egypt

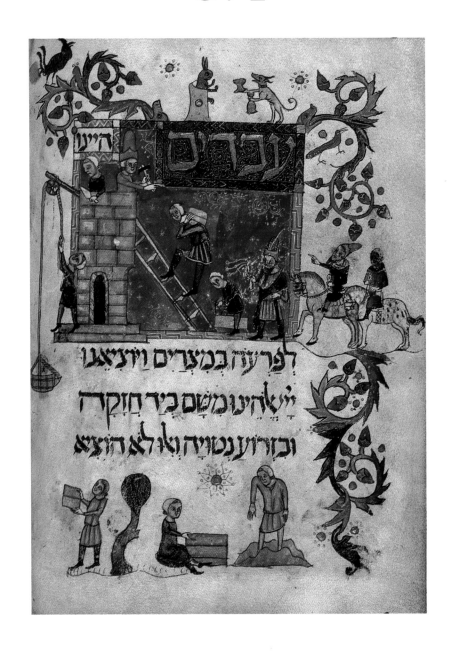

PERHAPS NO OTHER EVENT IS more central to Jewish national identity and memory than the exodus from Egypt, which marked the end of several centuries of slavery. For generations, Jewish families around the world have gathered at their festival tables each spring to enact the ancient ritual of Passover, retelling the story of their miraculous redemption from bondage. Why has this drama so mesmerized the Jewish imagination? What primal human experience does it recall for us? Of all the stories in the Bible, why is this the one that we tell and retell to our children and grandchildren?

Unlike the intimate stories of the first Jewish families, those of the exodus focus on the greater family of Israel—although the saga begins with the particular household of Moses, Aaron, and Miriam. Just as the twelve sons of Jacob function as prototypes for the twelve tribes, so these strong-willed siblings model Jewish leadership for future generations. Aaron first serves as his younger brother's mouthpiece before Pharaoh, then emerges as the people's spokesman before God—the high priest who safeguards divine sanctity and regulates the community's ritual purity. He is the prototype of the religious leader, who guides the people through law and teaching. Moses, in contrast, prefigures the political leader—charismatic, passionate, bold. His quarrelsome nature demands justice of Pharaoh and of God; his impatience galvanizes the people into action. And Miriam, who as a young girl stands vigil over her baby brother in the rushes, represents another type of leader—beloved of the people, leading them in song after their redemption at the sea, earning their affection and loyalty. No wonder later tradition associates her with a miraculous well that heals and inspires those who drink from it.

A singularly striking aspect of the first stories in this national epic is the prominent role played by women: The Hebrew midwives, Shifrah and Puah, courageously defy Pharaoh's murderous decree; Yokheved hides her baby from the Egyptian executioners; Miriam engineers her brother's rescue by the princess of Egypt, who in turn adopts the condemned slave child and raises him under Pharaoh's nose; Zipporah heroically confronts Satan through the act of circumcising her son. How extraordinary that ancient tales celebrate such women!

These six stories, drawn from the Book of Exodus, introduce the most formative period of Jewish history, during which a ragtag band of slaves coalesces into a free nation. But before they can undergo this transformation, they first have to be redeemed, an event accomplished through terror and miracles, ten harrowing plagues that bring Egypt to its knees.

The final act of this drama takes place at the Sea of Reeds, where Pharaoh and his chariots drown after the children of Israel pass through on dry land. This crossing begins a forty-year journey through the wilderness, leading ultimately to the Promised Land.

OPPOSITE: *Building the Temple* from the *Barcelona Haggadah* (Add. Ms. 14761, fol. 30v), 14th century. © The British Library, London. OVERLEAF: *The Blessing and the Curse*, Harry Lieberman, ca. 1970. Collection of Helen Popkin in memory of Rose Blake. Courtesy Museum of American Folk Art, New York.

Pharaoh and the Midwives

וַיָּקָם מֶלֶךְ חָדָשׁ עַל מִצְרָיִם

AFTER JOSEPH AND ALL HIS GENERATION DIED, THE ISRAELITES INCREASED IN NUMBER UNTIL THEY FILLED THE LAND. THEN A NEW PHARAOH AROSE WHO DID NOT KNOW JOSEPH, AND HE SAID TO HIS PEOPLE, "THE ISRAELITES HAVE BECOME TOO NUMEROUS FOR US. LET US OUTSMART THEM, OR ELSE THEY MAY JOIN our enemies in a war and fight against us." So the Egyptians forced them into hard labor and made them build the royal garrison cities of Pitom and Raamses. But the more the taskmasters oppressed the Israelites, the more they multiplied, until the Egyptians came to fear them. And the Egyptians embittered their lives with harsh labor, making them work with mortar and bricks and in the fields.

Then the king of Egypt said to the Hebrew midwives, Shifrah and Puah: "When you deliver an Israelite baby, if it is a boy, kill him; if it is a girl, let her live." But the midwives feared God, so they did not do what the king said: They kept the boys alive too.

So the king of Egypt sent for the midwives and said to them, "Why have you let the boys live?"

They answered, "Because the Hebrew women are not like the Egyptian women. They are like animals! Before the midwife can come to them, they have already given birth."

God favored the midwives, and the Israelites multiplied. God established households for the midwives because they revered God. Then Pharaoh ordered all his people, "Throw into the river every Hebrew boy that is born, but let every girl live."

The Pharaoh Ramses III, Valley of the Kings, Thebes. © G. Dagli Orti, Paris.

72

The Finding of Moses **from the Golden Haggadah (Add. Ms. 27210, fol. 9r), 1320. The British Library, London/Bridgeman Art Library, London/New York.**

73

The Birth of Moses

A MAN FROM THE HOUSE OF LEVI MARRIED A LEVITE WOMAN, AND SHE GAVE BIRTH TO A SON. WHEN SHE SAW HOW BEAUTIFUL HE WAS, SHE HID HIM FOR THREE MONTHS. WHEN SHE COULD NO longer hide him, she made an ark out of reeds, caulked it with pitch, and set it among the rushes along the banks of the Nile. In the distance, his sister watched to see what would happen to him.

Pharaoh's daughter came down to bathe in the Nile while her maids walked along the banks. She saw the ark among the reeds and sent her maid to bring it to her. When she opened it, she found a baby boy, crying. She took pity on him and said, "This must be one of the Hebrew children."

Then his sister said to Pharaoh's daughter, "Shall I go and fetch you a Hebrew wet nurse for the child?"

"Yes, go," Pharaoh's daughter answered.

So the girl called the child's mother. Pharaoh's daughter said to her, "Take this child and nurse him for me, and I will pay your wages." The woman took him and nursed him, and when he was grown up, she brought him to Pharaoh's daughter, who adopted him as her son. And she called him Moses, *Moshe,* "because I drew him—*mi-shi-teehu*—out of the water."

Moses Kills an Egyptian Taskmaster and Flees to Midian

SOME TIME LATER, WHEN MOSES WAS GROWN UP, HE WENT OUT AMONG HIS BROTHERS AND SAW THEIR HARD LABOR. AND WHEN HE SAW AN EGYPTIAN BEATING ONE OF HIS HEBREW BROTHERS, HE LOOKED AROUND, AND SEEING THAT NO ONE WAS LOOKING, HE STRUCK DOWN THE EGYPTIAN and buried him in the sand. The next day when he went out, he came upon two Hebrews fighting. "Why are you beating your brother?" he said to the one in the wrong.

"Who placed you over us?" the man replied. "Do you plan to kill me like you killed the Egyptian?"

Then Moses was afraid. "Everyone must know what happened!" he thought. And indeed, when Pharaoh learned about the incident, he wanted to kill Moses, but Moses fled to Midian. He came to a well and rested there.

Now the priest of Midian had seven daughters. They came to the well, but when they tried to draw water for their father's flock, the other shepherds drove them away. Moses defended them and watered their flock. When they returned home, their father asked them, "Why are you home so early?"

They answered, "An Egyptian saved us from the shepherds, and even watered our flock."

"Where is this man?" he asked his daughters. "Bring him home to break bread with us."

Moses agreed to stay with him, and he gave Moses his daughter Zipporah as his wife. She gave birth to a son, whom Moses named Gershom, for he said, "I have been a stranger—*ger*—in a strange land."

74

Moses Smiting an Egyptian from the *Golden Haggadah* (Add. Ms. 27210, fol. 9r), 1320. The British Library, London/Bridgeman Art Library, London/New York.

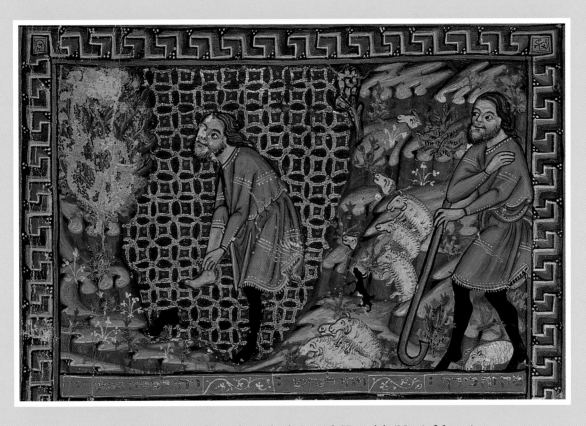

The Burning Bush from the *Rylands Spanish Haggadah* (Ms. 6, fol. 13v),
mid-14th century. Reproduced by courtesy of the Director and University
Librarian, the John Rylands University Library of Manchester.

The Burning Bush

ONE DAY MOSES TOOK HIS FATHER-IN-LAW'S FLOCK INTO THE WILDERNESS AND CAME TO HOREB, THE MOUNTAIN OF GOD. THERE AN ANGEL OF GOD APPEARED TO HIM IN A FLAMING BUSH. HE SAW THAT THE BUSH was on fire, yet it was not consumed by the flames. "I must go look at this miracle!" Moses said. "Why is the bush not burning up?"

Then God called to Moses out of the bush, "Moses!"

"Here I am!" Moses answered.

"Do not come closer!" God said "Take off your sandals, for you are standing on holy ground. I am the God of your fathers, Abraham, Isaac, and Jacob."

Moses hid his face because he was afraid to look at God.

"I have seen the suffering of My people in Egypt," said God, "and have heard their cries. I have come to rescue them and bring them to a good land, flowing with milk and honey, the land of Canaan. I will send you to Pharaoh, and you shall free My people from Egypt."

"Who am I to free the Israelites from Pharaoh's hand?" protested Moses.

"I will be with you," God replied. "And when you have freed the people,

you will worship Me at this mountain."

"When I tell the Israelites, 'The God of your fathers has sent me,'" said Moses, "they will ask me, 'What is this God's name?' What shall I tell them?"

"Tell them, '*Ehyeh-Asher-Ehyeh*, I Will Be Who I Am—the God of your ancestors, Abraham, Isaac, and Jacob—has sent me,'" God replied. "Tell them that I have seen their misery and will lead them out of Egypt to a land flowing with milk and honey. Take the elders with you to Pharaoh and say to him, 'Let us make a three-day journey into the wilderness to sacrifice to God.' But the king of Egypt will not let you go, and then I will stretch out My hand and strike Egypt with wonders until he lets you go. And I will not let you go empty-handed. Each Israelite woman shall ask her neighbor and boarders for silver, gold, and clothing, and you will thus plunder Egypt."

"What if they do not listen to me," said Moses, "but say, 'God did not appear to you!'"

"What is in your hand?" God asked him.

"A shepherd's staff," replied Moses.

"Throw it on the ground," commanded God.

So Moses threw it on the ground, and it became a snake. Moses drew back from it.

Then God said to Moses, "Grab hold of it by the tail." Moses did so and it became a rod again. "Thus they will believe that the God of Abraham, Isaac, and Jacob did indeed appear to you."

Then God said, "Put your hand upon your chest." Moses did so, and when he drew forth his hand, it was covered with snow-white scales. Then God said, "Put your hand back upon your chest," and the hand emerged whole. "If they do not believe

these two signs, then take water from the Nile, pour it upon dry ground, and the water will turn to blood."

"Please, God," Moses said, "I have never been a man of words. I am slow of speech and tongue."

"Who gives man his tongue?" God answered, "Who makes him dumb or deaf, sighted or blind? Now go, and I will be with you and tell you what to say."

"Please choose someone else," said Moses.

God became angry and replied, "Here comes your brother Aaron to see you. I know that he is sure of speech. You will put words in his mouth, and he will speak to the people on your behalf. He will serve as your mouth, and you will play the role of God to him. And I will be with you both. Now go back to Egypt, for the men who wished to kill you are now dead. Take this staff with you, to perform My wonders before Pharaoh."

Then Moses asked his father-in-law, Jethro, for permission to return to his kinsmen in Egypt. And Jethro said, "Go in peace." Then Moses set his wife and sons upon an ass and went back to the land of Egypt.

God said to him, "When you perform these signs before Pharaoh, I will harden his heart so that he will refuse to let My people go. Then you will say to him, 'Israel is My firstborn. Let My firstborn go to worship Me.' He will refuse, and then I will refuse, and then I will slay his firstborn."

So Aaron met Moses at the mountain of God, and together they went down to Egypt.

OPPOSITE: *Moses and the Burning Bush*, **William Blake, late 18th–early 19th century. Victoria & Albert Museum, London/Art Resource.**

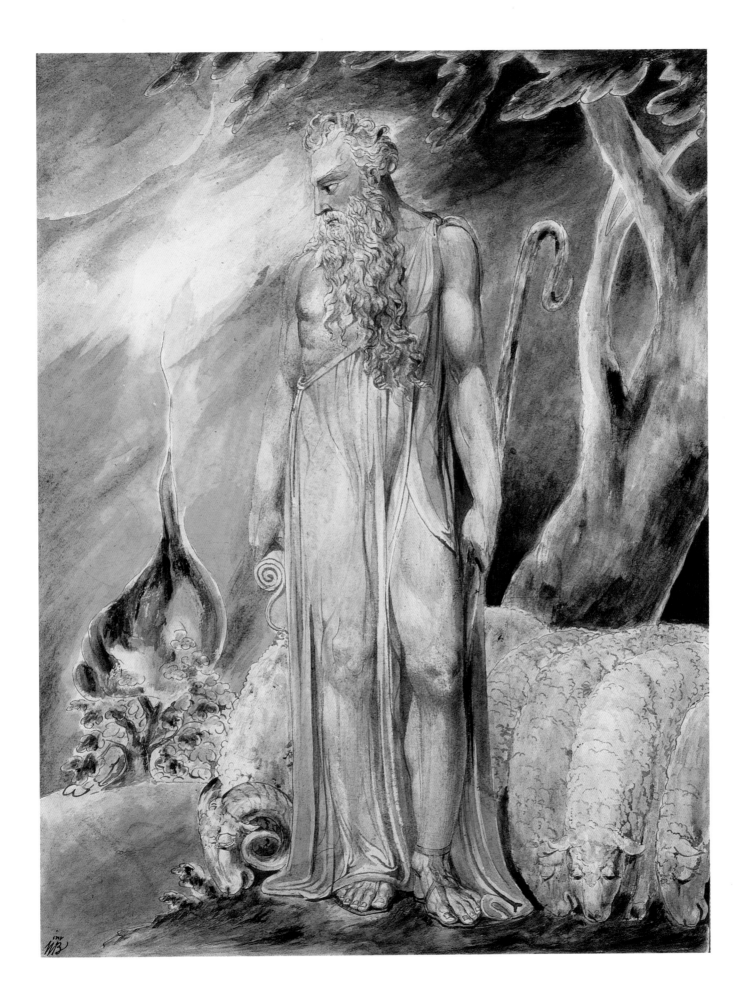

SLAVES IN THE LAND OF EGYPT

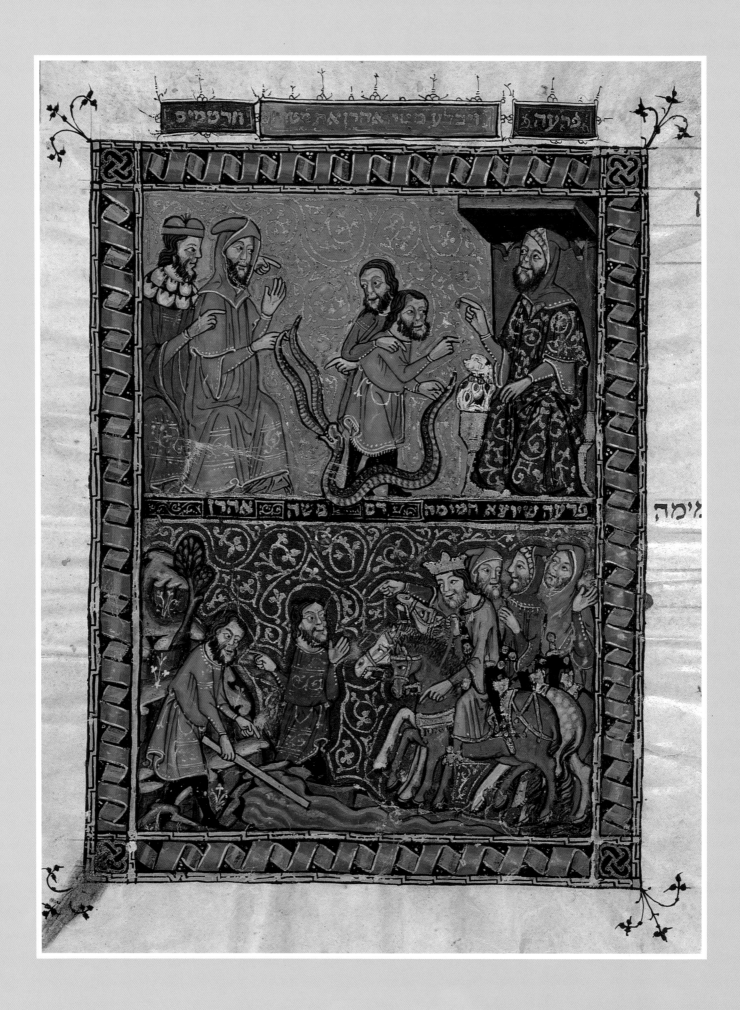

The Ten Plagues and the First Passover

"GO NOW BEFORE PHARAOH," GOD SAID TO MOSES, "AND ACT AS GOD BEFORE HIM, AND YOUR BROTHER AARON SHALL SERVE AS YOUR PROPHET. TELL PHARAOH TO LET THE ISRAELITES LEAVE HIS LAND. BUT I WILL HARDEN PHARAOH'S HEART SO THAT HE WILL REFUSE, AND THEN I WILL BRING GREAT judgments upon Egypt so that the Egyptians will know that I am God. Then I will stretch out My hand and bring the Israelites out of their midst." Now Moses was eighty years old and Aaron was eighty-three when they appeared before Pharaoh.

So Moses and Aaron came before Pharaoh. Aaron cast down his rod before Pharaoh and his court, and the rod became a serpent. But the Egyptian magicians did the same with their rods, so that they too became serpents. Then Aaron's rod swallowed up their rods. Yet Pharaoh's heart hardened, so that he paid no attention to Moses and Aaron.

ABOVE: *Frogs*, **Michal Meron, 1997. Courtesy The Studio in Old Jaffa, Israel.**
OPPOSITE: *Aaron's Rod Turning into a Serpent and Swallowing the Magician's Rods* from the *Rylands Spanish Haggadah* (**Ms. 6, fol. 15v**), **mid-14th century. Reproduced by courtesy of the Director and University Librarian, the John Rylands University Library of Manchester.**

Then God said to Moses, "Go to Pharaoh tomorrow morning when he goes down to the Nile and say to him, 'The God of the Hebrews has sent me to say to you, "Let My people go so that they may worship Me in the wilderness." Because you did not listen, God will now turn the water of the Nile into blood. By this you will know that I am God.'"

Moses and Aaron did just as God commanded: In the presence of Pharaoh and his court, Aaron lifted up his rod and held it over the waters of Egypt—its rivers, canals, and ponds, and even the water kept in vessels of wood and stone. Then he struck the water of the Nile with his rod, and all the waters of Egypt turned to blood. But when Pharaoh's magicians did the same with their spells, Pharaoh returned to his palace, his heart unmoved. Then all the fish in the Nile died, and the river stank. And all the Egyptians had to dig around the Nile for water to drink, because they could not drink the water of the Nile.

Seven days later, God said to Moses, "Go to Pharaoh and say to him, 'Let My people go so that they may worship Me. If you refuse, I will bring a plague of frogs out of the Nile, and they will swarm over your

79

palace and fill your bedrooms and beds, your ovens and kneading bowls.'"

So Aaron held out his rod over the waters of Egypt, and frogs came up and covered the land. But Pharaoh's magicians did the same with their spells, and brought frogs upon the land.

Then Pharaoh summoned Moses and Aaron and said, "Ask God to remove these frogs, and I will let the people go to offer sacrifices to God." So Moses cried out to God, and the frogs died in the houses, courtyards, and fields. And the Egyptians piled them up in heaps until the land stank. But when Pharaoh saw that the plague was over, he hardened his heart and did not listen to them.

Then God said to Moses, "Tell Aaron to strike the dust of the earth, so that it turns into lice." So Aaron struck the dust with his rod, and vermin covered the people and their beasts.

Beasts, **Michal Meron, 1997.**
Courtesy The Studio in Old Jaffa, Israel.

But when Pharaoh's magicians tried to do the same with their spells, they could not. They said to Pharaoh, "Surely this is the finger of God!" But Pharaoh hardened his heart and would not listen to them.

Then God said to Moses, "Early tomorrow morning as Pharaoh comes down to the water, say to him, 'Thus says God, "Let My people go so that they may worship Me. For if you refuse, I will bring upon Egypt a plague of wild beasts, so that the very ground the people walk upon shall be covered. But I will spare the land of Goshen, where My people dwell. Thus I will make a distinction between My people and yours."'"

And God did so. The next day swarms of wild beasts invaded Pharaoh's palace and the houses of his courtiers and people. And the land of Egypt was ruined.

Then Pharaoh summoned Moses and Aaron and said to them, "You may sacrifice to your God within Egypt's borders."

But they replied, "We cannot do so, for what we sacrifice to our God is abhorrent to the Egyptians, and they will surely stone us! No, we must go a distance of three days into the wilderness to sacrifice to God as we have been commanded."

Pharaoh said, "Go—but not too far, and plead with God on my behalf." So Moses pleaded with God to remove the wild beasts, and God removed them the next day. Not one remained. But Pharaoh then hardened his heart and did not let the people go.

Then God said to Moses, "Go tell Pharaoh: 'Thus says the God of the Hebrews, "Let My people go to worship Me. If you refuse to let them go, I will strike your livestock— your horses, asses, camels, cows, and sheep in the fields— with terrible disease. But I will spare the livestock of the Hebrews, making a distinction between their livestock and that of the Egyptians."'" And the next day, God did so: All the livestock of the Egyptians died, but not one of the Hebrews' animals perished. But Pharaoh hardened his heart, and he would not let the people go.

Then God said to Moses and Aaron, "Each of you take a handful of soot from the kiln and throw it up

80

toward the sky. And a fine dust will cover the land and will cause boils to break out on the Egyptians and their beasts." And they did so, and boils afflicted all the Egyptians and their beasts. But Pharaoh hardened his heart and would not listen to them.

Then God said to Moses, "Appear before Pharaoh early tomorrow morning and say to him, 'Thus says the God of the Hebrews, "Let My people go to worship Me. I could have destroyed every one of you with pestilence, but I have spared you so that you may see My power. For you still refuse to let My people go! This time tomorrow I will rain down heavy hail, such as has not been seen since the dawn of Egypt. Therefore, bring your beasts indoors and seek shelter for yourselves, for anything found outside shall be destroyed by the hail."'" Those among Pharaoh's courtiers who feared God brought their servants and livestock indoors, but those who did not left them in the open. Then Moses held out his rod toward the sky, and God sent thunder and rained down hail in a stream of fire. Throughout the land of Egypt the hail struck down all that was in the open—the Egyptians and their beasts, and all the grasses and trees of the field. Only in the land of Goshen, where the Israelites lived, no hail fell.

Then Pharaoh sent for Moses and Aaron and said to them, "God is right, and I and my people are in the wrong. Plead with God to end this thunder and hail, and I will let you go."

And Moses said, "I will do as you ask, and God will

Hail, **Michal Meron, 1997.**
Courtesy The Studio in Old Jaffa, Israel.

take away the thunder and hail. But I know that you and your courtiers do not yet fear God." So Moses went outside the city and spread out his hands, and the thunder and hail ceased. But when Pharaoh saw this, he hardened his heart and would not let the Israelites go.

Then God said to Moses, "Go to Pharaoh, for I have hardened his heart so that I might display My signs among the Egyptians. You will thus tell your children and your children's children how I humbled the Egyptians by displaying My signs among them, so that you might know that I am God."

So Moses and Aaron appeared before Pharaoh and said to him, "Thus says the God of the Hebrews, 'How long will you refuse to humble yourself before Me? Let My people go to worship Me. For if you refuse to let them go, I will bring locusts that will devour any grain left over from the hail and will consume all the trees in the field.'" Now the flax and barley were already ruined, but the wheat was not damaged, because it ripens late.

After Moses left, Pharaoh's courtiers said to him, "How long will this man hold us captive? Let the men go to worship their God! For do you not see that Egypt is lost?"

So Pharaoh summoned Moses and Aaron again and said to them, "Go worship your God! Who among you will go?"

"We shall all go," Moses replied, "young and old, with our sons and our daughters, our flocks and our herds. For

81

we must all celebrate God's festival."

But Pharaoh said to him, "No, only the men shall go to worship God, for that is what you have been demanding. Why should your children go— unless you are planning to make trouble?" And he drove them from his sight.

Then Moses held out his arm over the land, and God sent an east wind over the land all that day and all night. When morning came, locusts invaded, darkening the face of Egypt. Never before had there been so many locusts in the land, nor will there ever be so many again. They ate up all the grasses of the field and all the fruit of the trees spared by the hail, so that nothing green was left in all the land of Egypt.

Pharaoh summoned Moses and Aaron back and said to them, "I have sinned before God and before you. Forgive me this once and plead with your God to remove this death from me." So Moses pleaded with God, and God brought a strong west wind that drove the locusts into the Sea of Reeds. Not a single locust remained in all the land of Egypt. But God hardened Pharaoh's heart, and he would not let the Israelites go.

Then God said to Moses, "Stretch out your arm toward the sky so that darkness descends upon Egypt, a darkness so thick that it can be felt." So Moses held out his arm, and a thick darkness descended upon the land of Egypt for three days. During that time people could not see one another, and no one could get up from where he was. Only the Israelites had light in their dwellings.

Pharaoh then summoned Moses and said, "Go worship your God! Only your animals shall be left behind. Even your children can go with you." But Moses said, "You yourself must supply us with animals for our sacrifices! Our livestock shall go with us—not one beast shall remain behind. For we will not know until we arrive what God will demand of us as a sacrifice."

Then God hardened Pharaoh's heart and he would not let them go. "Leave me!" Pharaoh replied. "Take care that you do not see my face again, for on that day, you shall die."

"You are right," Moses replied. "I shall not see your face again."

Then God said to Moses, "One more plague will I bring upon Pharaoh and Egypt. After that, he will let you go. Indeed, he will drive you out from here. When he does, tell the people to ask their neighbors for objects of silver and gold."

Darkness, **Michal Meron, 1997.**
Courtesy The Studio in Old Jaffa, Israel.

Indeed, God turned the hearts of the Egyptians toward the Israelites, especially Moses, who was highly esteemed in Egypt, among Pharaoh's courtiers and all the people.

Then Moses said to Pharaoh, "Thus says God, 'Toward midnight I will go forth among the Egyptians, and every firstborn among them shall die, from the firstborn of Pharaoh to the firstborn of the slave girl who is behind the millstones, and all the firstborn of the cattle. And a loud cry shall go up from Egypt, such as has never been heard nor will be again. But as for the Israelites, not even a dog shall snarl at them.' Thus God shall make a distinction between

82

Egypt and Israel. Then all Pharaoh's courtiers will bow before me and order us to leave. And then we shall depart."

But God hardened Pharaoh's heart so that he would not let the people go.

"Tell the whole community of Israel to take one lamb for each household and watch over it until the fourteenth of this month," God said to Moses and Aaron. "At twilight of that day, they shall slaughter the lamb and place some of its blood on the doorposts of their houses. Then they shall eat the meat, roasted in fire, together with unleavened bread and bitter herbs. In haste shall they eat their meal, with their sandals on their feet and a staff in their hands, for on that night I will strike down every firstborn of Egypt. But I will pass over the houses marked with the sign of blood. And you shall celebrate this Feast of Unleavened Bread throughout the ages in remembrance of this day."

Moses told the people what God had commanded, and they did all that they had been told. And it came to pass in the middle of the night that God struck down all the firstborn of Egypt, from the firstborn of Pharaoh seated on the throne to the firstborn of the prisoner in the dungeon, as well as the firstborn of the herd. And Pharaoh arose in the night together with his courtiers and all his people, and there was a great cry in Egypt, for there was not a house without its dead. That night he summoned Moses and Aaron and said, "Get up and leave my land, you and your people!

Slaying of the First Born, **Michal Meron, 1997. Courtesy The Studio in Old Jaffa, Israel.**

Go worship God as you have demanded. Take your sheep and cattle with you—and go! And may you bless me too!"

The Egyptians pressed them to leave quickly, for they said, "Otherwise we shall all die!" The Israelites took their dough before it had time to rise and wrapped their kneading bowls in their cloaks upon their shoulders. And as Moses had instructed them, they asked the Egyptians for silver, gold, and clothing. And God disposed the Egyptians to be kind to them, so that they were given what they asked for—and thus the Israelites plundered Egypt.

And so after four hundred thirty years, to the very day, the vast legions of God—Israelites together with a mixed multitude, adults as well as children, and much livestock—departed Egypt. That was a wakeful night for the children of Israel throughout the ages, for on that day God freed the Israelites from the land of Egypt.

83

The Splitting of the Sea of Reeds

WHEN PHARAOH LET THE ISRAELITES GO, GOD DID NOT LEAD THEM ON THE SHORTER ROUTE, BY WAY OF THE LAND OF THE PHILISTINES, BUT INSTEAD TOOK THEM THE LONG WAY AROUND, ON the wilderness route by the Sea of Reeds. For God feared that if they faced a war they would lose heart and return to Egypt.

The Israelites left the land of Egypt armed. And Moses took with him the bones of Joseph, who had made the Children of Israel swear: "When God takes notice of you, carry my bones away with you."

By day God led them by a pillar of cloud, and by night, by a pillar of fire, so that they could travel day and night. These pillars never left them. And so they came to the edge of the wilderness and camped facing the sea.

God said to Moses, "Pharaoh will now say of you, 'They are closed in by the wilderness.' And I will harden Pharaoh's heart, and he will come after you. Then I will gain honor through Pharaoh and his army, and Egypt will at last know that I am the Lord."

When Pharaoh was told that the Israelites had gone, he said, "What have we done, freeing this people?" So he gathered six hundred chariots, and officers, horsemen and warriors, and they went in pursuit of the Israelites. They overtook them camped by the sea.

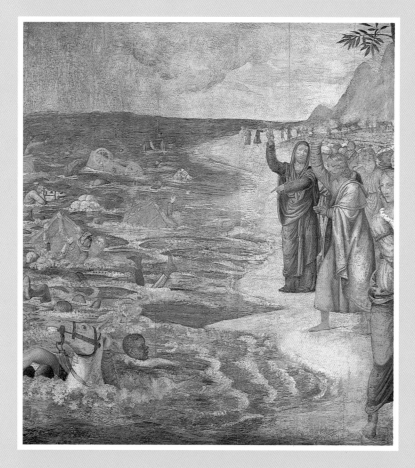

Crossing of the Red Sea, **Bernardino Luini, ca. 1481–1532. Pinacoteca di Brera, Milan/Scala/ Art Resource, NY.**

84

When the Israelites saw the Egyptians approaching, they were afraid and called out to God. And they cried out to Moses, "Were there no graves in Egypt? Is that why you brought us out to the wilderness to die? What have you done to us? Did we not tell you while we were still in Egypt: 'Leave us alone to serve the Egyptians, for it is better for us to serve them than to die in the wilderness!'"

"Do not fear!" Moses said to them. "Wait and see how God will redeem you today. These Egyptians whom you see today you will never see again. Only be still!"

Then God said to Moses, "Hold out your rod over the sea and divide it, so that the people can march through on dry land. For I will harden the hearts of the Egyptians and they will chase after you, and I will show them that I am the Lord."

Then the angel of God who had been leading the Israelite army moved to its rear, and the pillar of cloud settled behind the people, coming between them and the Egyptian army. And the cloud of darkness held them all spellbound that night, so that neither came near the other all night.

Then Moses stretched his arm out over the sea, and God drove it back with a strong east wind all night, so that the sea became dry land. And the Israelites walked into the sea on dry land, and the waters formed a wall to their right and left. Then the Egyptians pursued them, all of Pharaoh's horses, chariots, and horsemen racing into the sea. At sunrise, God looked upon the Egyptian army from a pillar of fire and cloud and threw panic into the men by locking their chariot wheels so that they had trouble advancing. "Let us flee from the Israelites," the Egyptians cried, "for God is fighting for them against us."

Then God said to Moses, "Stretch your arm out over the sea, so that the waters turn back upon the Egyptians and their chariots." And Moses did so. And as the waters resumed their course, the Egyptians fled the sea. But God flung them into the midst of the sea so that the waters covered the chariots and horsemen and Pharaoh's entire army. Not one of them survived.

Thus God saved Israel that day from the Egyptians. And when the people saw God's mighty power, they feared God, and had faith in God and Moses.

Then Moses and the Israelites sang this song to God:

I will sing unto God, for God has triumphed
 gloriously.
Horse and driver God has flung into the sea!

 Your right hand, O God,
 glorious in power,
 Your right hand, O God,
 shatters the enemy!

 Who is like You, O God,
 among the mighty?
 Who is like You, glorious
 in holiness,
 Awesome, praiseworthy,
 doing wonders!

Then Miriam the prophet took a tambourine in her hand, and all the women went out after her dancing with their tambourines. And Miriam chanted for them:

 Sing unto God, for God has
 triumphed gloriously—
 Horse and driver God has
 flung into the sea!

85

IV.
Forty Years in
the Wilderness

THE FIRST DIVISION OF THE Hebrew Bible, the Torah, consists of five books: Genesis, Exodus, Leviticus, Numbers, and Deuteronomy. In Genesis, the world is created, life begins, human beings lose their innocence and bring suffering into the world, civilizations rise and are drowned, Abraham and Sarah discover God and give birth to the Jewish people. Two generations later, Joseph saves his family and then unwittingly lures them into bondage. Indeed, Genesis constitutes a national epic, equal in drama and scope to other traditional myth cycles.

In contrast, the next four books cover only a fraction of Israel's history, little more than a century—the life span of Moses. The first fifteen chapters of Exodus, comprising the six stories in the previous section, narrate the dramatic tale of the Jewish people's redemption from slavery. The remainder of the book of Exodus, and the following three books, take place in the wilderness, where the Israelites wander for forty years until they reach the threshold of the Promised Land. Little of the material in this section of the Torah is narrative; it covers mostly laws, sacrifices, festivals, the construction and maintenance of the Tabernacle, moral teachings, population statistics, and lineages. In this part of the Bible we encounter the Ten Commandments and many of the laws that sustain a just and stable society. From details of the construction of the Tabernacle, Jewish tradition has derived the laws of Sabbath observance. Here we find the origins of the major institutions of Jewish life—the calendar, prayer book, synagogue, charitable societies, social taboos, and norms. We also discover much that has fallen away from Jewish practice over the centuries.

The twelve stories in this section focus primarily on watershed moments in Israel's desert trek: the divine revelation at Mount Sinai, the apostasy of the golden calf, the fateful report of the twelve spies, the rebellion of Korakh. This chapter also presents the semi-comic story of Balaam and the talking ass, which many scholars regard as an independent folktale imported into the biblical text. Through these cameo dramas the Torah sets the stage for the later trials and misadventures of Israel—its constant backsliding into idolatry, its unstable faith, its fractiousness, the frailties of its leaders.

Two parallel narratives drive these stories. In one, we see a nation in formation, striving to achieve a national identity, testing its military readiness to conquer a new homeland, challenging its leaders, straining against the yoke of law and moral accountability. In the other, we follow the tragic biography of one family, Moses and his two siblings, who fight among themselves and with the people they have been charged to lead and ultimately lose their share in the Promised Land. The final scene of this story is among the most poignant in the Bible: Moses stands high above Canaan, forbidden to reap the harvest he has sown over a lifetime.

Gifts of Manna
and Quail

וזבני ממטיר לכם לחם

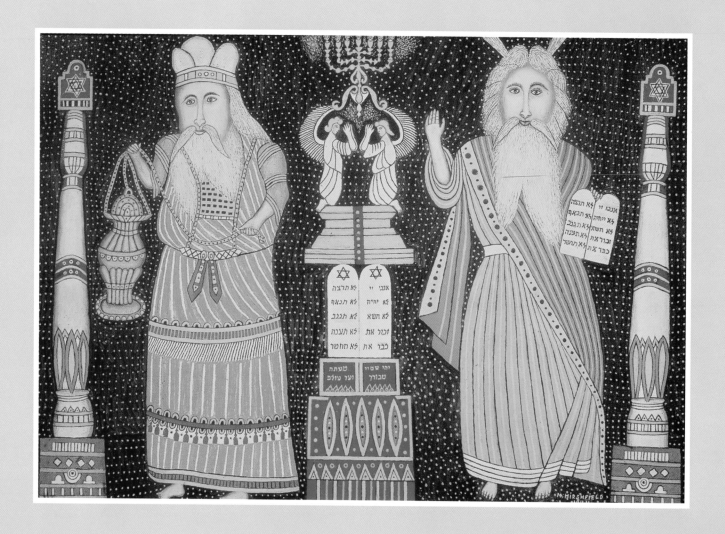

I N THE MIDDLE OF THE SECOND MONTH AFTER LEAVING EGYPT, THE ISRAELITES BEGAN TO GRUMBLE AGAINST MOSES AND AARON: "IF ONLY WE HAD DIED BY GOD'S HAND IN EGYPT, WHERE WE SAT BY THE STEW POTS AND ATE BREAD UNTIL WE WERE SATISFIED! INSTEAD YOU HAVE BROUGHT US INTO THIS WILDERNESS TO STARVE TO DEATH!"

Then God said to Moses, "I will now rain bread upon you from the skies, and the people shall go out and gather their portions each day. In this way I will test whether they will follow My instructions—or not. For on the sixth day the portions they gather will be double portions. And none will fall on the seventh day."

Moses and Aaron said to the Israelites: "In the evening you will know that it was God who brought you out of Egypt, and in the morning you will see God's glory. For God has heard your complaints and will give you meat in the evening and bread in the morning. Why do you now complain to us? For you are really complaining against God!" Then the people turned toward the wilderness: There, in a cloud, God's glory appeared to them.

In the evening, quail flew in and covered the camp; in the morning, dew blanketed the camp. When the dew melted, the surface of the desert was covered with fine flakes, like frost. When the Israelites saw this, they said to one another, "What manner of thing is this?" for they did not know its

OPPOSITE: *Moses and Aaron,* **Morris Hirshfield, 1944. Courtesy Sidney Janis Gallery, New York. © Estate of Morris Hirshfield/Licensed by VAGA, New York.**

meaning. Moses said to them, "This is the bread God has given you to eat. God has commanded that you gather each day only what you require, one omer measure per person, and one measure for each person in your tents."

And so the Israelites gathered it, some taking much, some little; but when they measured what they had gathered, every measure was the same. Moses said to them, "Do not leave any extra until morning." But some of them ignored his warning and left a portion overnight, which became infested with maggots. And Moses was angry with them.

Every morning they gathered what they needed, and when the sun grew hot, what was left melted. And on the sixth day, they gathered double portions. Moses said to the leaders of the community: "Tomorrow is the holy Sabbath, a day of rest. Cook what you wish, and leave the rest until morning." And they did as Moses said, and it did not spoil by morning. Moses said, "Today nothing will fall, for it is God's Sabbath. Six days you will gather it, but on the seventh day, the Sabbath, you will find none."

But some of the people went out on the Sabbath to gather their portions, yet they found nothing. God said to Moses, "How long will you refuse to follow My instructions! Since I have given you the Sabbath, I am also providing two days of food on the sixth day. Let no one leave his place on the seventh day." And so the people rested on the seventh day.

The Israelites called the food manna. It resembled coriander seed; it was white and tasted like honey. Moses said, "God has commanded: Let one omer of it be kept throughout the generations to remind you of the bread I fed you when I took you out of Egypt." So Aaron placed it before the Ark. And the Israelites ate manna for forty years, until they reached the border of the land of Canaan.

The Giving of the Ten Commandments

IN THE THIRD MONTH AFTER THE ISRAELITES HAD LEFT EGYPT, ON THAT VERY DAY, THEY ENTERED THE WILDERNESS OF SINAI. AND THE PEOPLE CAMPED IN FRONT OF THE MOUNTAIN.

MOSES WENT UP TO GOD, WHO CALLED TO HIM FROM THE MOUNTAIN: "TELL THE HOUSE OF JACOB, THE CHILDREN OF ISRAEL, 'YOU HAVE SEEN WHAT I

did to the Egyptians, and how I carried you on eagles' wings and brought you to Me. If you obey Me faithfully and keep My covenant, you will be My special treasure among all peoples. All the earth is Mine, but you will be to Me a kingdom of priests and a holy nation.' These are the words you are to say to the children of Israel."

Moses called the elders and told them all that God had commanded him.

All the people answered together: "All that God has said we will do!"

Then Moses brought the people's words back to God.

God then said to Moses, "I will come to you in a thick cloud, so the people will hear when I speak with you and trust you forever. Go to the people and warn them to stay pure today and tomorrow. Tell them to wash their clothes and be ready for the third day, for on the third day God will come down, in the sight of all the people, on Mount Sinai. Set boundaries for the people and tell them: 'Beware of going up the mountain or touching its borders. Whoever

OPPOSITE: *Moses Receives the Tablets from the Lord*, Marc Chagall, 1950–52. Coll. Chagall, France/Art Resource, NY. © 1999 Artists Rights Society (ARS), New York/ADAGP, Paris.

touches the mountain will be put to death. No hand will touch him, but he will either be stoned or shot. Whether beast or human being, he shall not live.' Then when the shofar sounds a long blast, they may ascend the mountain."

Moses came down from the mountain and warned the people to stay pure and wash their clothes. Then he said to them, "Be ready for the third day." And he added, "Do not go near a woman."

On the third day, as morning dawned, there was thunder and lightning, and a dense cloud on the mountain, and a very loud blast of the shofar, and all the people in the camp trembled. Moses led the people out of the camp toward God, and they took their places at the foot of the mountain.

Mount Sinai was covered in smoke, for God had descended upon it in fire. The smoke rose like the smoke of a furnace, and the whole mountain shook violently. The blast of the shofar grew louder and louder. When Moses spoke, God answered him in thunder. God descended upon Mount Sinai, on top of the mountain, and Moses went up.

God said to Moses, "Go down

93

and warn the people not to break through to look at God, for if they do, many of them will die. Also the priests, who come near God, must stay pure, or God will strike out against them."

Moses replied, "Indeed, the people cannot come up to Mount Sinai, for You have warned us, 'Set boundaries around the mountain and make it holy.'"

Then Moses went down to the people and declared, "God spoke all these words:

I the Lord am your God who brought you out of the land of Egypt, the house of slavery. You shall have no other gods besides Me.

You shall not make a sculptured image for yourself, or anything resembling what is in the heavens above, or on the earth below, or in the waters under the earth. You shall not bow down to these idols or serve them. For I the Lord your God am a jealous God, punishing children for their parents' sins to the third and fourth generations if they reject Me, but showing kindness to the thousandth generation of those who love Me and keep My commandments.

You shall not swear falsely by My name, for I will not clear anyone who swears falsely by God's name.

Remember the Sabbath day and keep it holy. Six days do all your work, but the seventh day is My Sabbath. You shall not do any work—you, your son or daughter, your male or female slave, or your cattle, or the stranger who is within your gates. For in six days God made heaven and earth and sea, and all that is in them, and God rested on the seventh day. Therefore, God blessed the Sabbath day and made it holy.

Honor your father and mother, so you may live long on the land that the Lord your God is giving you.

You shall not murder.

You shall not commit adultery.

You shall not steal.

You shall not bear false witness against your neighbor.

You shall not covet your neighbor's house, or his wife, or his male or female slave, or his ox or his donkey, or anything that belongs to your neighbor."

All the people saw the thunder and lightning, the blast of the shofar, and the mountain smoking. And when the people saw it, they retreated and stood at a distance.

"You speak to us, and we will obey," they said to Moses, "but do not let God speak to us, or we will die."

"Do not be afraid," Moses told them, "for God has come only to test you and to be sure that the fear of God will always be with you, so that you do not sin."

So the people remained at a distance while Moses approached the thick cloud where God was.

OPPOSITE: **Moses and the Ten Commandments**, **Michal Meron, 1997. Courtesy The Studio in Old Jaffa, Israel.**

94

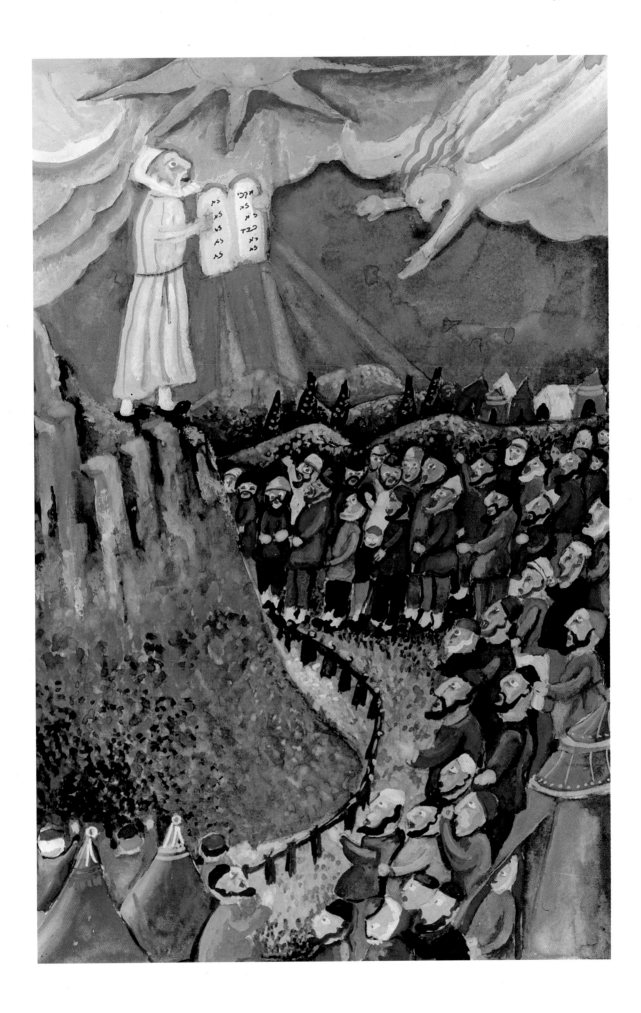

FORTY YEARS IN THE WILDERNESS

Dance of the Golden Calf, Emil Nolde, 1910. Staatsgalerie Moderner
Kunst, Munich/Giraudon/Art Resource, NY. © Nolde-Stiftung Seebull.

The Golden Calf

WHEN THE ISRAELITES SAW THAT MOSES HAD NOT YET COME DOWN FROM THE MOUNTAIN, THEY GATHERED TOGETHER AGAINST AARON AND SAID, "COME, MAKE US A GOD TO LEAD US! FOR

that man, Moses, who led us out of Egypt—we do not know what has become of him."

"Take the gold rings from the ears of your wives, your sons, and your daughters," Aaron told them, "and bring them to me." And the people did so. Aaron took the rings and fashioned the gold into a molten calf.

They cried: "This is your god, O Israel, who brought you out of Egypt!"

Then Aaron built an altar before it and declared, "Tomorrow will be a festival to God!"

Early the next day, the people offered sacrifices, sat down to eat and drink, and rose up to revel.

Then God said to Moses, "Quickly, go down! For the people you brought out of Egypt have debased themselves and have been quick to stray from the path I have shown them. They have made a molten calf for themselves and bowed down to it, declaring it the god who brought them out of Egypt. What a stiff-necked people this is! Let me unleash My anger at them and destroy them, and make of you a great nation."

But Moses said, "Do not unleash Your anger against this people whom You redeemed from Egypt

with a mighty hand. What if the Egyptians were to say, 'God took them out only to destroy them in the mountains!' Remember Your servants Abraham, Isaac, and Jacob, and Your promise to make their descendants as numerous as the stars, and to give them the Promised Land forever. Refrain from punishing them." And God relented and did not punish them.

Then Moses descended carrying the two Tablets of Testimony, engraved on both sides by God. When Joshua heard the wild shouts of the people, he said to Moses, "The sound of war is in the camp!"

"No," Moses replied, "it is neither the chant of victory nor of defeat that I hear, but rather the strains of song."

As soon as Moses drew near the camp and saw the calf and the dancing, he became furious and flung the tablets so that they shattered. Then he burned the calf, ground it to powder, scattered it upon the water, and made the people drink it.

"What did the people do to you to make you bring such sin upon them?" Moses asked Aaron.

"Do not be angry, my lord!" replied Aaron. "You know how wayward this people is! They said to me, 'Make us a god to lead us! For that man, Moses, who led us out of Egypt—we do not know what has become of him.' I said to them, 'Whoever has gold, remove it.' And they gave it to me and I threw it in the fire—and out came this calf!"

Moses saw that the people were unruly, for Aaron had failed to rule them. Moses stood at the entrance to the camp and cried, "Whoever is for God, come with me!" And all the Levites gathered around him. "Thus says the God of Israel," he said to them. "'Take your swords, and go throughout the camp, and kill brother, neighbor, and kinsman.'"

And the Levites did as Moses had commanded them. Three thousand fell that day.

The next day Moses told the people, "You have committed a great sin. I will go back up to God, and perhaps I can attain forgiveness on your behalf."

So Moses returned to God and said, "This people has committed a great sin in making a god of gold for themselves. Now, if you will only forgive them—but if not, erase me from Your book!"

God said to Moses, "The one who has sinned against Me, only that one will I erase from My book! Go now, lead the people where I told you to go. Behold, My angel will go before you. But when the day of reckoning comes, they will pay for their sins."

Then God afflicted the people with a plague because of what they had done with the calf that Aaron had made.

Bronze Bull Representing the Warrior-God Baal, **Bylos, Lebanon, 2nd-1st millenium** B.C.E. **Louvre, Paris/ Erich Lessing/Art Resource, NY.**

97

98

Moses Encounters God in the Cleft of the Rock

AFTER THE INCIDENT OF THE GOLDEN CALF, MOSES WENT UP AGAIN TO SPEAK TO GOD.

"YOU SAY TO ME, 'LEAD THIS PEOPLE FORWARD,'" MOSES SAID TO GOD, "BUT YOU HAVE NOT LET ME KNOW WHOM YOU WILL SEND WITH ME. YOU HAVE ALSO SAID, 'I HAVE SINGLED YOU OUT

by name, and I have favored you.' Now, if I have really gained Your favor, let me know Your ways so that I can know You and continue in your favor. Remember also that this nation is Your people."

"I will go in the lead," God replied, "and will make things easier for you."

"Unless You go in the lead," Moses said to God, "do not make us leave this place. Otherwise, how will Your people know that they have gained Your favor unless You go with us, so that we, Your people and I, can be told apart from every other people on the face of the earth?"

"I will also do this thing you have asked," said God, "because you have truly gained My favor, and I have singled you out by name."

Then Moses cried, "Let me see Your presence!"

"I will make My goodness pass in front of you," answered God, "and I will pronounce the Awesome Name of God and will reveal My grace and compassion. But you cannot see My face, for human beings cannot see My face and live.

"See, there is a place near Me," He continued. "Stand on the rock. As My Presence goes by, I will place you in a cleft of the rock and shield you with My hand until I have passed by. Then I will remove My hand and you will see My back, but My face must not be seen."

OPPOSITE AND ABOVE: *Synagogue Lions*, **Marcus Charles Illion, early 20th century. HUC Skirball Cultural Center, Museum Collection, Los Angeles (Museum purchase with Project Americana Acquisition Funds provided by Irvin and Lee Karlsman, Peachy and Mark Levy, and Gerald M. and Carolyn Z. Bronstein).**

Then God commanded Moses to carve two new stone tablets and write on them the terms of the covenant, the Ten Commandments. Then after forty days and nights of not eating bread or drinking water, Moses came down from Mount Sinai with the new tablets, the skin of his face glowing with radiance after speaking with God.

Nadav and Avihu Offer Strange Fire

אשר לא צוה אתם

ARON'S SONS NADAV AND AVIHU EACH TOOK HIS FIRE PAN, PUT FIRE AND INCENSE IN IT, AND OFFERED BEFORE GOD STRANGE FIRE THAT HAD NOT BEEN COMMANDED. AND FIRE CAME FORTH FROM GOD AND CONSUMED THEM, AND THEY DIED.

Then Moses said to Aaron, "This is what God means by saying, 'I set Myself apart through those near to Me, and thereby gain honor before the whole people.'"

And Aaron was silent.

Then Moses called Mishael and Elzaphan, sons of Aaron's uncle, Uzziel, and said to them, "Carry your cousins away from the sanctuary to a place outside the camp." And so they carried them outside the camp, holding them by their garments.

Then Moses said to Aaron and his remaining sons, Eleazar and Itamar, "Do not bare your heads and tear your clothes in mourning, lest you die and endanger the whole community. Your fellow Israelites will grieve for the burning that has blazed forth from God. But do not yourselves go outside the Tent of Meeting, for you are God's anointed." And they did as Moses said.

God then spoke to Aaron, "When you or your sons come into the Tent of Meeting, drink no wine or intoxicating liquor, so that you will not die. For you must make a distinction between the sacred and the everyday, between the impure and the pure, and you must teach God's laws to all the people of Israel."

100

Moses and the Column of Fire, Raphael, early 16th century. Logge, Vatican Palace, Vatican State/Scala/ Art Resource, NY.

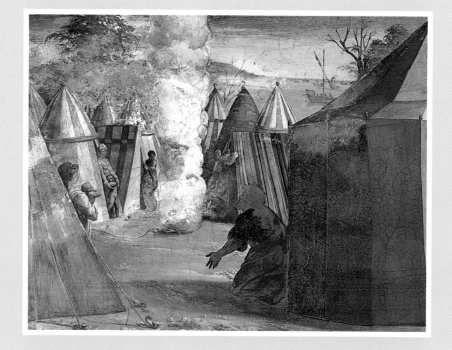

Miriam and Aaron Challenge Moses

אֶל־מֹשֶׁה וַיֹּאמֶר פָּא נָא לָהּ

MIRIAM AND AARON SPOKE WITH MOSES REGARDING THE CUSHITE WOMAN HE HAD MARRIED—FOR HE HAD MARRIED A WOMAN OF CUSH. "DOES GOD SPEAK ONLY THROUGH MOSES?" THEY SAID TO HIM. "DOES GOD NOT ALSO SPEAK THROUGH US?" MOSES HIMSELF WAS THE HUMBLEST MAN ON THE FACE OF

the earth. But when God heard it, God called to Moses, Aaron, and Miriam, "Go, all three of you, to the Tent of Meeting!"

So the three of them went. Then God came down in a pillar of cloud, which came to rest at the Tent of Meeting. And God called out, "Aaron and Miriam!" And the two of them came out. Then God said, "Listen to Me! When a divine prophet rises up among you, I become known to this prophet through visions and dreams. Not so with My servant Moses, who is the most trustworthy in My household. I speak with him intimately, clearly and not through riddles, and he looks upon the image of God. How dare you speak against My servant Moses!" And God's anger blazed forth against them. Then God departed.

When the cloud retreated from the tent, there was Miriam, blighted with snow-white scales. Seeing her, Aaron said to Moses, "O my lord, do not hold our sins against us! Do not leave her like a corpse, like an abortion emerging from its mother's womb, half wasted away."

Miriam, Sister of Moses and Aaron, **Sir Edward Burne-Jones, ca. 1872. Waterford, Hertfordshire/ Bridgeman Art Library, London/New York.**

Then Moses cried out to God, "Please, God, please heal her!"

"If her father spit in her face," God said to Moses, "would she not suffer shame for seven days? Therefore, let her be shut out from the camp for seven days and then be readmitted." And so Miriam was shut outside the camp for seven days, and the people did not travel on until Miriam was readmitted. Only then did the people travel from Hazerot and camp in the wilderness of Paran.

101

The Twelve Spies

ויתרם את־הארץ מה הוא

GOD SPOKE TO MOSES: "SEND MEN TO SCOUT OUT THE LAND OF CANAAN. CHOOSE ONE MAN FROM EACH OF THE TWELVE TRIBES, EACH ONE A LEADER AMONG HIS PEOPLE."

"GO TO THE NEGEV AND TO THE HILL COUN- TRY," MOSES SAID TO THEM, "AND SEE WHAT kind of land it is. Are the people who live there strong or weak, few or many? Is the land good or bad? Are the cities open or walled? Is the soil rich or poor? Are there trees or not? Be sure to bring back some fruit of the land." Now it happened that this was the season when the grapes were beginning to ripen.

So they went up to scout the land and came to Hebron, where the giant Anakites lived. And they came to the oasis of Eshkol, where they cut down a single grape cluster that was so heavy two men were needed to carry it, as well as some pomegranates and figs.

After forty days, they returned to Moses, Aaron, and the whole Israelite community. They showed them the fruit of the land and reported to them: "The land to which you sent us flows with milk and honey; here is its fruit. But the people who live there are strong, and their cities are large and forti- fied, and we even saw the giant Anakites there! Many other peoples live there—

OPPOSITE: *Fruit of the Promised Land,* **Nicholas Poussin, 1660–1664. Erich Lessing/Art Resource, NY.**

Amalekites, Hittites, Jebusites, Amorites, and Canaanites."

Caleb, from the tribe of Judah, said, "Let us go up and take it, for we can surely do so."

But the men who had gone up with him said, "No, this people is stronger than we are—we cannot master them! This land swallows up those who occupy it. The people who currently live there are giants. We seemed like grasshoppers in our own eyes, and so we must have looked to them."

That night the people wept, and they complained to Moses and Aaron, "If only we had died in Egypt! Or if only we had died in this wilderness! Why is God bring- ing us to this land to fall by the sword? Our wives and children will be taken captive. We would be better off returning to Egypt!" They said to one another, "Let us go back!"

Then Moses and Aaron prostrated themselves before the people, and Joshua and Caleb, two of the scouts, tore their clothing and said to the Israelite community, "The land we scouted is a very, very good land, flowing with milk and honey. If God is pleased with us, God will bring us there and give this land to us. Only do not rebel against God! Do not be afraid of the people of this land, for we will consume them; their protection is gone. God is with us—do not be afraid of them!"

But the whole community threatened to stone them. Then the Glory of God appeared at the Tent of Meeting in front of the whole community.

"How long will this people reject Me?" God said to Moses. "How long will they not believe in Me after all the miracles that I

HaGafen, Julie Staller-Pentelnik, 1988.
Courtesy of the artist.

have performed in their midst? I will strike them down with a plague and make of you a great and numerous people."

"When the Egyptians hear that You have slaughtered this people," Moses said to God, "they will tell those who dwell in that land. And when the nations who have heard of Your fame learn that You have killed every last one of Your people, they will say, 'God slaughtered them in the wilderness because God was unable to bring them into this land that had been promised them.' Therefore, show Your strength as You have declared:

God, slow to anger, full of lovingkindness, forgiving trespass and wrongdoing, but accounting a father's sins to the third and fourth generation of his children.

Please forgive this people's sin out of Your great kindness, as You have forgiven them ever since Egypt."

"I will forgive them as you have requested," God replied. "But as I live, not one of these men who have seen My glory and the miracles I performed in Egypt and in the wilderness, and who have defied Me these ten times, none of them will see the land I swore to their fathers. Indeed, your corpses will drop in this wilderness, and none of you above the age of twenty will enter the land I promised you—except Caleb and Joshua. Your children, whom you feared would be taken captive, shall enter the land that you have rejected. But they will wander in the wilderness for forty years, suffering on account of your betrayal, until every last one of you has dropped dead. Forty years will you be punished, one year for each day that you scouted the land. This way you will learn what happens to those who reject Me."

As for the men who had gone to scout out the land, they died of a plague sent by God. Only Joshua and Caleb survived.

When Moses told the people what God had said, they were filled with grief. Early the next morning, they headed toward the hill country, declaring, "We are ready to go where God has commanded, for we were in error."

But Moses said to them, "Why do you disobey God's word? You will not succeed! Do not go up there, for God is not with you since you have turned away. If you go, you will fall to the swords of the Amalekites and Canaanites."

Yet they marched nonetheless, but without either the Ark of the Covenant or Moses. And the Amalekites and the Canaanites roundly defeated them at Hormah.

The Rebellion of Korakh

NOW THE LEVITE KORAKH— TOGETHER WITH DATAN, ABIRAM, AND ON FROM THE TRIBE OF REUBEN, AND TWO HUNDRED FIFTY RESPECTED LEADERS OF THE COMMUNITY—ROSE UP AGAINST MOSES and Aaron. "You have overreached yourselves!" they declared. "All of the community is holy, and God is in their midst. Why do you hold yourselves above God's own congregation?"

When Moses heard this, he fell on his face. "By morning, God will make known who belongs to God and who is holy," he told Korakh and his followers. "And those who have been chosen by God will be drawn near. So take fire pans for yourselves, and tomorrow put fire and incense in them, and bring them before God. The man whom God chooses will be deemed holy. You are the ones who have overreached yourselves, sons of Levi!

"Listen to me, sons of Levi!" Moses continued. "Is it not enough that the God of Israel has set you apart from the rest of the community to bring you close through divine service in the Tabernacle and to minister to the community? Now that God has drawn you and your fellow Levites near, do you seek the priesthood as well? How can you murmur against Aaron—no, you and your followers have risen up against God!"

Then Moses sent for Datan and Abiram, but they said, "No, we will not come! For is it not

The Rebellion, Michal Meron, **1997. From** *The 54 Illustrated Portions of the Torah* **by Michal Meron, 1998. Courtesy The Studio in Old Jaffa, Israel.**

105

enough that you brought us out of a land flowing with milk and honey to die in the wilderness? Must you also lord it over us? And even if you were to bring us to a land flowing with milk and honey and give us fields and vineyards as our portion, must you mortify us? We will not come!"

Incensed, Moses said to God, "Do not accept their offerings! I have not taken even one of their asses, and I have wronged none of them."

Then Moses said to Korakh, "Tomorrow you and your company and Aaron will appear before God. Each man will take his fire pan and place incense upon it and offer it to God."

So each man took his fire pan, put fire and incense upon it, and stood at the entrance to the Tent of Meeting. Korakh assembled the whole community there, and the Glory of God appeared to the whole community.

Then God said to Moses and Aaron, "Separate yourselves from this community so that I may consume them this instant!"

They fell on their faces and answered, "God, Master of the Breath of Life! If one man sins, will you doom the whole community?"

"Speak to the community and tell them," God said to Moses, "'Remove yourselves from the dwelling places of Korakh, Datan, and Abiram.'"

Then Moses went to Datan and Abiram, and the elders of Israel followed him. And he said to the community: "Move away from the tents of these evil men, and do not touch what belongs to them, or you will be annihilated on account of their sins." So they moved away from the dwelling places of Korakh, Datan, and Abiram.

Datan and Abiram came out and stood at the entrance to their tents with their wives, children, and little ones. "By this shall you know that God, not my own heart, has directed me to do these things," Moses said. "If these men die ordinary deaths like other men, it was not God who sent me. But if God does something extraordinary, so that the earth opens up its mouth and swallows these men and everything that belongs to them, and they descend still living into the pit, then you shall know that these men have offended God."

Moses had barely finished speaking when the earth burst open beneath them, swallowing them and their households and every man who was allied with Korakh and all their possessions. They descended still living into the pit together with all that they owned, and the earth closed over them so that they vanished. When the Israelites heard their cries, they fled, for they thought, "The earth will swallow us as well!" Then fire flared forth from God and consumed the two hundred fifty men who had offered incense before God.

Basalt Double Altar, **Israel, second millenium B.C.E.**
The Jewish Museum, NY. Gift of Mr. Jonathan
Rosen/Art Resource, NY.

Moses Strikes
the Rock at Meribah

וַיַּךְ אֶת הַסֶּלַע בְּמַטֵּהוּ פַעֲמָיִם

ON THE FIRST NEW MOON OF THE FORTIETH YEAR, THE ISRAELITES ARRIVED AT THE WILDERNESS OF ZIN AND CAMPED AT KADESH. THERE MIRIAM DIED, AND THERE SHE WAS BURIED.

Then the community had no water, and they gathered against Moses and Aaron. "If only we had died as our brothers did before God!" they argued with Moses. "Why did you bring us and our animals here to die in this wilderness? Why did you bring us out of Egypt to this wicked place with no grain or figs or grapes or pomegranates and no water for us to drink?"

Moses and Aaron came to the Tent of Meeting and fell on their faces. Then the Glory of God appeared to them. "Take your staff and gather the people—you and your brother, Aaron," God said to Moses, "and before their eyes, speak to the rock, and it will yield up its water. Thus you will bring forth water from the rock for the community and its animals."

So Moses took his staff as he had been commanded, and he and Aaron gathered the people in front of the rock. "Listen, you rebels!" Moses said to them. "Shall we bring forth water for you from this rock?" Then Moses raised his hand and struck the rock twice with his staff, and water gushed forth. And the people and their animals drank.

Then God said to Moses and Aaron, "Because you did not trust Me enough to proclaim My holiness before the people, you shall

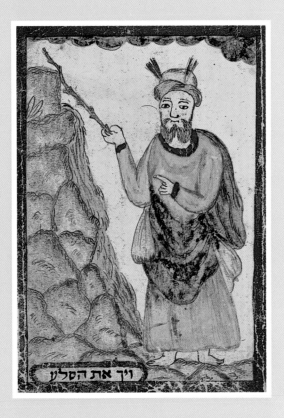

Moses Hitting the Rock from *Mahzor* (Ms. 8236), Corfu, 1709. Courtesy of The Library of The Jewish Theological Seminary of America.

not bring this community to the land I am giving to them."

Therefore, these are called the Waters of Meribah, that is, "quarreling," because it was here that the Israelites quarreled, *rabu*, with God, and through them that God was proclaimed holy

Not long after this, when they had been refused safe passage through the land of Edom, the Israelites came to Mount Hor on the boundary of that country, and Aaron died on the summit of that mountain. And the people mourned Aaron for thirty days.

107

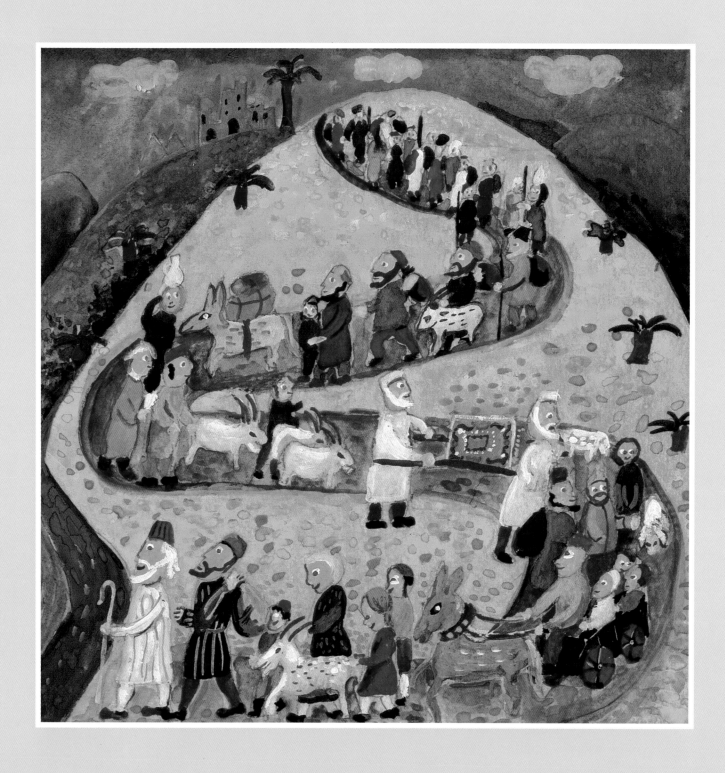

Balaam and the Talking Ass

HE ISRAELITES CAMPED IN MOAB, ACROSS THE JORDAN FROM JERICHO. THE PEOPLE OF MOAB TREMBLED BEFORE THE ISRAELITES, FOR THEY SAID, "THEY WILL STRIP US BARE, AS AN OX STRIPS THE GRASS OF THE FIELD."

Then the king of Moab, Balak, son of Zippor, sent messengers to Balaam, son of Beor, on the banks of the Euphrates, saying, "A people has come out of Egypt so numerous that they cover the earth. Now they have camped near me in Moab. Come put a curse on this people for me. Maybe then I can defeat them and drive them away. For I know that whomever you bless is blessed, and whomever you curse is cursed."

So the diviners of Moab and Midian came to Balaam and gave him Balak's message. "Stay here tonight," he said to them. "I will then give you the answer that God sends me."

So they stayed with Balaam. God came to Balaam and said, "Who are these people with you?"

"King Balak of Moab sent them to me," Balaam replied. "For a great host has come out of Egypt. Come and curse them, for perhaps I can then drive them away."

"Do not go with them," God said to Balaam, "and do not curse them, for they are blessed."

So Balaam arose in the morning and said to Balak's envoys, "Return to your land, for God will not let me go with you."

So they returned to Balak and told him what Balaam had said.

OPPOSITE: *Moses Crossing the Red Sea*, **Michal Meron, ca. 1996. Courtesy of The Studio in Old Jaffa, Israel.**

Then Balak sent other envoys, in greater numbers and more imposing than the first. And they said to Balaam, "So says Balak, 'Do not refuse to come to me. For I will reward you greatly and do whatever you say. Only come and doom this people!'"

"Even if Balak were to give me a house full of silver and gold," Balaam replied, "I could not go against the word of the Lord my God, either in large measure or small. Stay then tonight and I will find out what else God will say to me."

That night God came to Balaam and said to him, "You may go with these men, but whatever I tell you, so shall you do."

The next morning, Balaam arose, saddled his ass, and went off with the envoys from Moab. But God was angry at him for going and sent an angel to stand in his way and oppose him.

As he rode upon his ass, accompanied by his two servants, the ass caught sight of the angel standing in the path with a drawn sword in his hand. But when she swerved aside from the path and went into the field, Balaam beat her to turn her back onto the path. Then the angel of God placed himself between the vineyards, walled in by fences on either side. Seeing the angel of God, the ass pushed

109

against the wall and crushed Balaam's foot, and again he beat her. Once more the angel of God stood in a place so narrow that there was no room to move either to the left or right. And when the ass saw the angel of God, she collapsed under Balaam, and he beat her with a stick.

Then God opened the ass's mouth, and she said to Balaam, "What have I done to you that you have beaten me three times?"

"You have made an ass of me!" Balaam answered. "If only I had a sword with me, I would kill you!"

Then the ass said to Balaam, "Am I not your ass upon whom you have been riding until now? Have I behaved this way before?"

"No," Balaam replied.

Then God opened Balaam's eyes so that he saw the angel of God standing in the path with a drawn sword in his hand. Balaam bowed down to the ground.

Then the angel of God said to him, "Why did you beat your ass three times? It was I who came to oppose you! And when the ass saw me, she turned aside before me these three times. If she had not done so, I would have killed you and let her live."

"I acted wrongly," Balaam said to the angel of God, "for I did not know that you were standing in my way. If what I am doing is evil in your sight, I will go back."

But the angel of God said to Balaam, "Go with these men. But you must say nothing except what I tell you to say."

So Balaam went with Balak's envoys.

Balak came out to meet Balaam at the border. "Why did you not come when I first invited you?" asked Balak. "Is there really no way for me to reward you?"

Balaam replied, "Can I speak anything except what God puts in my mouth?"

The next day, Balak brought Balaam up to the High-Places-of-Baal, where he could see the Israelites. There Balak built seven altars, as Balaam instructed him to do, and sacrificed upon each a ram and a bull.

Then Balaam said to Balak, "Stay here by these sacrifices while I go aside. Perhaps God will appear to me, and I will tell you what I see." And he went off by himself.

Then God appeared to Balaam and said to him, "Return to Balak and speak as I tell you."

So Balaam returned and spoke before Balak and his courtiers:

How can I curse those whom
 God has not cursed?
How can I doom those whom
 God has not doomed?
There is a people who dwells apart,
Not counted among the nations.
Who can count the dust of Jacob,
Or number the multitude of Israel?

Then Balak said to Balaam, "What have you done to me? I brought you to curse my enemies, and instead you have blessed them!"

"I can speak only what God has put in my mouth," Balaam replied.

So Balak said, "Come with me to another place, where you can see only part of this people. And from there you can curse them."

But again Balaam pronounced only blessings upon Israel. Then Balak said to him, "Neither curse nor bless them!"

"Whatever God tells me," Balaam said to him, "I must do."

So Balak took him to a third high place

overlooking the wilderness. And when Balaam looked upon Israel encamped there, the spirit of God came upon him, and he said,

> How glorious are your tents,
> O Jacob!
> Your dwelling places, O Israel!
> Like palm groves that spread out,
> Like gardens alongside a river.
> Blessed are they who bless you,
> Cursed are they who curse you.

Balak was furious with Balaam and said to him, "I summoned you here to curse my enemies, and instead you have blessed them three times! I was going to honor you greatly, but God has refused you honor. Go home!"

"I told your messengers that no reward could make me say anything contrary to what God commands me," Balaam said to him. "I will now return to my people. But before I go, I will tell you what this people will do to your people in days to come:

> A star rises from Jacob,
> A scepter from Israel!
> It smashes the brow of Moab,
> The stronghold of the children
> of Seth!
> Alas, who can survive unless
> God wills it so!

Then Balaam and Balak each went on his way.

Balaam from the *Kennicott Bible* (Ms. Kennicott 1, fol. 89r), 1476. The Bodleian Library, University of Oxford.

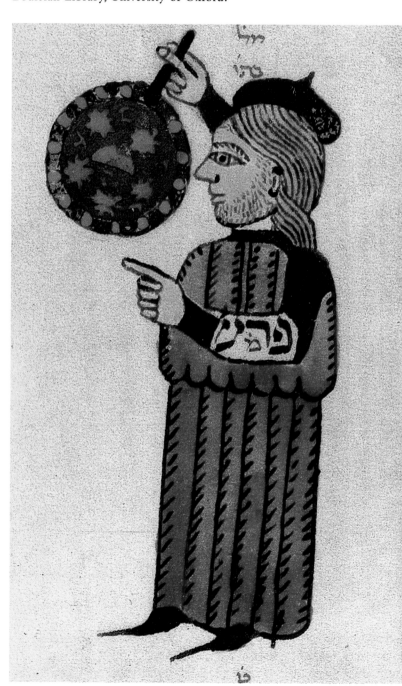

The Song of Miriam the Prophetess
(detail), **William Gale, 19th century.**
Christie's London/SuperStock, Inc.

112

The Daughters of Zelophehad

THE DAUGHTERS OF ZELOPHEHAD—
MAHLAH, NOAH, HOGLAH, MILCAH,
AND TIRZAH—CAME FORWARD. THEY
BELONGED TO THE TRIBE OF MANASSEH,
DESCENDANTS OF JOSEPH'S SON.

THEY STOOD BEFORE MOSES, THE PRIEST
ELEAZAR, THE ELDERS, AND THE WHOLE PEOPLE
at the Tent of Meeting and said,
"Our father died in the wilderness and left no sons. Do not let
our father's name be lost just
because he had no son. Give us
an inheritance among our kin!"

Moses brought their
case before God.

"Zelophehad's daughters are right!" God said to
Moses. "Give them an inheritance among their kin, their
father's share. Tell the people: 'If a man dies without
leaving a son, give his property to his daughter. If he has
no daughter, give it to his brothers. If he has no brothers, give it to his father's brothers. If his father had no
brothers, give it to his nearest relative in his own clan,
and he shall inherit it. This shall be a law for the
Israelites, according to My command to Moses.'"

Moses Bids Farewell

MOSES ANNOUNCED TO ALL THE ISRAELITES: "I AM NOW ONE HUN-DRED TWENTY YEARS OLD. I CAN NO LONGER COME AND GO. GOD HAS SAID TO ME, 'YOU WILL NOT CROSS THIS

Jordan.' God will cross over before you and destroy the nations in your path. Joshua will cross over before you as God has said. Be strong and steadfast and do not fear these nations, for God walks with you and will not forsake you."

Then Moses called Joshua and said to him in front of the whole people, "Be strong and steadfast, for you will bring this

people to the land God promised to their ancestors, and you will apportion it among them. And God will walk before you and will be with you and will not forsake you. Do not be afraid!"

Moses wrote down this Torah and gave it to the priests, the sons of Levi, who carried the Ark of the Covenant, and to the elders of Israel. And Moses commanded them, "At the end of every seventh year at Sukkot, when all of Israel comes to God's chosen place, read this Torah so all can hear it. Gather together the whole people—men, women, children, and the strangers among you—so that they may hear and learn, and fear God so that they obey the words of this Torah. And their children, who do not know these things, will hear and learn and fear God all the days that you live on this land you are now crossing over to inherit."

Then God called Moses and Joshua into the Tent of Meeting, and God appeared there in a pillar of cloud at the entrance. God said to Moses, "You will soon lie with your ancestors. And this people will lust after the foreign gods of this land, and they will desert Me and break My

Aaron and Hur Support Moses's Arms to Ensure Joshua's Victory at Rephidim, **B. Elkan, 20th century. Z. Radovan, Jerusalem.**

113

FORTY YEARS IN THE WILDERNESS

covenant. And My anger will blaze forth against them, and I will desert them and hide My face from them, and many evils and sorrows will befall them. Therefore, write down this poem and teach it to the people of Israel. It will serve as a witness against them when they break My covenant, for their children will never forget it."

So Moses wrote down the poem on that day and taught it to the Israelites. And when he had finished writing it, Moses instructed the Levites: "Place this book in the Ark of the Covenant, and let it remain there as a witness against you. I know how rebellious you have been while I have been alive—how much more so once I am dead! Gather together all the elders so that I may speak with them and call heaven and earth to witness against them."

Then Moses recited this poem before the whole community of Israel:

Listen, O heavens, and I shall speak!
Let the earth hear my words!
God found you in an empty desert,
And guarded you as the apple
 of God's eye.
Like an eagle bearing his young
 in his talons,
With outstretched wings,
 God guided you.
And God fed you honey from
 the rock,
So that you grew fat.
But you turned toward new
 gods you had not known,
And rejected the Rock
 who birthed you.
Then God declared: "I will hide
 My face from you.
But when I see that your
 strength is gone,
I will avenge you!
For there is no god beside Me.
I mete out death and life;
I have wounded, but I shall heal."

Then God said to Moses, "Climb to the top of Mount Nebo and look upon the land of Canaan, which I am giving to the Israelites. You shall die on the mountain and be gathered to your people, as your brother Aaron died on Mount Hor. For you both failed to safeguard My holiness at the waters of Meribah. Therefore, you shall see the land from a distance, but you shall not enter it."

Then Moses, man of God, blessed the people of Israel before he died. When he had finished, he climbed to the summit of Mount Nebo, where God showed him the land of Canaan.

"This is the land that I promised to Abraham, Isaac, and Jacob," God said to him. "I will give it to your children. I have let you see it with your own eyes, but you shall not enter it."

And Moses, the servant of God, died there, in the land of Moab. God buried him there, and no one knows his burial place to this day. He was one hundred twenty years old when he died. His eyes had not dimmed, nor had his strength diminished. And the Israelites mourned Moses for thirty days.

Now Joshua, the son of Nun, was filled with the spirit of wisdom because Moses had laid his hands upon him, and the Israelites listened to him as God had commanded.

Never again did there arise in Israel a prophet like Moses, whom God knew face to face, and who performed wonders and miracles before Pharaoh in the land of Egypt.

OPPOSITE: *Moses auf dem Berg Nebo*, **Lesser Ury, 1905. Jüdisches Museum Berlin.**

V.
In the Promised Land

BECAUSE THE STORIES IN THE Five Books of Moses are read in synagogue every year in a continuous annual cycle and are perpetual favorites in Sunday school, they have become familiar to many Jews. References to the patriarchs (and to a lesser extent, to the matriarchs) abound in the liturgy and in rabbinic lore. Rabbinic law-makers of the past and present accord greater authority to this first section of the Bible than to those that follow: All legal roads lead back to Sinai.

Yet the stories found in the next two sections, collectively known as the historical books, deserve equal time. They constitute some of the most action-packed narratives in the Bible. The Book of Joshua, here represented by a single tale—the famous Battle of Jericho—inaugurates that period of Jewish history when Israel is still a loose confederation of tribes, ruled by local leaders known as judges. Although Joshua and his successors manage to subdue many of the indigenous peoples of Canaan, they do not succeed in driving them out and often fall prey to their pagan influence. Periodically, a strong Jewish leader emerges to regain the upper hand for a particular tribe or region, but such victories are inevitably short-lived. Not until the reign of David, several centuries after they have first entered the land, is Israelite power finally consolidated and centralized.

Three leaders stand out in the biblical Book of Judges: Deborah, the only woman to preside over an Israelite tribe, who leads her people in battle alongside the male general Barak; Gideon, who uses stealth and strategic planning to overcome the enemy;

and Samson, the legendary strongman who loses his strength only to regain it in defeat. Two lesser-known stories, the curse of Yotam and the tragedy that befalls Jephthah's daughter, flesh out the portrait of a land still unruled and unruly.

Concluding this section is the famous story of Ruth and Naomi, which comprises its own biblical book in the section of Writings known as the five *megillot*, or Scrolls. I have chosen to place the story here, where it is traditionally positioned in the Christian canon, rather than later on as in the Hebrew Bible, because Ruth is the great-grandmother of King David, whose story comes next in the biblical sequence. Unlike other characters in these stories, however, neither Ruth nor her mother-in-law, Naomi, is a political or military leader of her tribe. In fact, these two women are politically vulnerable because they are widows, without men. The touching story of Ruth's loyalty to Naomi and to Naomi's God after the death of her husband has become a special favorite among converts to Judaism. It is also one of the few Bible stories exploring relationships between two generations of women.

At the end of this section, we enter a new era of Jewish history—the period of the monarchy, also known as the First Commonwealth of Israel.

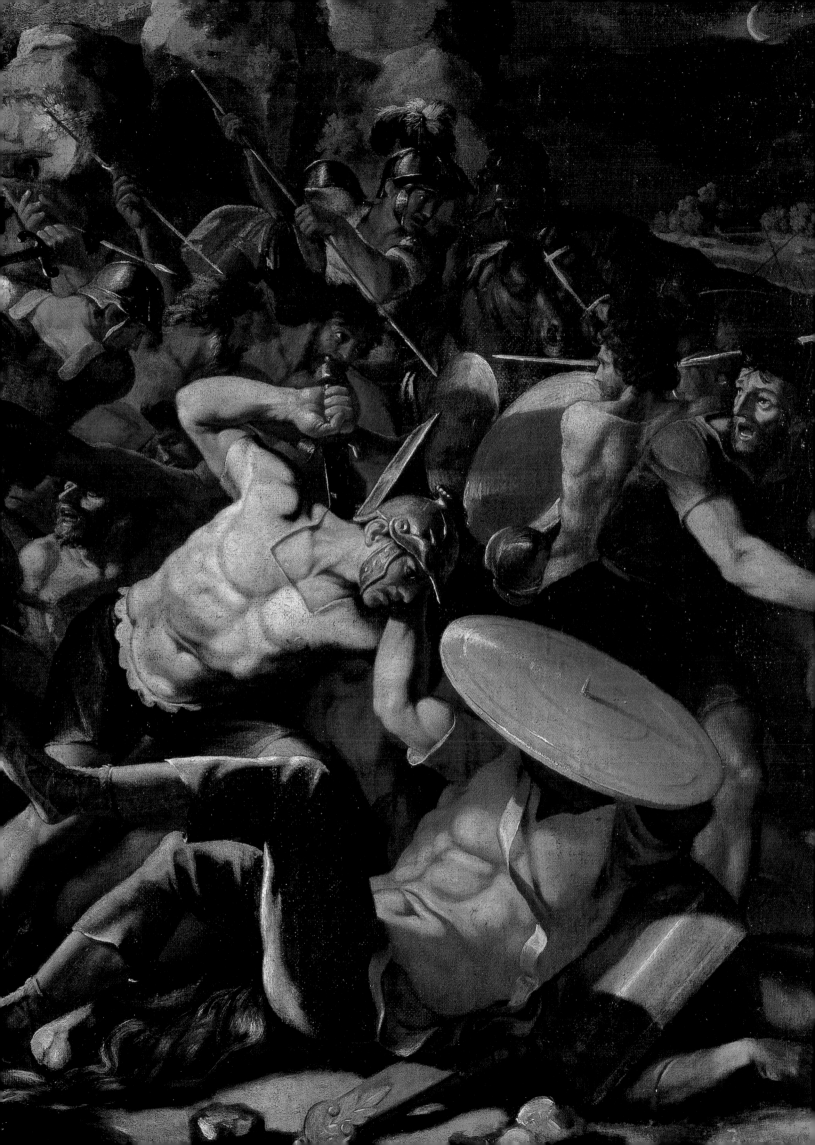

Joshua and the Battle of Jericho

AFTER THE DEATH OF MOSES, GOD SAID TO JOSHUA, SON OF NUN: "MY SERVANT MOSES IS DEAD. PREPARE NOW TO CROSS THE JORDAN. FOR I AM GIVING TO THE ISRAELITES THE LAND I PROMISED TO YOUR ANCESTORS—FROM THE WILDERNESS TO LEBANON, FROM THE GREAT RIVER EUPHRATES TO THE MEDITERRANEAN SEA. AS I WAS

with Moses, so will I be with you. Be strong and steadfast, for I will not fail or forsake you. But you must faithfully observe this Torah— only then will you be successful and prosper."

When Joshua told the people all that God had commanded, they replied, "We will obey you just as we obeyed Moses!"

Then Joshua sent two spies to scout out the region of Jericho. That night they lodged with a prostitute named Rahab, whose house was built into the city wall. When the king was told that Israelite spies had come to Rahab's house, he ordered her to turn them over. But Rahab hid them on the roof, under some stalks of flax. She said to the king's men: "Yes, the men did come here, but I did not know where they were from. They left after dark, just before the city gate was closed, but I do not know

OPPOSITE: *The Fall of Jericho,*
Jean Fouquet from *Antiquités
Judaïques* by **Flavius Josephus
(Ms. Fr. 247, Tome 1, fol. 80),
15th century. Bibliothèque
Nationale de France/Telarci-
Giraudon, Paris.**

where they went. If you go after them at once, you can catch them."

So the king's men pursued them in the direction of the fords of the Jordan River. And the city gate was shut behind them as soon as they left.

Then Rahab went up to the roof and said to the men she had hidden there, "I know that God has given the country to you. For we have heard how God dried up the Sea of Reeds when you left Egypt, and what you have done to the Amorite kings, Sihon and Og, across the Jordan. All the inhabitants of the land are quaking before you; we have all lost heart. For your God is the only God in heaven above and on earth below. Because I have shown you kindness, swear to me in God's name that you will show kindness to my family. Give me a sign that you will spare the lives of my father and mother, my brothers and sisters, and all who belong to them."

"Our lives are pledged for yours!" the men replied. "If you do not reveal our mission, we will show you true kindness when God gives us the land."

She lowered them down through the window by a crimson cord and said to them, "Hide in the hills for three days. Then after those who pursue you have returned, go on your way."

"Tie this crimson cord in your window," they said to her, "and bring your father, your mother, your brothers, and all your family into your house. When we invade the country, we will hold ourselves responsible for the safety of all

121

those within your doors. But if anyone goes outside, or if you reveal our mission, then the blood is on your own heads. We shall be released from our oath."

"So be it," she replied.

When they had gone, she tied the crimson cord in the window.

The men hid for three days in the hills, and the pursuers did not find them. Then they reported to Joshua all that had happened to them. "God has delivered the land into our hands," they declared, "for all the inhabitants are quaking before us."

The Israelites then set out from their camp and remained for three days on the banks of the Jordan. Joshua commanded the people, "When you see the priests carrying the Ark of the Covenant, follow behind it—but at a distance—so that you may know the way to go. Purify yourselves, for tomorrow God will perform wonders in your midst."

Then God said to Joshua, "Today, for the first time, I will raise you up in the sight of all Israel, so that everyone may know that I will be with you as I was with Moses."

Then Joshua said to the people, "Come closer and hear the words of YHVH your God. By this you will know that in your midst is a living God, who will drive out the nations of Canaan before you. Now select twelve men, one from each tribe. When the feet of the priests carrying the Ark come to rest in the Jordan, the water from upstream will be cut off and stand in a single heap."

Then the people set out, with the priests carrying the Ark of the Covenant in the lead. And as soon as the priests' feet touched the water's edge, the waters far upstream piled up in a single heap, and those flowing down to the Dead Sea ran out. The people crossed over near Jericho, while the priests carrying the Ark of the Covenant stood on dry land exactly in the middle of the Jordan.

When the entire nation had finished crossing, God said to Joshua, "Instruct the twelve men, one from each tribe, to pick up twelve stones from the spot where the priests are standing and bring them to the place where you will spend the night."

So Joshua commanded them: "This shall serve as a sign among you. When your children one day ask, 'What is the meaning of these stones to you?' you shall tell them, 'The waters of the Jordan were cut off when the Ark of God's Covenant passed through.' So these stones shall serve the children of Israel as a memorial for all time."

The twelve men did as Joshua commanded, carrying the twelve stones on their shoulders and setting them down where they camped that night. Joshua also set up twelve stones in the middle of the Jordan where the priests had stood—and they remain there to this day.

And when all his instructions had been carried out, Joshua commanded the priests, "Come up out of the Jordan." As soon as the priests' feet stepped onto dry ground, the waters resumed their course.

On the tenth day of the first month, the people crossed the Jordan and camped at Gilgal, on the eastern border of Jericho. Joshua set up the twelve stones from the Jordan at Gilgal and said to the Israelites, "When your children ask you in time to come, 'What is the meaning of these stones?' tell them, 'Here God dried up the waters of the Jordan while you crossed on dry land, just as God did to the Sea of Reeds.' Thus shall all peoples of the earth know of God's might, and thus shall you fear God always."

Then God commanded Joshua, "Make flint knives and circumcise all the male Israelites who were born after you went out of Egypt." For though all the male Israelites who had come out of Egypt had been

122

circumcised, none of those born during the forty years of wandering in the wilderness had been circumcised on the way. And after the circumcising was completed, the people remained where they were until they recovered.

Then God said to Joshua, "Today I have rolled away from you the disgrace of Egypt." And so the place was called Gilgal, "rolling." There on the steppes of Gilgal, on the fourteenth day of the first month, the Israelites offered the Passover sacrifice. On the next day, they ate the produce of the land—*matzah* (unleavened bread) and parched grain. And on that same day, the manna ceased.

Now Jericho was shut up tight against the Israelites; no one could leave or enter. God said to Joshua, "I will now deliver Jericho into your hands. For six days, let all your troops complete one circuit around the city, with seven priests carrying seven shofars before the Ark. On the seventh day, march around the city seven times, with the priests blowing the shofars. And when you hear a long blast of the shofar, the people shall utter a loud cry, and the city wall will collapse, and the people will go forward."

So Joshua commanded the people. Seven priests marched in front of the Ark, blowing the shofars continuously. But Joshua instructed the rest of the people, "Do not let a sound escape your lips until the moment that I command you, 'Shout!' Then you will shout."

For six days they did so, returning to the camp after a single circuit around the city. On the seventh day, they rose at dawn and marched around the city seven times. When they completed the seventh circuit, Joshua commanded the people, "Shout—for God has given you the city! Everything in the city is forbidden to you. Spare only Rahab the prostitute, and all who are with her in her house, for she hid our messengers. If you take anything for yourselves, you yourselves will be condemned, and you will bring disaster upon us all. As for the silver and gold and copper and iron, it is to be consecrated to God."

And when the shofars sounded, the people shouted—and the wall collapsed. The people rushed into the city, and they captured it. And they put every living thing to the sword—men and women, young and old, oxen and sheep and asses. But Joshua sent the two young spies to Rahab's house to save her and her family. And they brought out her whole family and left them outside the Israelite camp. Then they burned down the city and everything in it. But the silver and gold and copper and iron were deposited in the treasury of the House of God. And Rahab and her family lived among the Israelites—as they do to this day—because she had hidden the spies whom Joshua sent to spy out Jericho.

Then Joshua uttered this oath: "Cursed be the man who tries to refortify Jericho. He will pay for its foundations with his firstborn, and for its gates with his youngest child."

God was with Joshua, and his fame spread throughout the land.

The Story of Joshua from the *Gates of Paradise* (east doors), Lorenzo Ghiberti, 1425–52. Baptistry, Florence/Bridgeman Art Library, London/New York.

123

Deborah

Under the leadership of Joshua, the Israelites conquered most of the peoples of Canaan, and each tribe settled in a different part of the land. But God left some of the nations in the land instead of driving them out in order to test Israel by them, to see whether the Israelites would walk faithfully in God's ways, as their ancestors had done. Israel soon did what was offensive to God, turning aside to worship other gods and marrying among the peoples of the land.

THEN GOD DELIVERED THE ISRAELITES INTO THE HAND OF KING JABIN, WHO REIGNED IN HAZOR. THE COMMANDER OF HIS ARMIES WAS SISERA, WHO HAD NINE HUNDRED IRON CHARIOTS AND oppressed the Israelites cruelly for twenty years. And the Israelites cried out to God.

At that time, Deborah the prophet, wife of Lappidot, led Israel. She would sit under the Palm of Deborah in the hill country of Ephraim, and the people would come to her for judgment.

She sent for Barak, son of Abinoam, from Naftali and said to him, "So commands the God of Israel: 'Take ten thousand men of Naftali and Zebulun and march up to Mount Tabor. There I will deliver Sisera with his chariots and troops into your hands.'"

But Barak replied, "If you will go with me, I will go. But if not, then I will not go."

"I will go with you," she answered. "But you will gain no honor this way, for God will now deliver Sisera into the hands of a woman."

Then Barak gathered ten thousand men at Kedesh, and Deborah went with him.

At that time, Hever the Cainite, who like all Cainites was a descendant of Hovav, father-in-law of Moses, had pitched his tent nearby.

When Sisera heard that Barak had gone up to Mount Tabor, he ordered all his chariots and troops to the wadi Kishon.

Then Deborah said to Barak, "Rise up, for today God marches before you and will deliver Sisera into your hands!" So Barak led the ten thousand men down from Mount Tabor. And God struck terror into Sisera and his army in the face of Barak's assault, and Sisera dismounted from his chariot and fled on foot. Barak pursued the chariots and foot soldiers, and every one of them fell by the sword.

Sisera fled to the tent of Yael, wife of Hever the Cainite, for there was peace between Hever's family and King Jabin. Yael came out to greet Sisera and said to him,

OPPOSITE: ***Deborah the Prophetess Encourages Barak to Attack Sisera*** **(lower panel) (Ms 638. fol. 12). The Pierpont Morgan Library/Art Resource, NY.**

125

"Turn aside, my lord, turn aside with me and do not be afraid." So he turned aside and came into her tent.

"Please give me some water to drink," he said to her, "for I am thirsty." She gave him milk from a skin, and covered him with a blanket. "Stand at the opening of the tent," he told her, "and if anyone comes and asks you, 'Is there a man here?' answer no."

When he had fallen into an exhausted sleep, Yael took a tent stake, and gripping the mallet in her hand, crept up on him and drove the stake through his temple until it pierced the ground. And so he died.

Then Barak appeared, and Yael came out to meet him. "Come and I will show you the man you seek," she said to him. He went with her and there lay Sisera, dead, a tent stake through his temple.

On that day, Deborah and Barak sang:

In the days of Yael, caravans ceased,
And wayfarers went by
 roundabout paths.
Deliverance ceased in Israel,
Until you arose, O Deborah,
Arose, O Mother, in Israel!

Awake, awake, O Deborah!
Awake, awake, strike up the chant!
Arise, O Barak;
Take your captives, O son
 of Abinoam!
Most blessed of women be Yael,

Wife of Hever the Cainite,
Most blessed of women in tents.
He asked for water, she
 offered milk;
In a princely bowl she brought
 him curds.
Her left hand reached for
 the tent stake,
Her right for the workmen's
 hammer.
She struck Sisera, crushed his head,
Smashed and pierced his temple.

Through the window peered
 Sisera's mother,
Behind the lattice she gazed:
"Why is his chariot so long
 in coming?
Why so late the clatter of
 his wheels?"
The wisest of her ladies
 gives answer;
She too replies to herself:
"They must be dividing the spoil
 they have found:
A damsel or two for each man."

And the land was at peace for forty years.

OPPOSITE: *Jael Kills the Commander of the Canaanite Army*, Bartholomaeus Spranger, ca. 1580. Statens Museum for Kunst, Copenhagen/Erich Lessing/Art Resource, NY.

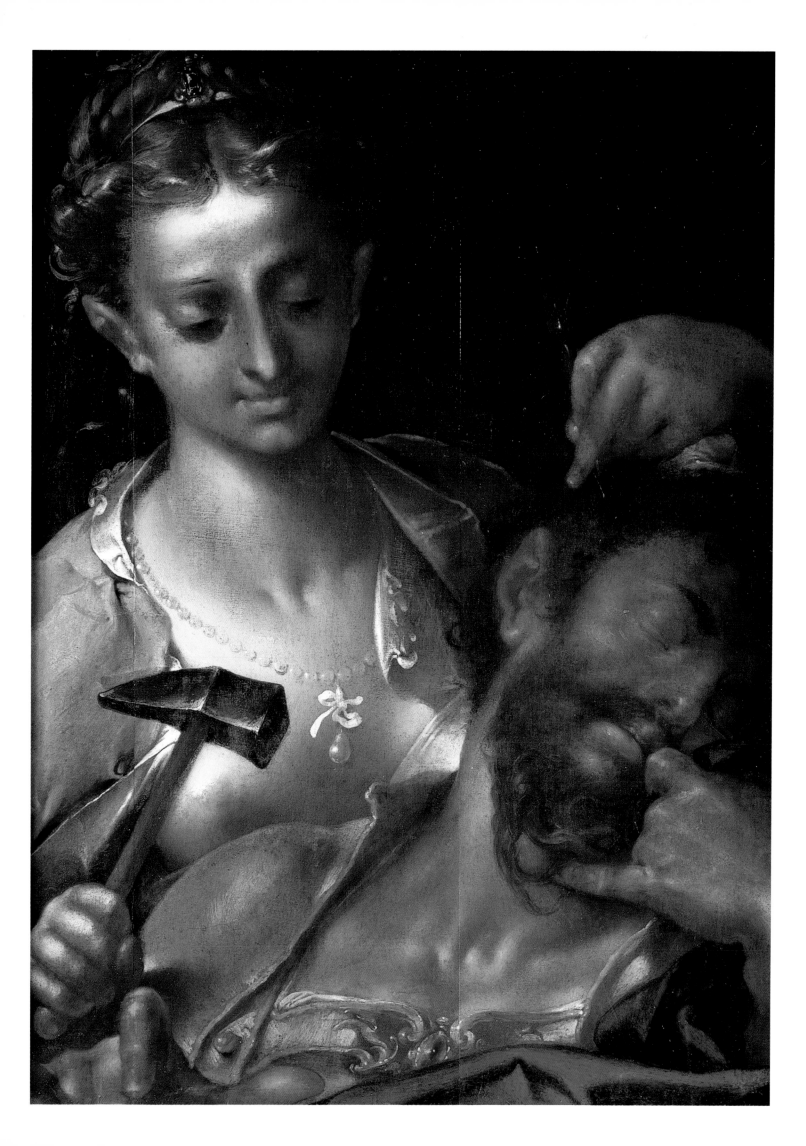

Judges 6:11–8:28

Gideon

בִּשְׁלֹשׁ מֵאוֹת הָאִישׁ
הַמְלַקְקִים אוֹשִׁיעַ אֶתְכֶם

After Deborah died, the Israelites slipped back into idolatry. God punished them by sending the Midianites to oppress them for seven years. The people took refuge in mountain caves to escape from their enemy. But while they were hiding there, the Midianites, the Amalekites, and the Kedemites swooped down upon the land and destroyed their crops and herds, so that the people were left with nothing.

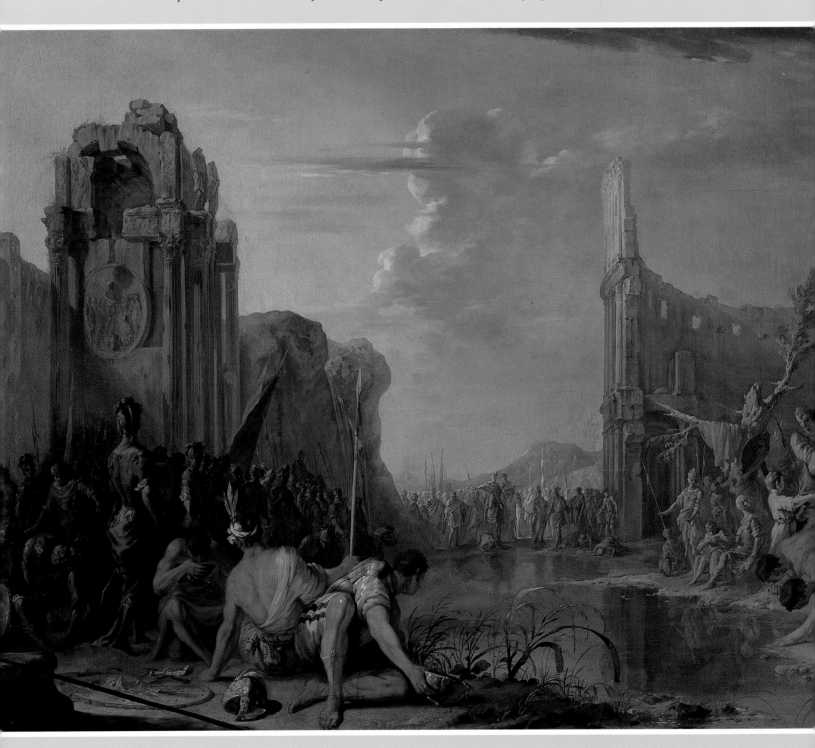

AN ANGEL OF GOD CAME AND SAT DOWN UNDER AN OAK TREE AT OPHRAH, WHICH BELONGED TO YOASH. AT THAT TIME, YOASH'S SON GIDEON WAS BEATING WHEAT INSIDE A WINEPRESS TO HIDE IT FROM THE MIDIANITES.

THE ANGEL OF GOD APPEARED TO GIDEON and said, "God is with you, mighty warrior!"

"Please, my lord," Gideon answered, "if God is indeed with us, why has all this happened to us? Where are all the miracles our elders told us about, reminding us, 'Didn't God bring us up out of Egypt?' Now God has abandoned us and delivered us into Midian's hands!"

"Go use your strength to deliver Israel from the Midianites," God said to him. "I am sending you as My messenger."

"Please, my Lord, how can I deliver Israel?" asked Gideon. "My clan is the humblest in Manasseh, and I am the youngest in my father's house."

"I will be with you," answered God, "and you will defeat every last man in Midian."

"If I have truly gained favor in Your eyes, give me a sign that it is really You speaking to me. Do not leave this place until I return with an offering for You."

"I will stay here until you return," God replied.

So Gideon prepared a kid and baked unleavened bread from flour. He put the meat in a basket and poured broth into a pot, and he brought his offering to the angel under the oak tree. When he presented these things, the angel of God said to him, "Take the meat and the unleavened bread, put them on that rock, and spill out the broth."

And Gideon did so.

Then the angel of God held out his staff and touched the meat and unleavened bread

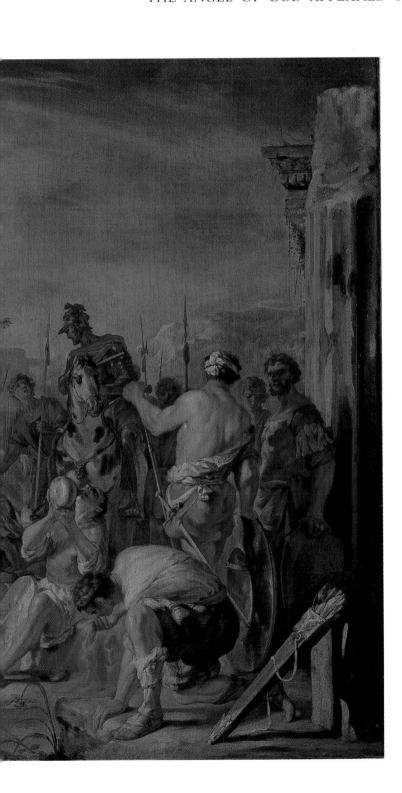

Gideon Tests the Valor of His Men, Johann Heinrich Schoenfeld, 1636. Kunsthistorisches Museum, Vienna/Erich Lessing/Art Resource, NY.

IN THE PROMISED LAND

with its tip. A fire sprang up from the rock and burned up the meat and unleavened bread. Then the angel of God vanished from Gideon's sight.

Gideon realized that this had truly been an angel of God. "O my God, *Adonai*!" he cried. "I have seen a divine angel face to face!"

"All is well; have no fear," God reassured him. "You will not die."

So Gideon built an altar to God and called it *Adonai-shalom*—"My God, all is well." To this day it stands in Ophrah.

That night God said to him, "Take your father's young bull and another bull seven years old. Pull down the altar of Baal belonging to your father and cut down the sacred post standing next to it. Then build an altar to God on the flat ground on top of this rock. Take the second bull and sacrifice it, using the wood of the sacred post you have cut down."

So Gideon took ten servants and did as God had commanded him. But he was afraid to do it by day, because of his father and the townspeople, so he did it by night.

Early the next morning, the townspeople found that the altar of Baal and the sacred post next to it had been torn down, and a bull offered on the newly built altar.

"Who did this?" they asked one another.

When they looked into the matter, they were told, "It was Gideon, son of Yoash!"

"Bring out your son, for he must die!" the townspeople said to Yoash. "He has torn down the altar of Baal and the sacred post!"

But Yoash said to them, "Do you have to fight on behalf of Baal? All those who fight his battles for him will be dead by morning. Let him fight his own battles, because it is his altar that has been torn down!"

That day they named Gideon Yeruv-Baal, meaning "Let Baal fight with him," because he tore down Baal's altar.

Then all the Midianites, Amalekites, and Kedemites joined forces, crossed over, and camped in the Valley of Jezreel.

Then the spirit of God filled Gideon. He sounded the shofar, and his clansmen, the Abiezrites, rallied behind him. He also sent messengers throughout the tribe of Manasseh, and those men too joined up with him. He then summoned men from Asher, Zebulun, and Naftali, who came up to meet the Manassites.

"If You really mean to deliver Israel through me as You have said," Gideon said to God, "I will ask for another sign. I will place a fleece of wool on the threshing floor. If dew falls only on the fleece and the ground remains dry, I will know that You will save Israel through me, as You have said."

And so it happened. Early the next day, he squeezed the fleece and wrung out a bowlful of dew from it.

Then Gideon said to God, "Don't be angry with me if I speak again. Let me make just one more test with the fleece. Let the fleece alone be dry while there is dew all over the ground."

God did so that night—only the fleece was dry, and there was dew all over the ground.

Early the next day, Gideon and all his troops camped above En-Harod; the camp of the Midianites was in the northern plain at Givat-Moreh.

"You have too many troops with you," God said to Gideon. "The Israelites might claim for themselves the glory due to Me, thinking, 'Our own hands have brought us victory.' Therefore, announce to your men, 'Let anyone who is afraid turn back.'"

Twenty-two thousand of the troops turned back, leaving ten thousand in the camp.

"There are still too many troops," God said to Gideon. "Take them down to the water, and I will sift them for you there. I will tell you who will go with you and who will not go."

So Gideon took his troops down to the water.

"Separate those who lap the water like dogs from those who get down on their knees to drink," God said to Gideon.

Only three hundred lapped the water like dogs; the rest got down on their knees to drink.

"With these three hundred lappers," said God, "I will deliver Midian into your hands. Let the rest of the troops go home."

So the rest of the Israelites took their food and shofars and went home, leaving only three hundred men to fight.

That night God said to Gideon, "Go attack the camp, for I have delivered it into your hands. But if you are afraid to attack, go down with your servant Purah and listen to what they say. After that, you will have the courage to attack the camp."

So Gideon and Purah sneaked into the enemy camp, which stretched out over the plain like the sands of a limitless shore, and eavesdropped at one of the tents. And Gideon heard a man telling another man a dream he had had that night: "A loaf of barley was spinning through the camp like a whirlwind, and it struck one of the tents and flipped it upside down so that it collapsed."

"That can have only one meaning—that the sword of Gideon will soon defeat us in battle," said the other man.

Then Gideon's heart filled with courage, and he returned to his camp and called his soldiers. He divided them into three columns and gave each man a shofar and an empty jar with a torch in each jar.

"Watch me," he said, "and do as I do. When I and the men with me get to the outpost of the enemy camp and blow our horns, blow your horns, too, and shout, 'For the Lord and for Gideon!'"

Gideon and the hundred men with him arrived at the outpost of the enemy camp at the beginning of the middle watch, just after the sentries had been posted. They blew their shofars and smashed the jars, and the rest of the troops did the same. Holding the torches in their left hands and the horns in their right, they shouted, "A sword for the Lord and for Gideon!"

The Midianites were so startled to see their camp suddenly lit up and to hear the noise of so many trumpets that they began attacking one another with their own swords and soon fled in panic.

Then the Israelites from Naftali and Asher and all of Manasseh chased after the Midianites. Gideon also sent messengers throughout the hill country of Ephraim giving orders to seize access to the water all along the Jordan. The men of Ephraim did so, and they chased the Midianite generals, Oreb and Zeev, and killed them, and brought their heads back to Gideon. And Gideon and his army pursued the enemy until they were all defeated.

Then the Israelites said to Gideon, "Rule over us—you, your son, and your grandson—for you have saved us from the Midianites."

"I will not rule over you myself," declared Gideon, "nor shall my son rule over you. God alone shall rule over you."

And peace ruled the land for the next forty years.

131

Yotam's Parable

NOW ABIMELECH—SON OF YERUV-BAAL, THAT IS, GIDEON—WENT TO HIS MOTHER'S BROTH-ERS IN SHECHEM AND SAID TO ALL OF HIS MOTHER'S FAMILY THERE, "ASK THE TOWNS-PEOPLE OF SHECHEM: 'WHICH IS BETTER FOR YOU—TO BE RULED BY SEVENTY MEN, THAT IS, BY ALL THE SONS OF YERUV-BAAL, OR BY ONE MAN?

And remember, I am of your own bone and flesh.'" His uncles put this question to the townspeople of Shechem, and they were all won over to Abimelech's cause. They gave him seventy shekels from the temple of Baal-B'rit.

With this money Abimelech hired some rogues, and they followed him to his father's house in Ophrah. There he killed his seventy brothers, all on one stone. But Yotam, the youngest son of Yeruv-Baal, survived and went into hiding.

Then all the townspeople of Shechem proclaimed Abimelech king. When Yotam heard this, he stood atop Mount Gerizim and proclaimed: "Listen to me, townspeople of Shechem, so that God may listen to you!" And he recounted this parable:

"Once the trees went to anoint a king over them-selves. 'Rule over us,' they said to the olive tree. But the olive tree answered, 'Have I stopped yielding my rich oil, through which God and human beings are honored, that I should go about waving over the trees?' So they said to the fig tree, 'Rule over us.' But the fig tree replied, 'Have I stopped yielding my sweet and delicious fruit, that I should go about waving

over the trees?' Then they said to the vine, 'Rule over us.' But the vine answered, 'Have I stopped yielding my wine, which gladdens the divine and human heart, that I should go about waving over the trees?' Then all the trees said to the thornbush, 'Rule over us.' And the thornbush answered, 'If you are indeed anointing me king over you, then come find shelter in my shade. But if not, may fire come forth from the thornbush and consume the cedars of Lebanon!'

"Now then, if you have acted honorably in making Abimelech king, if you have honored Yeruv-Baal and his house and repaid him for risking his life to save you from the Midianites, if you have done so by rising up against my family, killing my father's seventy sons on one stone, and setting up Abimelech, the son of his handmaid, as your king simply because he is kin to you—then may you and your king have joy in each other. But if not, may you consume each other with fire!"

Then Yotam fled to Be'er, away from his brother, Abimelech.

For three years Abimelech ruled Israel. Then enmity arose between Abimelech and the townspeople of Shechem, and they

133

OPPOSITE: *A Woman Breaks the Skull of Abimelech*, **James Jacques Joseph Tissot, 19th century. The Jewish Museum, NY/Art Resource, NY.**

began to weave plots against each other. The townspeople lay in ambush on the hills outside the city and robbed passersby. And Abimelech heard of it.

Then Gaal, son of Eved, and his companions passed through Shechem. The townspeople confided in him and made a festival to their god and cursed Abimelech. "Did not this son of Yeruv-Baal and his captain Zevul once serve Hamor, the father of Shechem?" asked Gaal. "So why should we serve him? Oh, if only I ruled this people, I would get rid of Abimelech!"

When Zevul, the overseer of the city, heard this, he was incensed and sent messengers to Abimelech. "Bring men with you at night," he advised, "and hide in the fields around Shechem. Attack the city at dawn."

Abimelech positioned his army in four hiding places. The next day, when Gaal came out to the city gate, Abimelech advanced on the city. "See, an army is marching down from the hills!" Gaal said to Zevul.

"It is only the shadows of the hills that seem like men to you," Zevul replied. Then Gaal saw two more forces advancing. "Where is your boast now?" Zevul said to him. "Go out now and fight the army you mocked!"

So Gaal led an army of townspeople against Abimelech, but he had to flee before Abimelech, and many were slain. Then Abimelech retreated, and Zevul expelled Gaal and his companions from Shechem. The next day Abimelech and his forces again lay in ambush outside Shechem, and when the people went out into the fields, he struck them down. All day he fought against the city until he captured it and massacred all the people in it. Then he razed the town and sowed it with salt. He also set fire to the Tower of Shechem, where about a thousand men and women had taken refuge from his troops. And every one of them perished.

He then marched against Tevetz and occupied it. All the townspeople shut themselves inside the fortified tower within the town and gathered together on the roof. When Abimelech approached the door of the tower to burn it, a woman dropped a millstone upon his head and cracked his skull. "Kill me with your dagger," Abimelech ordered his servant, "so they will not say of me, 'A woman killed him!'" So the servant stabbed him, and he died. When his men saw that Abimelech was dead, they returned home.

So God repaid Abimelech for the murder of his seventy brothers, and also repaid the men of Shechem for their wickedness. And so the curse of Yotam came to pass.

Jephthah's Daughter

The Israelites again did what was offensive to God, turning away toward the gods and goddesses worshipped by the peoples of the land. So God delivered them into the hands of the Ammonites, who oppressed them for eighteen years. Then Israel repented and turned back to God. And God could not bear their suffering.

JEPHTHAH WAS ONE OF THE SONS OF GILEAD AND A BOLD WARRIOR—BUT HIS MOTHER WAS A PROSTITUTE. WHEN GILEAD'S OTHER SONS GREW UP, THEY DROVE THEIR BROTHER OUT, FOR THEY SAID, "YOU SHALL not inherit a share of our father's property, because your mother is not one of us." So Jephthah fled from his brothers and settled in the land of Tov. There he gathered wicked men, who went out marauding with him. When the Ammonites went to war against Israel, the elders of Gilead sent for Jephthah in the land of Tov. "Come be our commander," they said to him, "so that we can fight the Ammonites."

"Did you not despise me and drive me from my father's house?" Jephthah asked them. "How dare you come to me now that you are in trouble!"

"We have now returned to you," the elders said. "Come

with us and fight the Ammonites—and we will make you chief of all Gilead!"

"If I return to fight the Ammonites, and God delivers them to me," Jephthah said to the elders of Gilead, "then I will be your chief."

"As God is our witness," they said, "we will keep our word!"

So Jephthah went with the elders of Gilead, and the people made him their chief and commander. Then Jephthah sent messengers to the king of the Ammonites. "What is there between us that you come to wage war in my land?"

"When the Israelites came up out of Egypt," the king of the Ammonites said to Jephthah's messengers, "they took my land—from the Arnon to the Jabbok Rivers, all the way to the Jordan! Now return it in peace."

Jephthah again sent messengers to the king of

***Jephthah's Homecoming*, Jacob Holgers, 1630. Germanisches Nationalmuseum, Nüremberg.**

135

the Ammonites. "So says Jephthah: Israel did not take the lands of Moab or Ammon. For when the Israelites came up out of Egypt, they went by way of the Sea of Reeds and came to Kadesh. Israel sent messengers to the king of Edom, asking safe passage through his land, but he would not hear of it, neither would the king of Moab. So the Israelites went through the desert, skirting the land of Edom, and staying to the east of Moab until they camped at the Arnon River, which marks the border of Moab. Then Israel sent messengers to Sihon, king of the Amorites, king of Heshbon, asking passage through his land. But Sihon did not trust that Israel would respect his borders, so he gathered his people to fight against Israel. Then the God of Israel delivered Sihon and his people into the hand of the Israelites, and they took possession of the land of the Amorites, from the Arnon to the Jabbok Rivers, from the desert to the Jordan.

"So the God of Israel dispossessed the Amorites in favor of Israel. Who are you to possess their land? Has not your god Chemosh ordained what you are to possess? So has our God, YHVH, ordained what we are to possess. Are you better than Balak, son of Zippor, king of Moab? Did he start a squabble or wage a war with them?

"Besides, Israel has lived in these lands for three hundred years.

Why have you not tried to reclaim them all this time? I have not wronged you; rather, you are wronging me in waging war against me! Today the God of Justice will judge between the Israelites and the Ammonites!"

But the king of the Ammonites did not listen to Jephthah's message.

Then the spirit of God fell upon Jephthah, and he marched through Gilead toward the Ammonites. Jephthah swore a vow to God: "If you deliver the Ammonites into my hand, then whatever comes through the door of my house to greet me when I return safely from the Ammonites, that shall be God's, and I will offer it as a burnt offering."

Jephthah attacked the Ammonites, and God delivered them into his hand. He utterly crushed them, and they submitted to the Israelites.

When Jephthah returned home, his daughter came out to greet him with tambourine and dance. She was his only child—he had no other sons or daughters. When he saw her, he tore his clothes and cried, "Alas, my daughter! You have been my downfall! I have made a vow to God, and I cannot turn back on it!"

"My father, if you have sworn a vow," she said, "then do to me as you have sworn. For God has avenged you against your enemies, the Ammonites. But let this be done for me: Leave me alone for two months, so that I can go with my companions to the hills and there grieve for my girlhood."

He said to her, "Go."

He sent her away for two months, and she went off with her companions and grieved for her girlhood in the hills. And at the end of two months, she returned to her father, and he did to her as he had sworn to do. And she had never known a man.

So it became the custom in Israel for the daughters of Israel to go for four days each year to keen for the daughter of Jephthah of Gilead.

OPPOSITE: *Jephthah's Daughter Laments with Her Companions in the Mountains* (detail), France (Ms. 638, fol. 13v), ca. 1250. The Pierpont Morgan Library, NY/Art Resource, NY.

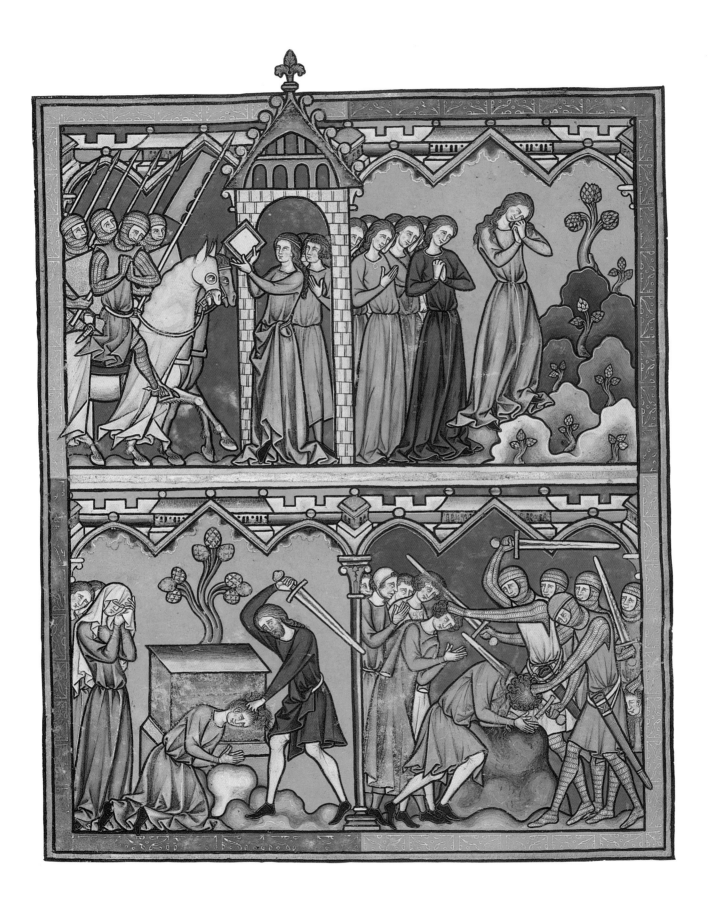

Samson

וַיֹּאמֶר שִׁמְשׁוֹן תָּמוֹת נַפְשִׁי עִם פְּלִשְׁתִּים

The Israelites again did what was evil in God's eyes, and God delivered them into the hands of the Philistines for forty years.

THERE ONCE WAS A MAN FROM THE TRIBE OF DAN WHOSE NAME WAS MANOAH. HIS WIFE WAS BARREN, AND THE COUPLE HAD NO CHILDREN. ONE DAY AN ANGEL APPEARED TO THE WOMAN AND said to her, "Though you are barren, you shall conceive and bear a son. Be careful not to drink wine or other strong drink, or eat anything impure. For your son is to be a Nazirite to God from the womb; no razor shall touch his head. He shall deliver Israel from the Philistines."

The woman went and told her husband, "A man of God came to me. He looked like an angel of God, awe-inspiring! I did not ask him where he came from, nor did he tell me his name. He told me I am to bear a son, who will be a Nazirite to God from the womb until the day of his death. That is why I am not to drink wine or other strong drink, or eat anything impure."

Manoah prayed to God, "Oh, my God! Please send the man of God to us again, and let him teach us how to act with the child who will be born to us."

God listened to his prayer and sent the angel to the woman again while she sat in the field. Her husband was not with her, so she ran to tell him. Manoah followed his wife and came to the man of God.

"May your words come true!" Manoah said to him. "What rules should we observe for the boy?"

The angel replied, "The boy's mother must abstain from all those things I warned her about."

"Let us prepare a kid for you," Manoah said (for he did not know that the man was an angel).

"I will not eat your food," the angel replied. "And if you will offer a sacrifice, offer it to God."

"What is your name?" Manoah asked. "For we would like to honor you when your words come true."

"You must not ask me my name," cried the angel, "for it is unknowable!"

When Manoah offered the kid and a cereal offering upon the altar as a burnt sacrifice to God, a wondrous thing happened: As Manoah and his wife looked on, the angel of God ascended in flames toward heaven, never to reappear. And Manoah and his wife flung themselves on the ground.

"We shall surely die," Manoah said to his wife, "for we have seen a divine being."

"Had God meant to take our lives," his wife replied, "God would not have accepted our sacrifice, nor let us see these things, nor announced such news to us."

The woman gave birth to a son, whom she named Samson. The boy grew up, and God blessed him.

ONE DAY SAMSON WENT DOWN to Timnah. On the way, he was attacked by a full-grown lion. Possessed by the spirit of God, he tore the lion apart with his bare hands. In Timnah, he took a fancy to a certain Philistine woman. When he returned home, he did not tell them about killing the lion, but he told his father and mother, "A Philistine woman has caught my eye. Please get her for me as a wife."

"Is there no one for you among the daughters of your own people?" his parents asked. "Must you take a wife from the uncircumcised Philistines?"

"Give me that one," Samson said. "She is the one who pleases me."

139

OPPOSITE: **Samson and the Lion from the *Verdun Altar*, Nicholas of Verdun, 1181. Sammlungen des Stiftes, Klosterneuburg Abbey, Austria/Erich Lessing/Art Resource, NY.**

What his parents did not realize was that God was behind this thing, for God was seeking to provoke the Philistines, who ruled Israel at this time.

The following year, when he returned to Timnah to marry the woman, Samson turned aside to see the lion's carcass and found a swarm of bees and honey inside the beast's remains. He scooped up some of the honey and ate it on the way. When he rejoined his parents, he gave them some of the honey to eat, but he did not tell them where he had gotten it.

Samson and his father came to the woman in Timnah, and Samson made a feast there, as young men used to do. Thirty men of Timnah kept him company. "Let me propose a riddle for you," Samson said to them. "If you can tell me the answer during the seven days of this feast, I will give you thirty linen robes. But if you are stumped, then you must give me thirty linen robes."

"Ask your riddle and we will listen," they replied.

"Out of the eater came food to eat; out of the strong came the sweet."

For three days they were stumped. On the fourth day, they said to Samson's wife, "Coax the answer out of your husband, or else we will set you and your father's house on fire. Did you invite us here to ruin us?"

So Samson's wife plied him with tears. "You don't really love me!" she said. "You asked my countrymen a riddle, but you won't tell me the answer."

"I have not even told my own father and mother," Samson protested. "Should I then tell you?"

For the next three days, she nagged him and shed many tears, until at last he told her the answer. And she told it to her countrymen.

On the seventh day, just before sunset, the townspeople asked Samson: "What is sweeter than honey and stronger than a lion?"

"Had you not plowed with my cow," responded Samson, "you would not have unriddled my riddle!"

Then, possessed by the spirit of God, he went down to Ashkelon and killed thirty men there. Stripping them of their clothing, he gave their robes to the men who had answered his riddle. Then he returned home, enraged by what had happened. And Samson's wife married one of his wedding guests.

SOME TIME LATER, DURING the wheat harvest, Samson came to visit his wife, bringing a kid as a gift. "Let me go into my wife's room," he said to her father. But her father would not let him go in.

"I was certain," he told Samson, "that you had come to hate her, so I gave her to one of the wedding guests. But her younger sister is even more beautiful—marry her instead."

Samson retorted, "Now the Philistines have no right to blame me for the harm I will do to them."

Then Samson went and caught three hundred foxes. He tied their tails together, two by two, and attached a torch to each pair of tails. He then set the foxes loose among the fields of the Philistines, setting fire to the harvested and standing grain, to vineyards and olive trees.

"Who did this?" cried the Philistines.

"It was Samson," they were told, "whose father-in-law gave his wife to one of his wedding guests."

Then the Philistines burned the woman and her father's household.

"If that is how you act," said Samson when he heard what they had done, "I will not rest until I have my revenge."

So he trounced them thoroughly, and then took refuge in a cave.

The Philistines then marched against Judah.

"Why have you gathered against us?" the men of Judah asked them.

"We have come to take Samson prisoner," they replied, "to requite the wrong he did to us."

Then three thousand men of Judah came to Samson in his cave. "You know that the Philistines rule over us," they said to him. "Why did you do this to us?"

"I did to them only what they had done to me," Samson replied.

"We have come to take you prisoner and hand you over to the Philistines."

"Then promise me," said Samson, "that you will not attack me yourselves."

"We promise," they replied, "that we will only hand you over to them, but will not kill you ourselves." So they bound him with two new ropes and took him to the Philistine camp.

When they reached the camp, the Philistines began to shout as soon as they saw Samson. Possessed by the spirit of God, he freed himself from the ropes, for they became like burning flax and melted off his hands. Coming upon the fresh jawbone of an ass, he seized it and with it killed a thousand men. Then, parched with thirst, he called out to God for water. God split open a nearby stone from which water gushed out, and he drank and regained his strength. To this day, this place bears the name "Jawbone Heights" and "Spring of the Caller."

SAMSON THEN FELL IN LOVE WITH a woman named Delilah. The lords of the Philistines came to her and said, "If you will find out what makes him so strong, and how we can overpower him, and bind him so that he is helpless, we will each pay you eleven hundred shekels of silver."

So Delilah asked Samson, "Tell me, what makes you so strong? How could you be tied up and made helpless?"

"If I were to be tied up with seven fresh tendons that have not been dried for bowstrings," Samson told her, "I would become as weak as any ordinary man."

So the Philistine lords brought her seven fresh tendons, and she bound him up while the Philistines lay in ambush in the next room. She called out, "Samson, the Philistines are upon you!" But Samson tore the tendons apart like straw scorched by fire. So the secret of his strength remained unknown.

"You lied to me, Samson!" Delilah reproached him. "Tell me how you can be bound."

"If I were to be tied up with new ropes that have never been used," he told her, "I would become as weak as any ordinary man."

So Delilah bound him with new ropes while the Philistines lay in ambush in the next room. She cried, "Samson, the Philistines are upon you!" But he tore off the ropes like thread.

"You have been deceiving me all along!" lamented Delilah. "Tell me how you can be bound."

"If you weave seven locks of my hair into a web, and pin it with a peg to the wall, then I will become as weak as any ordinary man."

She did so, but when she cried, "Samson, the Philistines are upon you!" he woke up and pulled out the peg and the web.

"How can you say you love me," she protested, "when you will not confide in me? You have now deceived me three times. Tell me what makes you so strong."

Finally, wearied to death by her nagging, he told her everything. "No razor has ever touched my head, for I have been a Nazirite

to God since I was conceived. If my hair were cut, my strength would depart from me, and I would become as weak as any ordinary man."

Certain that this time he had told her the truth, she sent a message to the lords of the Philistines: "Come up once more, for this time he has told me everything." So they came to her, bringing the money with them. After she had lulled Samson to sleep on her lap, she called a man to cut off the seven locks of his hair. So she weakened him, and his strength fell away. And this time when she cried, "Samson, the Philistines are upon you!" he awoke and tried to free himself, but he did not realize that God had now left him.

The Philistines seized him and gouged out his eyes. They took him down to Gaza, his feet bound in bronze shackles, and made him a mill slave in the prison. But his hair soon began to grow back.

Then the lords of the Philistines gathered to celebrate and offer a great sacrifice to their god Dagon. And when the people saw Samson, they sang:

Our god has delivered Samson—
The enemy who devastated our land
And killed so many of us—
Into our hands.

"Let Samson dance before us!" the people cried. After he danced for them, they put him between the pillars of the temple. "Let go of me and let me lean upon the pillars that the temple rests upon," Samson said to the boy who was leading him by the hand. Now the temple was filled with three thousand men and women on the roof, including all the lords of the Philistines. Then Samson cried out to God, "O God, please remember me and give me strength just this once! O God, let me take revenge on the Philistines, if only for one of my two eyes!"

With his two arms, Samson then grasped the two middle pillars that the temple rested upon and pulled them with all his might, crying, "Let me die with the Philistines!" The temple came crashing down on all the lords and the people in it. Those whom Samson killed as he died outnumbered those whom he had killed when he lived.

His brothers and all his father's household came and carried him up and buried him in his father's tomb. Samson had ruled Israel for twenty years.

Samson and Delilah, Caravaggio (follower of),
ca. 1600. Hospital de Tavera, Toledo/Bridgeman
Art Library, London/New York.

Ruth and Naomi

THERE ONCE WAS A FAMINE IN THE LAND OF JUDAH. AND ELIMELEKH, A MAN FROM BETHLEHEM, WENT WITH HIS WIFE, NAOMI, AND THEIR TWO SONS, MAHLON AND CHILION, TO LIVE IN THE LAND OF MOAB. AFTER ELIMELEKH DIED, MAHLON AND CHILION MARRIED TWO MOABITE WOMEN, RUTH AND ORPAH. BUT AFTER TEN YEARS,

Mahlon and Chilion also died, and Naomi was left without either husband or sons.

Then Naomi learned that the famine was over in Judah. So she set off with her two daughters-in-law to return home.

On the way back to Judah, Naomi said to Ruth and Orpah, "Go back home! May God be kind to you, as you have been to me and my family. And may God help you find new husbands!" Then she kissed them both good-bye.

"No," they said to her, weeping, "we want to go back to your people with you."

"Turn back, my daughters!" Naomi said to them. "Why should you go with me? Do I have more sons for you to marry? I am too old to marry again and provide new husbands for you!"

The two women wept again. Then Orpah kissed Naomi good-bye and headed back to Moab. But Ruth held on to her mother-in-law and refused to go back.

"See, your sister-in-law has returned to her people and her gods," Naomi said to Ruth. "Go with her."

"Do not tell me not to go with you," Ruth replied. "For wherever you go, I will go.

Wherever you stay, I will stay. Your people will be my people, and your God, my God. Wherever you die, there will I die, and there I will be buried. Only death will separate me from you."

When Naomi saw that Ruth's mind was made up, she stopped arguing with her, and the two of them traveled on to Bethlehem. When they arrived there, the whole city buzzed with excitement.

"Can this be Naomi?" the women asked each other.

"Don't call me Naomi, which means 'pleasantness,'" Naomi told them. "Instead call me Mara, which means 'bitterness,' for God has made my life very bitter. I went away full and came back empty."

When Ruth and Naomi arrived from Moab, it was the time of the barley harvest. In Bethlehem, where they made their home, Naomi had a relative on her husband's side, Boaz, who was a very wealthy man.

Not long after their return, Ruth asked her mother-in-law if she could glean for barley in the fields, picking up ears of grain when they fell from the reapers' hands, and Naomi agreed. By chance, Ruth went to glean in a field owned by Boaz, the kinsman from Elimelekh's family.

While she was working in his field, Boaz arrived from Bethlehem.

"God be with you!" he greeted the reapers.

"May God be with you!" they answered him.

Then Boaz saw Ruth. "Whose girl is that?" he asked the servant in charge of the reapers.

"That is the Moabite girl who came back with Naomi from the land of Moab. She asked to glean behind the reapers. She has been on her feet since morning, only stopping to rest a little in the hut."

Boaz went up to Ruth and said to her, "Listen to me.

145

Don't go to glean in another field, but stay here close to my women. Keep your eyes on the field they are reaping and follow them. I have ordered my men not to harm you. When you are thirsty, go drink some of the water the men have drawn."

Ruth bowed low to the ground. "Why are you so kind to me? I am a foreigner!"

"I've heard how kind you were to your mother-in-law, Naomi, after her husband died," Boaz replied, "how you left your father and mother and the land where you were born to come to a land and a people you did not know. May you receive the reward you deserve from the God of Israel, under whose wings you have come to shelter!"

"You are most kind, my lord," said Ruth, "to comfort me and say such gentle words to me, though I am not even your servant."

When it was mealtime, Boaz said to Ruth, "Come and have something to eat." So she sat down among the reapers and ate roasted grain that Boaz gave her until she was full. When she went back to glean, Boaz ordered his workers to leave extra stalks of barley behind for her and not to scold her as she worked.

Ruth gleaned in the field until evening. Then she beat the grain and carried the barley home to Naomi. When Naomi saw how much grain Ruth had brought home, even after eating her day's meal, she asked her daughter-in-law, "Where did you work today? Blessed be the man who paid so much attention to you!"

Ruth told Naomi that she had gleaned in Boaz's field.

"Blessed be God, whose kindness has not failed the living or the dead!" Naomi cried. "Boaz is related to us. He might marry you to carry on our family's name."

"He told me to stay in his field until the harvest was finished," Ruth said to her.

"Then do so, my daughter."

So Ruth stayed close to Boaz's maidservants until the barley and wheat harvest was finished. Then she stayed home with Naomi.

After a time, Naomi said to her, "Ruth, I must find a home for you, where you will be happy. Go tonight to the threshing floor, where Boaz will be winnowing barley. Bathe, put on sweet-smelling oil, dress yourself up, and go to him, but do not show yourself to him until he has finished eating and drinking. Then go to where he is lying, uncover his feet, and lie down next to him. He will then tell you what to do."

"I will do everything you tell me," said Ruth.

So Ruth went to the threshing floor and did just as her mother-in-law had told her. Boaz ate and drank and cheerfully lay down beside the pile of grain. Ruth crept over to him, uncovered his feet, and lay down. In the middle of the night, Boaz woke up startled—for there was a woman lying at his feet!

"Who are you?" he asked her.

"I am your servant Ruth. Spread your robe over me and ask for my hand in marriage, because that is your duty as a redeeming kinsman."

"God bless you, Ruth!" Boaz cried. "Your latest deed of loyalty is even greater than your first. Although you could have looked for a husband among younger men, rich or poor, you have not done so. Have no fear, Ruth. I will do whatever you ask. All the elders of the town know what a fine woman you are. But you should know that there is another redeeming kinsman even

more closely related to your family than I. If he wishes to marry you, good! Let him redeem the family. But if he does not, I will do so myself. Now lie down and stay here until morning."

Ruth lay down at Boaz's feet until dawn. Then she got up before it was light, because Boaz was afraid it would become known that a woman had stayed with him on the threshing floor. Boaz then told her to hold out her shawl. Into it he measured six measures of barley and put the bundle on her back.

Ruth went back to Naomi and told her everything that had happened.

"Stay here with me, daughter," said Naomi, "until you discover how things turn out. I am sure that Boaz will not rest, but will settle the matter today."

Meanwhile, Boaz went to the town gate and sat there to wait. Soon Naomi's other relative came by.

"Come over here and sit down!" Boaz called out to him.

The man sat down next to Boaz. Then Boaz called ten elders of the town and asked them to sit down too.

"Naomi has come back from Moab and must sell a piece of land belonging to her dead husband, Elimelekh," he said to the kinsman. "I wanted to tell you about this in front of the elders and give you a chance to redeem the land. If you are willing to redeem it, do so! But if not, let me know, because I am next after you as the redeemer in our family."

"I am willing to redeem it," said the man.

"When you redeem the property from Naomi," continued Boaz, "you must also marry Ruth the Moabite, the wife of Naomi's dead son, so you can carry on the family name."

"That I cannot do," the man replied, "because my inheritance would then go to Mahlon's family, not to my own. You take over my right of redemption, for I cannot do so."

It was the custom in Israel at the time for people to seal a matter between them by taking off a sandal and handing it to the other person. So the redeeming kinsman took off his sandal and handed it to Boaz.

"Today you are all witnesses," Boaz said to the elders and the rest of the people, "that I am buying from Naomi all that once belonged to Elimelekh and her two sons, Mahlon and Chilion. I am also marrying Ruth the Moabite, the widow of Mahlon, in order to carry on his name."

"We are witnesses!" all the people said. "May God make the woman coming into your house like Rachel and Leah, who built up the House of Israel! May your name become famous in Bethlehem! And may your house be like the House of Peretz, the child whom Tamar bore to Judah, your ancestor. May you and this young woman have children to carry on your name!"

So Boaz married Ruth, and they had a son.

The women then said to Naomi, "Blessed be God, who has not left you without someone to redeem your family! Your grandson will renew your life and help you in your old age, for he is born to your daughter-in-law Ruth, who loves you and is kinder to you than seven sons."

Naomi picked up the child and held him close to her. And she became like another mother to him. Her neighbors declared, "A son is born to Naomi!" They named him Oved. He was the father of Jesse, who was the father of David.

VI.
The Founding of the Kingdom of Israel

ALTHOUGH ISRAEL'S MONARCHY lasts six centuries and numbers among its ranks more than forty kings, only the first three—Saul, David, and Solomon—have been notably memorialized in Jewish tradition, primarily in legends, liturgy, rabbinic teachings, and songs. Their successors, embroiled in palace intrigues and military invasions, generally do not distinguish themselves as national heroes, as we shall see in the next section. Instead, they bring idols into the Temple and greed into the palace. Thus they fulfill the dire prophecy of Samuel, who long before warned the people against setting a king over themselves: "The day will come when you will cry out because of this king you have chosen for yourselves, but God will not answer you."

But at the beginning of the monarchy, the people are grateful to have a single ruler to govern them, and their first king, Saul, admirably meets their expectations. Tall and commanding, he leads the people in battle and raises princely sons. However, his volatile temper, his black moods, and his arrogance lose him the kingdom. It is David, the young shepherd from Bethlehem, who establishes the royal house. Their tragic rivalry lies at the heart of the first book of Samuel, and their stormy relationship, it can be argued, infuses the Book of Psalms, traditionally ascribed to David, with its particular pathos.

David's story encompasses all the elements that Shakespeare later dramatizes in his tragedies: lust, betrayal, oedipal struggle, revenge, and overweening ambition. Like Saul before him, David is a man of many passions, but unlike his predecessor, he also possesses vision, imagination, and guile. And his sons learn too well from their father's example. Their rivalry over succession to the throne and their violent deaths, the subject of the second book of Samuel, finally break David's heart.

Although David conquers Jerusalem and makes it Israel's capital, thus centralizing political and religious authority, his son Solomon is the one to reap the fruits of his father's campaigns. David, the man of war, is forbidden to erect a Temple in the city that still bears his name, and this honor falls to Solomon, whose very name means peace. (How ironic that this man of peace is born of a union accomplished by adultery, betrayal, and murder.) Solomon's is the grandest kingdom the Jewish people have ever known; under his reign Israel's borders extend from the Mediterranean to the Euphrates, from Lebanon to the southern desert. His fame travels to the far corners of the earth. Rulers from all the surrounding kingdoms dine at his table and bring him tribute. But his crowning achievement is the building of the Temple, God's house on earth, one of the wonders of the ancient world.

OPPOSITE: *Samuel Anoints David*. **Fresco from the synagogue at Dura Europos, Syria, ca. 245 C.E. The Jewish Museum, NY/Art Resource, NY.** OVERLEAF: *Ceremonial Objects* **from the** *Duke of Sussex Spanish Bible*, **ca. 1300. (Add. Ms. 15250, fols. 3v, 4r), © The British Library, London.**

Samuel Appoints Saul King

Samuel grew up in Eli's house and became a judge in Israel. During his lifetime, the hand of God was set against the Philistines, and Israel recovered all the land that had been taken by its enemies. Samuel turned the people back to God, and peace reigned in the land.

HEN SAMUEL WAS OLD, HE APPOINTED HIS SONS YOEL AND ABIYAH JUDGES IN BEERSHEBA. BUT THEY DID NOT FOLLOW THEIR FATHER'S WAYS; THEY BECAME CORRUPT AND SUBVERTED JUSTICE.

THE ELDERS OF ISRAEL CAME TO SAMUEL at Ramah and said to him, "You are old, and your sons do not follow in your ways. Appoint a king over us, to rule us like all other nations."

Their words displeased Samuel, and he prayed to God. "Give the people what they demand," God told him. "For it is not you, but Me they have rejected as their king. They now forsake Me, as they have done since I brought them out of Egypt. Listen to their demands, but warn them what such a king will do to them when he rules over them."

So Samuel told the people what God had said, warning them, "A king will take your sons for his army, making them his charioteers, horsemen, and runners. He will make them plow his fields, reap his harvest, and make weapons for his wars. He will take your daughters as perfumers, cooks, and bakers.

OPPOSITE: *David Playing the Harp Before Saul*, **Rembrandt Harmensz van Rijn, 1657. Mauritshuis, The Hague/Erich Lessing/Art Resource, NY.**

He will give away your fields, vineyards, and olive groves to his courtiers and take a tenth of your produce for his eunuchs and attendants. He will press into his own service your slaves and livestock. And the day will come when you will cry out because of this king you have chosen for yourselves, but God will not answer you."

But the people would not listen to Samuel. "Give us a king so that we might be a nation like all other nations," they demanded. "Let our king rule over us and lead us into battle."

"Do as they wish," God told Samuel. So Samuel sent the people home.

In the tribe of Benjamin, there was a man named Kish, whose son Saul was the handsomest man among the Israelites, standing a head taller than any of the other people. One day Kish's asses wandered off, and he sent his son Saul and a servant to look for them. They traveled through the whole territory of Benjamin, but could not find them.

"Let us turn back," Saul told his servant, "or my father will stop worrying about the asses and begin to worry about us."

"There is a man of God nearby, a seer," replied the servant, "whose words always come true. Perhaps he can tell us about our errand."

155

"What present can we bring this man of God?" asked Saul. "For our bags are empty."

"I have a quarter shekel of silver," replied the servant. So they went to the town where the man of God lived. At the town gate, they met Samuel as he was coming to bless a sacrifice at the shrine.

The day before, God had revealed to Samuel: "At this time tomorrow I will send to you a man of Benjamin, and you shall anoint him ruler of Israel. He will deliver My people from the hands of the Philistines, for I have heard their cries."

As soon as Samuel saw Saul, God told him, "This is the man!"

Saul came toward Samuel and asked, "Where is the house of the seer?"

"I am the seer," replied Samuel. "Go to the shrine, for you will eat with me today. Tomorrow morning I will tell you what is on your mind. As for the asses that wandered off three days ago, you no longer need to worry about them, because they have been found. As for you, all Israel has been waiting for you and your father's house!"

"But my tribe is the smallest among Israel's tribes," protested Saul, "and my clan is the smallest within the tribe of Benjamin! Why do you say these things to me?"

Samuel took Saul and his servant to the hall and placed them at the head of the thirty guests gathered there to eat. The next morning Samuel called Saul up to the roof and said to him, "Get up, and I will send you on your way."

As the two of them were walking toward the edge of town, Samuel said to Saul, "Send your servant on ahead while we stop here to talk. For I will now make known to you the word of God."

Samuel took a flask of oil and poured some on Saul's head and kissed him, saying, "God anoints you ruler over Israel. When you leave me today, you will meet two men near Rachel's tomb in the territory of Benjamin. They will tell you that your father's asses have been found, and that your father is worried about you, saying, 'What shall I do about my son?' Then you will go

*Saul's Coronation; Samuel Annoints
Saul* from the *Nüremberg Bible*, 1493.
Victoria & Albert Museum,
London/Art Resource, NY.

to do when the time comes, for God is with you. After that, go down to Gilgal, and I will join you there to offer sacrifices. Wait seven days until I come to tell you what to do next."

As Saul turned to leave, God gave him another heart; and all these signs came to pass on that day. And when he came to the Hill of God and saw the band of prophets approaching, he was suddenly seized by the spirit of God and began to prophesy. Those who knew him exclaimed, "What has happened to the son of Kish? Is Saul too among the prophets?" Then Saul stopped prophesying and came to the shrine.

"Where did you go?" Saul's uncle asked him.

"To look for the asses," he replied. "And when we could not find them, we went to Samuel."

"What did Samuel say to you?" asked his uncle.

"Only that the asses had been found," Saul told him. But he did not reveal to his uncle what Samuel had said about the kingship.

Then Samuel gathered the people and drew lots to see who would be king. And the lot fell upon Saul, the son of Kish. And the people proclaimed, "Long live the king!" Samuel then taught the people all the rules of monarchy and recorded them in a book.

157

to the oak tree at Tabor and meet there three men making a pilgrimage to Bethel. One will be carrying three kids, another three loaves of bread, and the third a jar of wine. They will greet you and offer you two loaves of bread. You will then go to the Hill of God, where the Philistine magistrates preside, and meet there a band of prophets coming down from the shrine, accompanied by lyres, timbrels, flutes, and harps, and prophesying. The spirit of God will overcome you, so that you become one of them, prophesying alongside them. Once these signs have come to pass, you will know what

ויסב שמואל ללכת ויחזק
בכנף מעילו ויקרע

Saul Loses His Kingdom

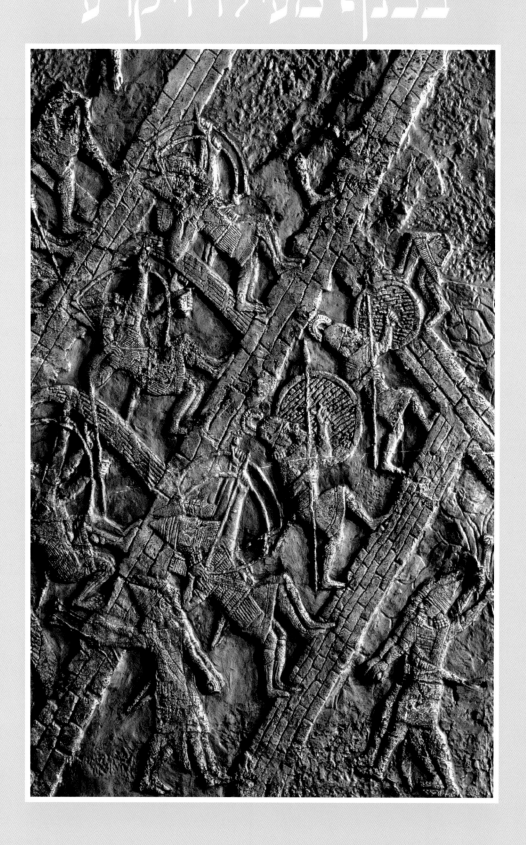

After Saul was anointed king, the Ammonites waged war against Israel. Saul defeated the Ammonites and was crowned king by the people at Gilgal. During the years that he was king, Saul was always at war against Israel's enemies, especially the Philistines. And every able-bodied Israelite was pressed into the king's service.

H EAR THE WORD OF GOD," SAMUEL SAID TO SAUL. "I RECALL WHAT AMALEK DID TO ISRAEL ON THE WAY UP FROM EGYPT, HOW THEY ATTACKED THE PEOPLE ON THE ROAD. NOW GO ATTACK AMALEK and spare no one. You must kill every man, woman, and child, as well as oxen and sheep, camels and asses."

So Saul gathered his troops and attacked the Amalekites, putting all living things to the sword. But Saul spared King Agag and the best of the herd animals and spoils.

Then God said to Samuel, "I regret that I made Saul king, for he has turned away from Me and not obeyed My commands."

Distressed by God's words, Samuel prayed all night, and early the next morning went to meet Saul in Gilgal.

"Blessed are you of God!" Saul said when he saw Samuel. "I have done what God commanded."

"Then what is this bleating and mooing that I hear?" asked Samuel.

"The best of the sheep and oxen we spared to sacrifice to God," replied Saul. "All the rest we put to death."

"Listen! You are not a mere individual, but the head of all the tribes of Israel," said Samuel. "God anointed you king and sent you on a mission to exterminate the sinful Amalekites. Why did you disobey God's will?"

"But I did obey God!" protested Saul. "I

captured King Agag and brought sheep and oxen to sacrifice to God. The rest I destroyed."

"Does God prefer sacrifices or obedience?" replied Samuel. "Because you rejected God's command, God has rejected you as king."

"I was wrong to disobey God's command and your instructions," Saul said. "But I was afraid of my troops, so I did what they wanted. Please forgive me and return with me, and I will bow before God."

"I will not go back with you," Samuel answered, "for you have rejected God's command, and God has rejected you as king."

As Samuel turned to go, Saul seized the corner of his robe, and it tore. Samuel said to Saul, "So has God today torn the kingship from you, and has given it to another more worthy than you."

"Indeed, I have sinned!" cried Saul. "Please honor me before the elders of my people and come back with me, and I will bow before God."

So Samuel went back with Saul and bowed low before God.

"Bring me King Agag of Amalek!" ordered Samuel. When Agag stumbled toward him, Samuel said, "Just as your sword has bereaved other women, so now your own mother shall be bereft." And he struck down Agag before God at Gilgal.

As long as he lived, Samuel never saw Saul again. But he mourned over Saul, because God had come to regret making him king of Israel.

OPPOSITE: *The Siege of Lachish* (detail). Relief from Sennacherib's palace, Ninevah, 7th century B.C.E. Z. Radovan, Jerusalem.

159

1 *Samuel* 17

David and Goliath

After Saul had been rejected as king, God sent Samuel to Bethlehem to anoint David—the handsome red-haired son of Jesse, the youngest of eight sons—as king. Then the spirit of God departed from Saul, and he became possessed by an evil spirit that would periodically terrify him. The king was told of a handsome and brave young shepherd who was skilled at playing the lyre, so David entered Saul's service to play music to soothe the troubled king.

THE PHILISTINES WAGED WAR ON ISRAEL, AND THE TWO ARMIES LINED UP AGAINST EACH OTHER ON FACING HILLS, WITH A RAVINE BETWEEN THEM. THEN A CHAMPION OF THE PHILISTINES STEPPED FORWARD: HE WAS GOLIATH OF GATH, WHO STOOD OVER NINE FEET TALL. HE WORE HEAVY BRONZE ARMOR—HELMET, scale armor, breastplate, and greaves—and had an iron-tipped bronze javelin slung over his shoulder.

"Why should you all fight in battle?" Goliath called out to the Israelites. "Send out your champion to fight against me. If he kills me, we shall be your slaves. But if I kill him, you shall be our slaves and serve us. I defy you, Israelites! Choose a man and let us fight!"

When Saul and his army heard the Philistine's words, they were seized with fear. And so it went for the next forty days: Each morning and evening, Goliath called out his challenge to the Israelites.

Now David's three oldest brothers were fighting in Saul's army. David went back and forth between attending Saul and shepherding his father's flock in

OPPOSITE: *David Showing Goliath's Head*, Caravaggio, 1605. Kunsthistorisches Museum, Vienna/Erich Lessing/Art Resource, NY.

Bethlehem. Now Jesse said to his youngest son, "Take this parched corn and these loaves of bread to your brothers in Saul's camp. Also take these cheeses to their captain. See how your brothers are doing and bring me back word."

Leaving the flock in another shepherd's charge, David set out early the next morning and reached the Israelite camp just as the two armies were lining up against each other. While David was talking with his brothers, Goliath stepped forward and shouted out his challenge. Hearing him, the Israelite soldiers fled in terror.

"What will be done for the man who kills that Philistine?" asked David. "Who is that uncircumcised Philistine who dares to defy the army of the living God?"

"The king will reward such a man with great riches and the hand of his daughter in marriage," the soldiers answered, "and his family will be released from the king's taxes."

David's oldest brother, Eliav, overheard this conversation and rebuked David. "Why did you come here? Who is guarding the flock? You came only to watch the fighting!"

"What have I done now?" protested David. "I was only asking!" And he continued to ask questions of the troops. When word of this was brought to Saul, he sent for David.

"I will go and fight that Philistine!" David declared.

"You cannot fight him!" said Saul. "You are only a boy, and he has been a warrior from his youth."

"When I was tending my father's flock, and a lion or bear carried off a sheep," David told him, "I fought it and rescued the animal from its jaws. If it attacked me, I seized it and killed it. I have killed both lion and bear; this uncircumcised Philistine will meet the same fate. The God who has saved me from lion and bear will also save me from that Philistine."

"Then go," said Saul, "and may God be with you!"

Saul outfitted David in his own battle gear—his bronze helmet, breastplate, and sword. But David was unable to walk in the heavy armor, so he took it off. Then he took his staff, picked up a few smooth stones, put them in his shepherd's pouch, and with sling in hand, approached the Philistine.

When Goliath saw David, he scoffed, for David was only a boy. "Am I a dog that you come against me with sticks?" he cried. "Come here and I will give your flesh to the birds of the sky and the beasts of the field!"

"You come against me with sword and spear and javelin," answered David. "But I come against you in the name of the God of Israel, whom you have defied. Today God will deliver you into my hands. I will kill you and cut off your head, and I will give the Philistines' carcasses to the birds of the sky and the beasts of the land. Then the whole land will know that there is a God in Israel. All of you shall know that God can give victory without sword or spear, for the battle and the victory belong to God."

As Goliath drew near, David ran forward, withdrew a stone from his pouch, and slung it. It struck the Philistine in the forehead, and he fell face down on the ground. David had no sword, so he grasped Goliath's sword and cut off his head.

When the Philistines saw that their champion was dead, they fled. The men of Israel and Judah shouted a war cry and pursued them all the way to the gates of Ekron. And many Philistines fell to the sword along the way. Then the Israelites returned and looted the enemy camp. Then David took to Saul the head of the Philistine.

162

The Struggle Between Saul and David

הכה שאול באלפיו ודוד ברבבותיו

After David killed the Philistine champion, Goliath, he won many more battles at the head of Israel's army. When the troops returned home victorious, the women came out singing and dancing with tambourines, chanting: "Saul has slain his thousands; David, his tens of thousands!" Then the evil spirit of jealousy gripped King Saul, and he tried to kill David. But he soon relented and gave him his daughter Michal in marriage. Yet again and again, Saul's favor turned to rancor, until David had to flee for his life to the wilderness, hiding in the caves, forests, and hills of Judah. But between David and Saul's son Jonathan there was such great love that the king's son helped David escape from his father's wrath.

AFTER SOME TIME, DAVID AND HIS MEN CAME TO THE WILDERNESS OF EN-GEDI AND HID THEMSELVES IN A CAVE. SAUL PURSUED THEM WITH THREE THOUSAND MEN AND CAME TO THE CAVE WHERE DAVID was hiding. Alone, Saul entered the cave to relieve himself, but he did not see that David and his men were hiding in the back of the cave.

"This is the day about which God declared: 'I will deliver your enemy into your hands,'" David's men said to him. "'Do with him as you wish.'"

In stealth, David cut off a corner of Saul's cloak, but he immediately felt remorse for having done so.

"God forbid that I should raise my hand against God's anointed!" he said to his men. And he forbade them to attack Saul.

When Saul left the cave, David followed after him and shouted, "My lord king!" And when Saul turned to face him, David bowed down to the ground. "Why do you listen to those

Saul Tries to Slay David with His Spear
**(detail)(Ms. 638, fol. 29), France, ca. 1250.
The Pierpont Morgan Library, NY/Art
Resource, NY.**

163

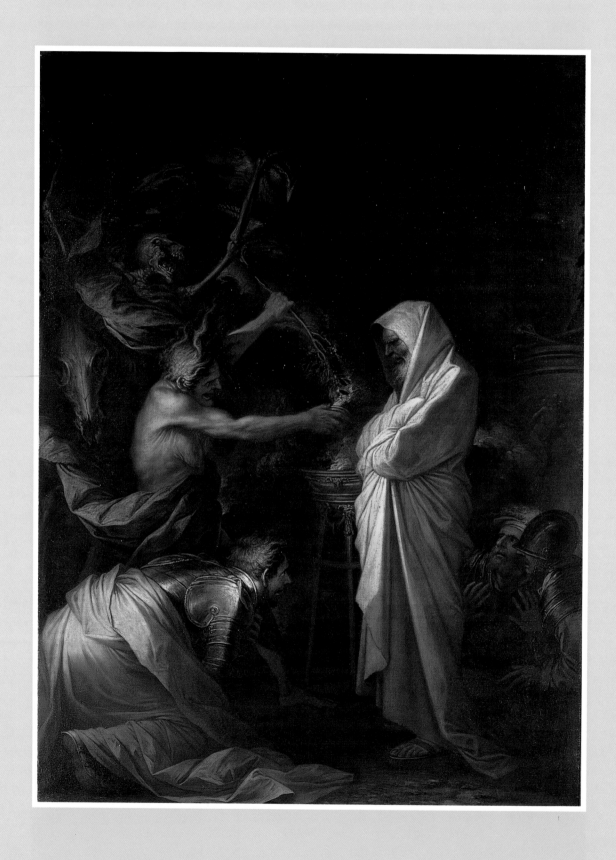

Saul Consults the Witch of Endor

Fleeing Saul's rekindled wrath, David took refuge among the Philistines with King Achish of Gath. There he remained for over a year. The Philistines now went to war against Israel, and they camped at Gilboa. Seeing their strength, Saul's heart trembled with fear, and he sought counsel from God, but God did not answer him. Samuel had died and had been buried in Ramah. And Saul had forbidden the Israelites to consult ghosts or familiar spirits.

FIND ME A WOMAN WHO CONSULTS GHOSTS," SAUL COMMANDED HIS COURTIERS, "SO I CAN INQUIRE THROUGH HER." SO HIS COURTIERS TOLD HIM ABOUT A WOMAN IN ENDOR WHO COMMUNED WITH GHOSTS.

SAUL DISGUISED HIMSELF AND SET OUT WITH two men. They came to the woman at night, and Saul said to her, "Bring up for me a ghost whom I shall name."

"Do you not know that Saul has banned divining by ghosts?" she protested. "Why are you laying a trap for me, to get me killed?"

"As God lives," said Saul, "you will not get into trouble."

"Whom shall I summon?" she asked.

"Bring up Samuel," he replied.

When the woman saw the spirit of Samuel, she cried, "Why have you tricked me? You are Saul!"

"Do not be afraid," Saul reassured her. "Tell me what you see."

"I see a divine being coming up from

OPPOSITE: *The Spirit of Samuel Appearing to Saul at the House of the Witch of Endor*, **Salvator Rosa, 1668. Louvre, Paris/Bridgeman Art Library, London/New York.**

the earth," she replied.

"What does he look like?" he asked.

"An old man wrapped in a robe," she answered.

Saul knew that it was Samuel, and he bowed down to the ground before him.

"Why have you disturbed me and brought me up?" demanded Samuel.

"I am in great trouble," Saul answered. "The Philistines are attacking me, and God has turned away from me. I have called you up to ask you what to do."

"Why do you ask me," said Samuel, "since God has become your enemy? God has done what I foretold: The kingship has been torn from your hands and given to David, because you did not obey God's command to destroy the Amalekites. God will now deliver Israel into the hands of the Philistines. Tomorrow your sons and you will be with me."

In terror Saul threw himself upon the ground. He was already weakened from fasting all day and night. Although he protested, the woman and his courtiers prevailed upon him to eat, and that very night he and his courtiers went on their way.

167

David Conquers Jerusalem

וילכד דוד את מצודת
ציון היא עיר דוד

Map of the World in Cloverleaf Form with Jerusalem at the Center,
Heinrich Bunting, 1581. The Jewish National & University Library, Laor Collection, Jerusalem.

As Samuel had foretold, Saul and Jonathan were killed in battle with the Philistines, and David bitterly mourned their death. Then David was anointed king in Hebron, and he ruled there over the House of Judah. But the Benjaminites made Saul's son Ishboshet king over the House of Saul; Abner, son of Ner, served as his general. For two years, civil war raged between the House of David and the House of Saul. Then Ishboshet and Abner both lost their lives through treachery, and David was declared king over all of Israel in Hebron. David was thirty years old when he became king, and he ruled in Hebron seven and a half years. Six sons were born to David there; Amnon was his firstborn, and his thirdborn son was named Absalom. And while he was in Hebron, his first wife, Michal, daughter of Saul, was restored to him.

THEN DAVID AND HIS MEN SET OUT TO CONQUER JERUSALEM, WHICH WAS INHABITED BY THE JEBUSITES. DAVID DEFEATED THE JEBUSITES AND CAPTURED THE STRONGHOLD OF ZION, RENAMING IT THE CITY OF DAVID. KING HIRAM OF TYRE SENT CEDAR beams, carpenters, and stonemasons to David, and they built there a palace for the king. Then David took more wives and concubines, who gave him more sons and daughters.

When the Philistines heard that David had become king over Israel, they encamped in the Valley of Rephaim. David routed them from there and drove them all the way to Gezer. Then David gathered thirty thousand men and went to bring up the Ark of God from the House of Abinadab, where it had rested for twenty years. David and all the House of Israel accompanied the Ark with song and dance, with the sounds of lyres, harps, and cymbals. Abinadab's sons, Uzzah and Ahio, guided the cart carrying the Ark, but once, when the oxen stumbled, Uzzah grasped the Ark to steady it and was struck down by God.

David was afraid, and cried, "How can I let the Ark of God come to me?" And so David detained the Ark in the house of Obed-edom the Gittite for three months. And God blessed Obed-edom and his whole household. When David heard of this, he went and brought the Ark to the City of David. Dressed in a linen loincloth, David whirled with all his strength before the Ark. And the people accompanied the Ark with shouts and blasts of the shofar.

As the Ark entered the City of David, Michal looked out the window and saw King David leaping and whirling before God. And she loathed him for it.

David set up the Ark inside the tent he had erected for it, and he offered burnt offerings and sacrifices of well-being. Then he blessed the people and gave every man and woman a portion of bread and cake. Then the people returned to their homes.

When David returned home to greet his household, Michal came to meet him and said, "What honor did the king of Israel bring upon himself today—to expose himself before his subjects' slave-girls! You exposed yourself like one of the rabble!"

"It was before God that I was dancing, who chose me over your father and his family to rule Israel!" David retorted. "I will dishonor myself before you even more by dancing before God—but I will be honored among the slave-girls!"

And to the day she died, Saul's daughter Michal bore no children.

169

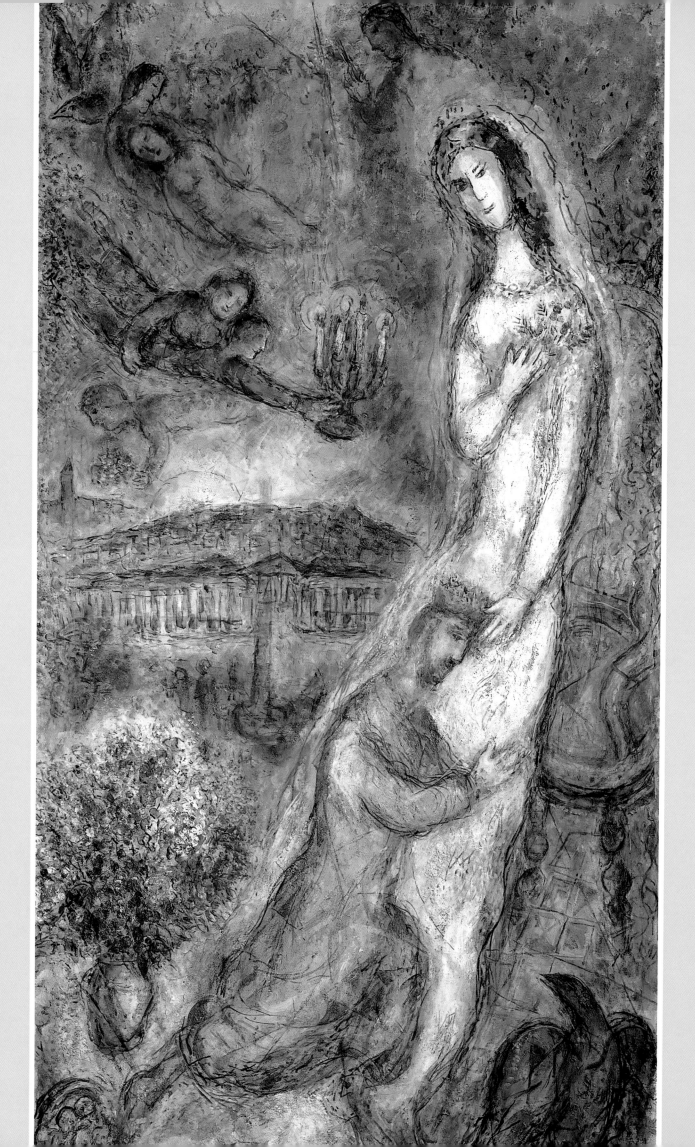

David and Bathsheba

ויאמר נתן אל דוד אתה האיש

DURING THE SEASON WHEN KINGS WENT TO WAR, DAVID SENT HIS ARMY OUT TO BESIEGE THE ENEMY WHILE HE REMAINED IN JERUSALEM. ONE AFTERNOON AS HE WAS STROLLING ON THE ROOF OF HIS ROYAL PALACE, DAVID SAW A BEAUTIFUL WOMAN BATHING. HE SENT SOMEONE TO FIND OUT ABOUT HER.

"She is Bathsheba, the daughter of Eliam and the wife of Uriah the Hittite," the messenger reported. David sent for her and she came. He lay with her, and then she went back home. She soon sent word to David, "I am pregnant." Then David sent a message to his general Joab at the front, "Send Uriah the Hittite to me." And it was done.

"How is the war going and how are the troops faring?" David asked Uriah when he came to him. Then he said to Uriah, "Go home now."

After Uriah left the palace, David sent a present to his house. But Uriah did not go to his house; he slept at the entrance to the palace, along with the other officers. When David was told of this, he said to Uriah, "You just came from a journey. Why did you not go home?"

OPPOSITE: *Bathsheba*, **Marc Chagall, 1962–63. Private Collection, Basel/Giraudon/Art Resource, NY. © 1999 Artists Rights Society (ARS), New York/ADAGP, Paris.**

"While the Ark and the people of Israel are away from home," replied Uriah, "and your majesty's army is camping in the field, how can I go home and eat and drink and sleep with my wife? By your life, I will not do so!"

"Stay here one more day," David said to Uriah, "and tomorrow I will send you off."

So Uriah stayed in Jerusalem that day. The next day, David sent for him, and he ate and drank with him until he got Uriah drunk, but that evening Uriah again went to sleep in the same place, with the officers. He did not go home.

The next morning, David wrote a letter to Joab: "Send Uriah to the front line, where the fighting is the fiercest. Then withdraw from him so that he will be killed."

So when Joab returned to the siege, he placed Uriah in the line of fire of the most skilled enemy warriors. And when the men of the town attacked Joab, several of David's officers fell, among them Uriah the Hittite.

Joab sent a full report of the battle back to David. "When you finish reporting to the king," he told the messenger, "he may become angry at you and ask, 'Why did you come so near the city when you attacked it? Did you not realize that the enemy would shoot at you from the wall? Did not a woman strike down Gideon's son, Abimelech, by dropping a millstone upon him from the wall of Tebetz?' Say then to the king, 'Your servant Uriah the Hittite was among those killed.'"

171

The messenger went to David and repeated Joab's words to him. "First the enemy came against us in the open," he said. "Then we drove them back to the city gate. But the archers shot at us from the wall, and some of your majesty's men fell, among them Uriah the Hittite."

"Give Joab this message," David said to him: "Do not be distressed about this. The sword always swallows its prey. Go back and encourage your master. Destroy the city!"

When Uriah's wife heard that her husband was dead, she mourned him. When the period of mourning was over, David sent for her. And she became his wife and bore him a son.

But God was displeased with what David had done and sent to him the prophet Nathan, who related the following parable to the king: "There once were two men in the same city, one rich and the other poor. The rich man had large flocks and herds, but the poor man had only one little lamb that he had bought. He took care of her, and she grew up alongside him and his children. She shared his bit of bread, drank from his cup, and nestled on his chest. Indeed, she was like a daughter to him.

"One day a traveler came to the rich man, but he was unwilling to take an animal from his own flock to serve to his guest. So he took the poor man's lamb and served it to the traveler instead."

When David heard this, he became enraged and said to Nathan, "As God lives, the man who did this deserves to die! He shall pay four times the lamb's worth, for he showed no pity!"

Then Nathan said to David, "You are that man! Thus says the God of Israel, 'I anointed you king and saved you from the hand of Saul. I gave you your master's house and your master's wives, and the House of Israel and Judah. And if that is not enough, I would give you double that. Why then have you spurned My command and done what displeases Me? You have taken the wife of Uriah the Hittite and had him slain by the sword of the Ammonites. Therefore, the sword shall never depart from your house! I will bring misfortune against you from within your house. I will give your wives to another man before your very eyes, and he shall sleep with them. You acted by stealth, but I will bring this to pass in broad daylight before the entire people of Israel.'"

Hearing this, David cried, "I stand guilty before God!"

"God has pardoned your sin," replied Nathan. "You shall not die. But because you have defied God, the child just born to you shall die."

Nathan went home, and God struck the newborn child so that it hovered near death. David pleaded with God on behalf of the child; he fasted and spent the night lying on the ground. His servants tried to lift up his spirits, but he rebuffed them, and he refused any food they offered him. On the seventh day, the child died.

David's servants were afraid to tell their master that the child was dead, for they said to one another, "If David refused to listen to us when the child was still alive, what terrible things might he do now that the child is dead?"

But when David saw his servants whispering to one another, he understood that his child was no longer alive, and he asked them, "Is the child dead?"

"Yes, he is dead," they told him.

Then David rose from the ground, bathed and anointed himself, and changed his clothes. He went and prostrated himself in the House of YHVH. When he returned home, he asked for food, and he ate.

"Why have you acted this way?" his servants asked him. "When the child was still alive, you fasted and wept. Now that the child is dead, you rise up and eat!"

"While the child yet lived," replied David, "I fasted and wept because I thought, 'Perhaps God will have pity on me and spare the child.' But now that he is dead, why should I fast? Can I bring him back? I shall go to him, but he shall never return to me."

David comforted his wife Bathsheba. He lay with her, and she conceived and bore a son, whom she named Solomon. God loved him and sent the prophet Nathan to bestow on him another name: *Yedidyah,* "beloved of God," for such he was.

Bathsheba and David, Nicola Pellipario of Urbino, 16th century.
Museo Correr, Venice/Bridgeman Art Library, London/New York.

The Rebellion of Absalom

בני אבשלום בני יתן
מותי אני תחתיך אבשלום בני בני

BSALOM, THE THIRD SON OF DAVID, HAD A BEAUTIFUL UNMARRIED SISTER NAMED TAMAR. DAVID'S ELDEST SON, AMNON, BECAME INFATUATED WITH HER, AND HE FELL SICK, FOR SHE WAS UNATTAINABLE TO HIM. WHEN DAVID'S NEPHEW JONADAB, A CLOSE FRIEND OF AMNON'S, LEARNED THE CAUSE OF HIS COUSIN'S

melancholy, he proposed a stratagem: "Pretend you are sick, and ask that Tamar come and prepare food for you and serve it to you."

Amnon did as his cousin had suggested. David sent Tamar to tend Amnon at his sickbed. She kneaded cakes in front of him and cooked them, but Amnon refused to eat until everyone except Tamar had withdrawn from the room. But when she came near to serve him, he seized and raped her. Then his passion for her turned to an even greater loathing, and he drove her out of the room, barring the door behind her.

Tamar was wearing the ornamental tunic that maiden princesses customarily wore, and she now tore it and put dust on her head. Wild with grief, she walked away, screaming loudly as she went.

"Was it your brother Amnon who did this to you?" Absalom asked her. "Keep quiet about it for now, because he is your brother. Do not torment yourself."

Grief-stricken, Tamar remained in her brother Absalom's house. When King David heard what had happened, he was very much distressed. Absalom

OPPOSITE: *Absalom*, **Gerald Wartofsky, 1993. B'nai B'rith Klutznick National Jewish Museum, Washington, DC. Courtesy of the artist.**

meanwhile said nothing to his brother Amnon, but he hated Amnon because he had violated his sister Tamar.

Two years later, when Absalom was shearing his flocks near Ephraim, he invited the king and all the king's sons. David refused and did not want Amnon to go, but Absalom prevailed upon him, so David sent all his sons. When Amnon was drunk with wine, Absalom ordered his attendants to kill him, and all the other princes fled in terror. When they came weeping to King David, he and all his courtiers wept bitterly as well, and David mourned Amnon for a long time. Absalom found asylum with the king of Geshur and remained there for three years.

And after King David finished grieving over Amnon, he pined away for his son Absalom.

WHEN JOAB, COMMANDER of David's army, saw that the king was brooding over Absalom, he sent a clever woman from Tekoa to speak with the king. Dressed in mourning, she flung herself down before David and cried, "Help, O King!"

"What is the matter?" asked David.

175

"I am a widow," she answered, "and have two sons. They fought with each other in the fields, and one killed the other. The whole clan has demanded the slayer's death, even though that would leave me bereft, and my husband without name or heir. Let Your Majesty restrain the blood avenger, so that my son will not be killed."

"As God lives," swore David, "not one hair of your son's head will fall to the ground."

"Please let your maidservant speak another word to my lord the king," said the woman.

"Speak on," David replied.

"Why has Your Majesty not followed the same course with his own banished one? We must all die; we are like water that is poured upon the ground and cannot be gathered up again. God will not take the life of one who welcomes back him who is banished. My lord the king is like an angel of God, understanding all, good and bad. May God be with you."

"Did Joab put you up to this?" David asked her.

"It is just as you say, my lord," she replied. "Your servant Joab told me everything to say. He wished to conceal his real purpose, but my lord is as wise as an angel of God, knowing all that goes on in the land."

Then the king said to Joab, "Go and bring back my boy Absalom."

So Joab brought Absalom back to Jerusalem. But the king told Joab, "Let him go directly to his house and not present himself to me." And Absalom lived in Jerusalem two years without appearing before the king.

Absalom then sent for Joab to bring him before the king, but Joab refused to come. And he would not come when Absalom sent for him a second time. Then Absalom set

Joab's barley field on fire, and Joab came to him at once.

"Why did your servants set fire to my field?" he demanded.

"I sent for you but you would not come. It would have been better had I remained in Geshur! Take me to the king, and if I am found guilty of anything, let him put me to death!"

Joab reported all this to the king, and David summoned Absalom to him. He came and flung himself to the ground before the king, and David kissed him.

NO ONE ELSE IN ISRAEL WAS AS ADMIRED FOR his beauty as Absalom. He was without blemish, and his hair was so luxuriant that it had to be cut every year, weighing two hundred shekels by royal weight.

Each day Absalom would rise early, stand by the city gates, and speak to every Israelite who came to the king for judgment. After asking the man his name and grievance, he would say to him, "Your claim is right and just, but the king has assigned no one to hear your case. If only I were appointed judge, I would see that every man got his due." And Absalom extended his hand and kissed all whom he met, so he won away the hearts of Israel.

After several years had gone by, Absalom appeared before the king and said, "When I lived in Geshur, I made a vow that if I returned safely to Jerusalem, I would worship God in Hebron."

"Go in peace," the king said, and Absalom set out for Hebron with two hundred men.

But Absalom sent agents to all the tribes of Israel to announce, "When you hear the blast of the shofar, declare that Absalom has become king in Hebron." The conspiracy grew, and the people rallied around Absalom.

When David heard of the revolt, he said to his courtiers, "Let us flee at once, or Absalom will overtake us and put the city to the sword." So the king departed with all his household, leaving behind ten concubines to watch over the palace.

The people wept as the king and all his troops marched by. Then Zadok and the Levites appeared, carrying the Ark of the Covenant. But David ordered them to take the Ark back to the city. "If I find favor with God," David said to Zadok, "God will bring me back and will let me see the Ark in its dwelling place. And if not, I am ready. I will wait in the wilderness until you send me word."

So Zadok brought the Ark back to Jerusalem.

Then David, his head covered and barefoot, ascended the Mount of Olives, weeping. And all the people with him covered their heads and wept as they went up. David sent his loyal servant Hushai to Absalom to serve as a spy in Absalom's court. But David's counselor Ahithophel was disloyal to the king and became counselor to Absalom.

When Absalom and all his followers arrived in Jerusalem, Ahithophel advised him, "Sleep with your father's concubines, whom he left behind to watch over the palace. And when all Israel hears that you have defied the wrath of your father, the people will be encouraged." So they pitched a tent for Absalom on the roof of the palace, and he lay there with his father's concubines before the eyes of all the people.

Then Ahithophel said to Absalom, "Let me take twelve thousand men and pursue David tonight. I will come upon him when he is exhausted and panic-stricken. Then all his troops will flee, and I will kill the king alone. Then I will bring the people back to you, and all the people will be at peace."

Though the counsel pleased Absalom and all the elders of Israel, he went to Hushai to hear what he would advise. "The counsel of Ahithophel is not good," said Hushai, "because David is an experienced and courageous soldier, as are his men. He is probably not with his troops, but is hiding someplace else. If your men fail in their first attack, the rest of the people will lose heart. No, call up all the people from Dan to Beersheba to march into battle. We shall descend upon him and his troops like dew falling upon the ground; no one will survive."

Absalom and all Israel favored Hushai's advice, for God had decreed that Ahithophel's wiser counsel would be ignored, so that God might bring about Absalom's ruin. And when Ahithophel saw that his advice had not been heeded, he returned home, set his affairs in order, and hanged himself.

Hushai sent word to David of Absalom's plans, and David and all his troops crossed over the Jordan, so that by daybreak no one was left in the camp. Absalom and his troops pursued David across the Jordan.

David set captains over his troops and sent them out against Absalom's army. And though he wished to march with them, his troops refused to let him. "No, you are worth ten thousand of us," they said. "It is better for you to support us from the town."

Before they marched out to battle, David told his three generals, Joab, Abishai, and Ittai, "Deal gently with my boy Absalom, for my sake." All the troops heard the king give this order to the officers.

The battle was fought in the forest of Ephraim. David's followers routed Absalom's troops, and twenty thousand men fell that day.

Absalom was riding upon a mule. As he

passed under the tangled boughs of a great terebinth, his hair was caught in the tree, and he was left hanging there when the mule moved on. One of David's soldiers saw this and reported it to Joab.

"Why did you not kill him then and there?" Joab demanded. "I would have paid you ten shekels of silver and a belt."

"Even if you were to give me one thousand shekels," the man replied, "I would not raise a hand against the king's son. For I heard what the king said to you and Abishai and Ittai: 'Watch over Absalom for my sake.' Nothing is hidden from the king; if I were to kill Absalom, you would not come to my defense."

"Then I will not wait for you," Joab said.

Taking three darts, Joab went to Absalom and drove the darts into his chest. Then ten of Joab's young arms-bearers closed in upon the dying Absalom and finished him off.

Joab then sounded the shofar and called back his troops. They threw Absalom's body in a large pit in the forest and heaped stones over it. Then his troops fled to their homes. Absalom had no sons to keep his name alive. He had a pillar set up in the Valley of the King, and that pillar has been called Absalom's Monument to this day.

When David was told of the death of his son, he burst out weeping, crying, "My son Absalom! O my son, my son Absalom! If only I had died instead of you! O Absalom, my son, my son!"

The Revolt of King David's Son Absalom and His Death at the Hands of His Father's General, Joab, **15th century. Bibliothèque Nationale de France, Paris/Erich Lessing/Art Resource, NY.**

178

Solomon Teaching His Students. **Initial panel of** *Book of Proverbs* **from the** *Rothschild Miscellany*
(Ms. 180/51, fol. 65v), Northern Italy, ca. 1450–1480. Collection Israel Museum, Jerusalem.

179

Solomon Becomes King

AFTER ABSALOM'S DEATH, DAVID'S SON ADONIJAH BEGAN BOASTING, "I WILL BE KING!" FOR HE WAS NEXT IN LINE AFTER HIS BROTHER AND WAS ALSO VERY HANDSOME. ADONIJAH MADE A SACRIFICIAL FEAST AND INVITED ALL HIS SUPPORTERS—HIS BROTHER PRINCES, THE ROYAL COURTIERS from the tribe of Judah, Joab, and the priest Abiathar. But he did not invite those who opposed him—the prophet Nathan; Benaiah ben Yehoiada, the captain of the king's bodyguard; David's loyal fighting men; or his brother Solomon.

Then Nathan said to Solomon's mother, Bathsheba, "You must have heard that Adonijah has declared himself king without telling David. Now, if you wish to save your own life and that of your son Solomon, go to David and say, 'Did you not swear to me that my son Solomon would succeed you as king and sit on your throne? Why then has Adonijah become king?' And while you are still there speaking with the king, I myself will come and confirm your words."

So Bathsheba went in to the old king and bowed low before him.

"What is wrong?" David asked her.

"My lord, you swore to me by the name of God that my son Solomon would succeed you. But now Adonijah has become king, and you know nothing about it. He has made a great sacrificial feast and invited Joab and the priest Abiathar and all the king's sons—except Solomon. The eyes of Israel are upon you, O lord king, to learn who shall succeed you as king. If you do not tell the people that it will be Solomon, my son and I will be branded as traitors after you die."

While she was still speaking, the prophet Nathan arrived and entered the king's presence.

"O lord king," he said, bowing low, "have you declared Adonijah the next king of Israel? For he is now hosting a great feast, to which he has invited all your sons and officers and the priest Abiathar. At this very moment, they are eating and drinking, and shouting, 'Long live King Adonijah!' But he did not invite me or Zadok or Benaiah or your son Solomon. Have you made such a decision without telling me?"

David then took an oath before Bathsheba: "As God lives, who has saved me from every trouble, I will fulfill my oath to you this very day. Your son Solomon shall succeed me as king!"

Bathsheba bowed low to the ground and said, "May my lord King David live forever!"

Then David summoned the priest Zadok, the prophet Nathan, and Benaiah ben Yehoiada. "Take Solomon upon my mule to Gihon," he said to them, "and anoint him there king over Israel. Sound the shofar and declare, 'Long live King Solomon!' Then bring him here and seat him upon my throne. I designate him ruler over Israel and Judah."

They did so. The priest Zadok took the horn of oil from the Tent and anointed Solomon. They sounded the shofar and all the people shouted, "Long live King Solomon!" The people marched up behind him, playing flutes and celebrating until the earth split open from the clamor.

When Adonijah and his guests heard the shofar sounding,

Adonijah cried, "Why is the city so full of noise?"

Then Jonathan, son of the priest Abiathar, arrived and said, "Alas, King David has made Solomon king! The priest Zadok and the prophet Nathan anointed him at Gihon, and the city is celebrating. That is the noise you heard. Solomon is now seated on the royal throne!"

Alarmed, all of Adonijah's guests rose and fled. Fearing his father's wrath, Adonijah himself went at once to the Tent and grasped the horns of the altar, saying, "Let King Solomon swear that he will not put his servant to death."

"If he behaves worthily," Solomon declared, "he will live; but if he commits any offense, he shall die."

Then David died and was buried in the City of David. He had ruled over Israel forty years. Adonijah now came to Bathsheba, the queen mother, and requested that she intercede on his behalf, asking her son Solomon to give Adonijah David's concubine, Abishag the Shunamite, as his wife.

"Why request only Abishag?" cried Solomon when his mother repeated Adonijah's request. "Why not ask for the kingship! For he is my older brother, and Joab and the priest Abiathar are on his side! As God lives, who has established me on my father's throne, Adonijah shall be put to death this very day!"

Then Solomon commanded Benaiah to strike him down, and so he died.

OPPOSITE: *Planning Solomon's Temple*, Jack Levine, 1940. **Collection Israel Museum, Jerusalem. © Jack Levine/ Licensed by VAGA, New York.**

THE FOUNDING OF THE KINGDOM OF ISRAEL

1 *Kings* 3:4–28; 5:9–14; 9:1–9

The Wisdom of Solomon

LTHOUGH SOLOMON LOVED GOD AND FOLLOWED THE PRACTICES OF HIS FATHER, DAVID, HE SACRIFICED AT THE OPEN SHRINES IN THE LAND, JUST AS ALL THE PEOPLE DID, FOR NO HOUSE HAD YET BEEN BUILT FOR GOD. THE KING WENT TO GIBEON, THE SITE OF THE LARGEST SHRINE, AND OFFERED THERE ONE THOUSAND BURNT

offerings. That night God appeared to Solomon in a dream and said, "Ask, and it shall be granted you."

"You dealt graciously with my father, David," Solomon said, "because he walked before You in faithfulness and righteousness with an upright heart. You have continued Your kindness by giving him a son to sit on his throne. You have made Your servant king in place of my father, David, but I am just a young boy, with no experience to lead the people You have chosen, who are too numerous to count. Therefore, grant me a discerning heart to judge Your people, to distinguish between good and evil."

God was pleased with Solomon's words. "Because you asked for this, and did not request long life, riches, or the life of your enemies, but instead asked for wisdom to judge good and evil, I will

OPPOSITE: *King Solomon in Judgment* **from the** *British Library Miscellany* **(Add. Ms. 11639, fol. 518r) 1280. © The British Library, London.**

grant you a wise and perceptive mind. Never before has there been anyone as wise as you, nor will there be again. I will also grant you what you did not ask for—riches and honor all your life, more than any other king before you. And I will grant you long life, if you walk in My ways and observe My commandments, as did your father, David."

Then Solomon woke—and behold, it was a dream! He went to Jerusalem, stood before the Ark of the Covenant, and sacrificed there. Then he made a banquet for his entire court.

Some time afterward, two prostitutes appeared before the king. The first woman said, "Please, my lord! This woman and I live in the same house. I gave birth to a child while she was in the house, and three days later, she too gave birth to a child. No one was in the house except the two of us. During the night, the other woman's child died because she lay upon it. Then she took my son from my side while I was asleep and laid it on her breast, and laid her dead son upon mine. And when I arose the next morning to nurse my son, I looked at him closely and saw that he was not my son."

"No, the living one is mine," protested the other woman. "The dead one is yours!"

"No, the dead one is yours," replied the first woman, "and mine is the living one!"

And they continued arguing before the king.

Solomon said to them, "Each of you says, 'The living

183

one is mine; the dead one, yours.'" Then the king gave the order: "Bring me a sword!" And it was brought to him. "Cut the living child in two," the king commanded, "and give half to each."

But the woman whose son was the living one pleaded with the king, for she had compassion on her son. "Please, my lord, give her the living child! Do not kill him!"

"It shall be neither yours nor mine," the other woman said. "Cut it in two!"

"Give the living child to the first woman," the king declared, "for she is its mother. Do not put it to death."

When all Israel heard the king's judgment, the people were in awe of him, for they saw that his wisdom truly came from God.

GOD ENDOWED SOLOMON WITH WISDOM AND understanding as vast as the sands of the seashore. His wisdom exceeded that of all the wise men of the world. It was greater than all the wisdom of Egypt. And his fame spread throughout the nations. He composed three thousand proverbs and more than a thousand songs. He possessed remarkable knowledge about trees and plants, about beasts, birds, creeping things, and fishes. People from all over came to hear Solomon's wisdom, for all the kings on earth had heard of it.

Solomon built God's House in Jerusalem to house the Ark of the Covenant and the altar. He also built there royal palaces, the citadel of Millo, and the wall of Jerusalem. And at the end of twenty years when the work was done, God appeared to Solomon a second time, as had happened long before at Gibeon. God blessed Solomon and promised to establish his kingdom, as long as he acted justly and followed God's commandments. But God warned him that if he turned aside to worship other gods and forsake God's laws, then "I shall cut Israel off from the land and reject the House consecrated to My name."

184

Judgment of Solomon (detail of a ceiling), Raphael, ca. 1511. Stanza della Segnatura, Vatican Palace, Vatican State/Scala/Art Resource, NY.

The Retinue of the Queen of Sheba from *History of Solomon and the Queen of Sheba*, 20th century. Ethiopia. Private Collection, Paris/Giraudon/Art Resource, NY.

Solomon and the Queen of Sheba

185

THE QUEEN OF SHEBA HEARD OF SOLOMON'S FAME AND WENT TO JERUSALEM TO TEST HIM WITH RIDDLES. SHE TRAVELED IN A LARGE CONVOY, WITH CAMELS BEARING SPICES AND GOLD AND PRECIOUS STONES.

And when she came to Solomon, she told him all that was in her mind, and Solomon had answers for all her questions. Indeed, there was nothing that the king did not know, nor was he stumped by anything she asked.

When the queen of Sheba saw how wise Solomon was, when she saw the palace that he had built, the food and wines at his table, the pageantry of his court, and the procession with which he went up to the House of God, she was breathless. "Everything I heard in my country about your wisdom was true!" she said to the king. "I did not believe it until I came and saw with my own eyes. The reports did not convey even the half of it. How lucky are those who serve you and can always hear your wisdom. Blessed is your God who treasured you and set you on the throne of Israel! Because God loves you eternally, you have been made king to do justly and righteously."

She presented the king with a great treasure—one hundred twenty talents of gold and many spices and precious stones. Never again did such treasure as the queen of Sheba brought ever come to King Solomon. In turn Solomon gave the queen of Sheba anything her heart desired—and more. Then she and her court returned to their own land.

VII.
The Divided
Kingdom

IN THE TWO BOOKS OF KINGS that follow the double books of Samuel, Israel's precarious political position is played out to its tragic end. Caught amid the warring empires of Assyria, Babylonia, Persia, and Egypt, the tiny kingdom of Israel becomes a battleground for foreign armies until at last its people's agony is ended through dispersion and exile. Before this unraveling, Israel comes apart at the seams when Solomon's son loses the lion's share of his realm to a northern rebellion. Thus, David's united kingdom lasts only two generations.

This division produces two lines of Jewish kings: in the southern kingdom of Judah, the descendants of David; in the northern kingdom of Israel, a constant series of usurpers and failed dynasties. As the rulers of both kingdoms pollute the land with idolatry and moral corruption, the prophets chastise them and warn of their ultimate downfall. As foreign invasions bring the nation to its knees, the prophets assure the people of their ultimate redemption.

Few righteous men stand out among all the wicked kings. The most notable is Josiah, who presides over a religious reformation in Judah when a lost scroll of Deuteronomy is discovered in the Temple. After the scroll is authenticated by the female prophet Huldah, Josiah orders his people to follow its teachings by celebrating Passover, a holiday they have not properly observed in many years. He also rids the Temple of the idols and pagan functionaries that have held sway there for several regimes, and he renews Israel's allegiance to its God.

In the stories of this section, we encounter two extraordinary holy men, the prophet Elijah and his disciple Elisha, whose miraculous feats clearly inspired many of the stories in the New Testament. The tales of the biblical Elijah portray a figure very different from the one that emerges in later legend. The Elijah depicted here is a wrathful prophet, jealous on God's behalf and bent on divine vindication. His later persona, on the other hand, is considerably softer—in folklore he becomes a champion of the vulnerable and downtrodden, the wandering Jew who presages messianic redemption. Elijah's disciple Elisha, who inherits his teacher's mantle of prophecy, is even more of a wonder-worker than his master, resurrecting the dead son of the Shunamite woman, multiplying loaves and oil, summoning wild bears to do his will.

Unfortunately, neither the prophets' rebuke nor their consolation succeeds in forestalling the inevitable. In the eighth century BCE, Assyria conquers the northern kingdom and scatters its ten tribes to foreign parts. Two centuries later, Babylonia razes the Temple and forces the remnant of Judah into exile. So ends the First Commonwealth of Israel.

OPPOSITE: *King Rehoboam* (detail), Hans Holbein the Younger, 16th century. Oeffentliche Kunstsammlung, Basel, Kunstmuseum.
OVERLEAF: *Vision of Ezekiel: The Valley of Dry Bones*. Fresco from the synagogue at Dura Europos, Syria. ca. 245 C.E. The Jewish Museum, NY/Art Resource, NY.

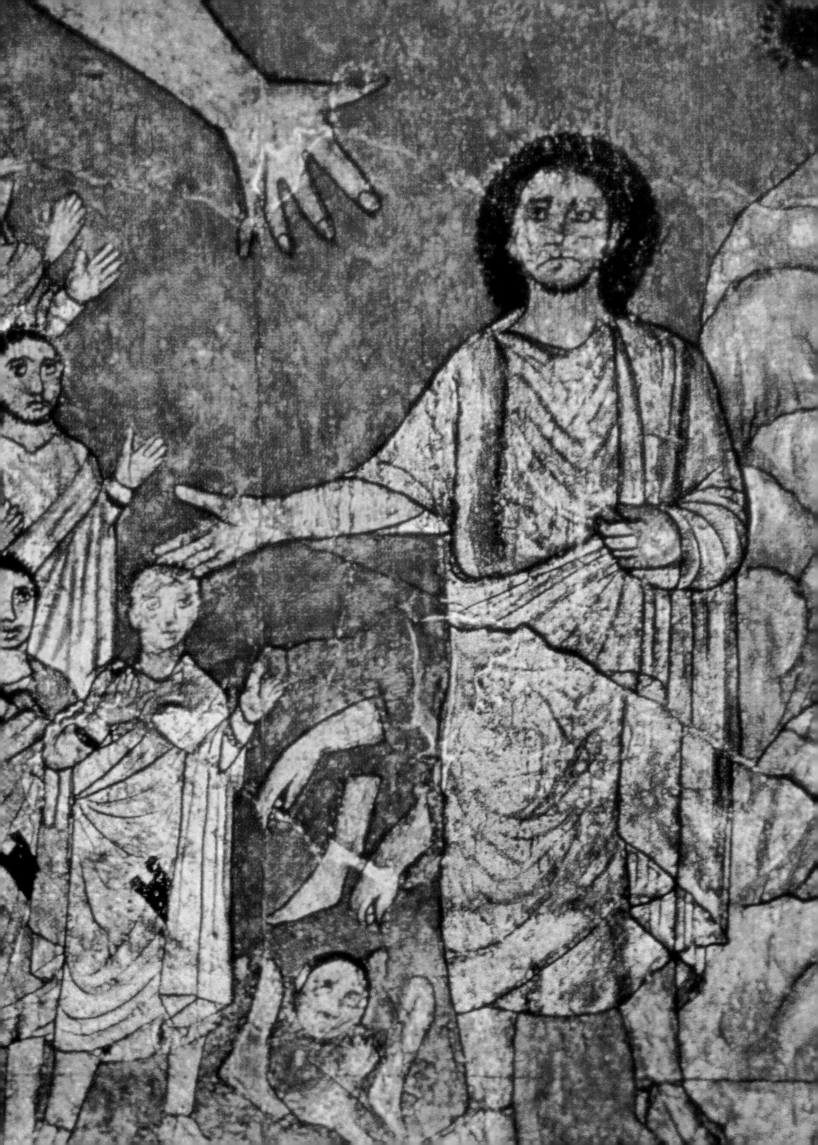

The Kingdom Divides

Solomon took seven hundred wives and three hundred concubines. And his foreign wives turned his heart away from God. Solomon did what was displeasing to God, building shrines and offering sacrifices to the gods and goddesses of his foreign wives. So God said to Solomon, "I will tear the kingdom away from you and give it to one of your servants. But for the sake of your father, David, and My chosen city, Jerusalem, I will not tear it away during your lifetime, but will tear it away from your son, and I will leave to your house one tribe, so that there may be a lamp for Me in Jerusalem."

JEROBOAM, SON OF NEBAT, AN EPHRAIMITE, WAS AN ABLE YOUNG MAN IN KING SOLOMON'S SERVICE, AND THE KING PUT HIM IN CHARGE OF ALL THE FORCED LABOR OF THE HOUSE OF JOSEPH.

When the prophet Ahijah of Shiloh met Jeroboam in the countryside, he ripped off the new robe Jeroboam was wearing and tore it into twelve pieces.

"Thus says the God of Israel," he told Jeroboam. "'I will soon tear the kingdom out of Solomon's hands and give you ten tribes. One tribe will remain his, for the sake of My servant David and My chosen city, Jerusalem. For they have forsaken Me and worshipped other gods and have not walked in My ways. I will tear the kingdom out of the hands of his son and give you ten tribes to rule. If you follow My commandments and do what is right in My sight, as David did, I will establish for you a lasting dynasty. But I will not chastise David's descendants forever.'"

Solomon sought to kill Jeroboam, but he fled to Egypt and remained there until Solomon died. Then Solomon slept with his fathers after reigning in Jerusalem for forty years, and his son Rehoboam, whose mother was Naamah the Ammonite, became the new king.

When Jeroboam heard that Solomon was dead and that his son Rehoboam ruled, he left Egypt and came to the king with the whole community of Israel. "Your father made our yoke heavy with harsh labor," he said to Rehoboam. "Lighten our yoke, and we will serve you."

"Go away for three days," Rehoboam answered, "and then come back to me." So the people went away.

Rehoboam asked the elders who had counseled Solomon during his lifetime, "What shall I tell this people?"

"If you serve them today and speak kindly to them," they replied, "they will be your servants always."

But the king ignored their counsel, and he asked the young men who had grown up with him, "What should I say to them?"

"Say to them," replied the young men, "'My little finger is thicker than my father's loins. My father made your yoke heavy; I will make it heavier still. My father beat you with whips; I will beat you with scorpions.'"

On the third day, Rehoboam spoke to the people according to the counsel of the

Torah Ark (detail), Westheim bei Hassfurt, Bavaria, 18th century.
The Jewish Museum, NY. Gift of Arthur Heiman/Art Resource, NY.

young men. (For God thus fulfilled Ahijah's prophecy to Jeroboam.)

The people answered the king: "We have no portion in David, no share in Jesse's son! To your tents, O Israel! Now look to your own house, O David!" And the people returned to their own tents. But Rehoboam still ruled over the Israelites who lived in the towns of Judah.

The king sent Adoniram, who was in charge of the forced labor, to speak with the people, but they stoned him to death. Then King Rehoboam fled to Jerusalem in his chariot. And so began Israel's revolt, which continues to this day. Then the people declared Jeroboam king over Israel. Only the tribe of Judah remained loyal to the House of David.

Once back in Jerusalem, Rehoboam mustered one hundred eighty thousand warriors from the tribes of Judah and Benjamin to fight against the House of Israel, in order to restore the kingship to Rehoboam. But the word of God came to Shemaiah, the man of God, "Say to King Rehoboam: 'You shall not make war upon your kinsmen. Let every man return home, for this is My doing.'" And all the men turned back as God had commanded.

But Jeroboam feared that the people would still go up to Jerusalem to offer sacrifices in God's House there, and so return to the House of David. "Indeed," he thought, "they will kill me and go back to King Rehoboam." So he made two golden calves, setting up one in Bethel and one in Dan. He declared to the

people: "This is your god, O Israel, who brought you out of the land of Egypt!" He also appointed priests who were not descended from Levites and stationed them at both shrines. Then he established a festival on the fifteenth day of the eighth month, as was the practice in Judah, and on that day, he ascended the altar he had made in Bethel.

But as he mounted the altar to offer a sacrifice, a man of God arrived from Judah and declared, "O altar! Hear the word of God: 'A son shall be born to the House of David, whose name is Josiah, and he shall slaughter the priests who offer sacrifices upon you, and human bones shall be burned upon you. By this sign shall you know that such is God's decree: This altar shall split apart, and the ashes on it shall be spilled.'"

When Jeroboam heard the man's words, he stretched out his arm over the altar and cried, "Seize him!" But his arm became rigid, and he could not withdraw it. Then the altar split apart, spilling its ashes to the ground— and so God's sign was fulfilled.

Jeroboam pleaded with the man of God, "Please pray to God that I may draw back my hand." The man prayed, and the king's arm became as it was before.

Then Jeroboam invited the man of God to come to his house to eat and receive a gift. But the man said to him, "Even if you were to give me half of your wealth, I would not eat bread or drink water in this place, for God commanded me: 'Eat no bread and drink no water, neither go back on the same road by which you came.'" And he left by a different road from Bethel.

An old prophet living in Bethel learned about all this from his sons. He asked them, "By which road did he leave?" When they told him, he said, "Saddle my ass," and he rode after the man of God. He came to him sitting under a terebinth. "Are you the man of God who came from Judah?" he asked him.

"I am he," he answered.

"Come home with me and share some bread."

"God commanded me neither to eat nor drink there," answered the man from Judah, "nor to leave by the road on which I came."

"I too am a prophet," said the old man, "and an angel of God said to me, 'Bring him back with you so that he may eat and drink.'" And the man of Judah believed the old man's lies and went back with him and ate and drank in his house.

Then the word of God came to the old prophet while the two were sitting at his table, and he cried out to his guest: "Because you spurned God's command not to eat or drink in this place, your corpse shall not sleep in your fathers' grave."

When the man of God set out again on his ass, a lion came upon him and killed him. His corpse lay on the road, with the ass and the lion standing beside it. Some men rode by and saw the corpse and the lion beside it, and brought word to the old prophet.

"This is the man who spurned God's command," he declared, "and God delivered him to the lion." Then he mounted his ass and rode back to where the corpse lay. The lion had not eaten it, nor mauled the ass standing beside it. The prophet laid the corpse upon his ass and brought it back to town. He buried it in his own burial place, crying, "Alas, my brother!" Then he said to his sons, "When I die, bury me beside this man of God. For what he foretold about the altar at Bethel and all the cult places in Samaria will surely come to pass."

Jeroboam continued to incur guilt and forsake God's commandments. Thus did the House of Jeroboam condemn itself to utter annihilation from the face of the earth.

Elijah and the Priests of Baal

הבעל ענה ואין קול ואין עונה

*Ahab, son of Omri, became king over Israel and ruled in Samaria for twenty-two years.
Ahab and his wife Jezebel of Phoenicia did what was displeasing to God, worshipping Baal
and Asherah. Ahab did more to provoke God than all the kings who came before him.*

*Elijah the Tishbite of Gilead became a prophet in Israel, and he declared a drought
because of the king's wickedness. Fearing for his life, he hid from Ahab east of the Jordan,
and the ravens fed him there at God's command. Then he took refuge with a poor widow
in Sidon and performed miracles on her behalf, multiplying her store of flour and oil and
reviving her son after he fell ill and died.*

IN THE THIRD YEAR OF THE
DROUGHT, GOD SAID TO
ELIJAH, "GO APPEAR BEFORE
AHAB. THEN I WILL SEND
RAIN." SO ELIJAH SET OUT TO
APPEAR BEFORE THE KING.
AHAB SUMMONED OBADIAH,

the palace steward, who feared God. When
Jezebel was killing God's prophets, Obadiah
hid one hundred of them in two caves, pro-
viding food and drink for them. "Let us
search the land for springs and wadis," Ahab
said to Obadiah. "Perhaps we will find
enough grass to feed our horses and mules,
so that they will not die."

They divided up the territory, Ahab
going one way and Obadiah the other.
While he was on the road, Obadiah suddenly
came upon Elijah, and when he recognized
him, he bowed down, asking, "Is that you,
my lord Elijah?"

**Baal with Thunderbolt from Ugarit (Ras
Shamra), Syria, 2nd–1st millenium** B.C.E.
Louvre, Paris/Erich Lessing/Art Resource, NY.

193

"Yes, it is," answered Elijah. "Go tell your lord that Elijah is here."

"What wrong have I done to you that you send me off to Ahab to be killed?" cried Obadiah. "For Ahab has sent me everywhere searching for you, and all have sworn that you are nowhere to be found. And now you say to me, 'Elijah is here!' As soon as I am gone, God will carry you off so that you cannot be found, and when Ahab looks for you and cannot find you, he will kill me! You know that I have feared God from my youth, and surely you have heard how I hid and kept alive one hundred of God's prophets in a cave. Yet you now tell me to announce to Ahab, 'Elijah is here!'"

"As God lives," declared Elijah, "I will appear before Ahab this very day."

So Obadiah informed Ahab, and the king went out to meet Elijah. When the king saw Elijah, he asked him, "Is that you, troubler of Israel?"

"It is you, not I, who have troubled Israel," Elijah answered, "forsaking God's commandments and worshipping Baal. Now gather together all of Israel on Mount Carmel, together with the four hundred fifty prophets of Baal and the four hundred prophets of Asherah who eat at Jezebel's table." Ahab did so. Elijah asked the people, "How long will you waver? If YHVH is God, then that is whom you should follow; if Baal, then follow him!" But the people were silent. "I am the only one of God's prophets left," Elijah said to them. "But Baal has four hundred fifty prophets. Let two bulls be brought, one for Baal and one for God. Let the priests of Baal choose one, cut it up, and lay it on the wood of the altar, but let no fire be lit. I will do the same with the other bull. We will then each call our God by name. The one who answers, that one is God."

"We agree!" the people answered.

"Prepare your bull first," Elijah said to the priests of Baal, "because you are the majority."

So they took the bull and prepared it, and they called upon Baal from morning until noon, shouting, "Baal, answer us!" But there was no answer. Then they danced and leapt around the altar, but no answer came. Elijah mocked them: "Shout louder! He may be talking, or detained, or perhaps he is on a journey, or asleep. You need to wake him." So they shouted louder and cut themselves with knives and spears, according to their custom, until blood flowed over them. They kept prophesying until noon, but still no one responded.

"Draw nearer," Elijah said to the people, and they drew near. Then he repaired the damaged altar of God. With twelve stones, one for each tribe, he built up the altar. Around the altar he dug a deep trench. Then he arranged the wood, and upon it he laid the bull he had cut up.

"Fill four jars with water," Elijah commanded, "and pour it over the burnt offering and the wood." He ordered them to do this three times. The water ran down the altar and filled the trench.

Then Elijah came forward and declared, "God of Abraham, Isaac, and Jacob, let it be known today that You are the God of Israel, and I am Your servant. Answer me, O God, answer me!"

Then God's fire descended and consumed the offering, the wood, the stones, and the earth, even licking up the water in the trench. When the people saw this, they flung themselves upon their faces and shouted, "YHVH is God! YHVH is God!"

"Seize the prophets of Baal!" Elijah cried. "Do not let even one of them escape!"

Elijah on Mount Carmel. **Fresco from the synagogue at Dura Europos,
Syria, ca. 245 C.E. The Jewish Museum, NY/Art Resource, NY.**

So they seized them, and Elijah brought
them down to the wadi of Kishon and
slaughtered them there.

Then Elijah said to Ahab, "Go eat and
drink, for I hear thunder." And Ahab did so.

Elijah climbed to the top of Mount
Carmel and crouched on the ground, his
face between his knees. "Look toward the
sea," he said to his servant.

The servant did so and told Elijah,
"There is nothing." Elijah sent him back
seven times to look, and the seventh time he

reported, "A cloud as small as a man's hand
is rising in the west."

Elijah sent word to Ahab, "Mount your
chariot and go down, before the rain stops
you." For the sky was growing black with
clouds, and a wind was rising, and then a
heavy downpour fell. Ahab hitched up his
chariot, and drove off.

And Elijah, propelled by the hand of
God, caught up the hem of his robe and ran
before Ahab all the way to Jezreel.

The Still,
Small Voice

ואחר האש קול דממה דקה

HEN AHAB TOLD JEZEBEL WHAT ELIJAH HAD DONE, HOW HE HAD KILLED ALL THE PRIESTS OF BAAL, SHE SENT A MESSENGER TO ELIJAH, SAYING, "THUS MAY THE GODS DO TO ME IF I HAVE NOT made you like those you have slain by this time tomorrow."

Elijah fled for his life to Beersheba, in the land of Judah, and from there he went a day's journey into the wilderness. Exhausted, he sat down under a broom bush and prayed, "Enough, O God! Take my life, for I am no better than my fathers."

Then he fell asleep under the broom bush. Suddenly an angel touched him and said, "Rise up and eat." There beside his head was a cake baked on hot stones and a jar of water! He ate and drank and then lay down again. Again the angel of God touched him and said, "Rise up and eat, or the journey will prove too much for you." Elijah did so. His strength renewed, Elijah walked forty days and forty nights until he came to the Mountain of God at Horeb. He went into a cave and spent the night.

The word of God came to him, saying, "Why are you here, Elijah?"

"I have been zealous for God," answered Elijah, "because the Israelites have forsaken Your covenant, torn down Your altars, and killed Your prophets. I alone am left, and they seek my life."

"Come out," God said, "and stand on the mountain before Me."

And behold—God passed by. First there was a great and mighty wind, splitting

OPPOSITE: *Elijah Cup and Cover,* **Bohemian ruby cut-glass, ca. 1850. Christie's Images.**

mountains and shattering rocks, but God was not in the wind. After the wind—an earthquake, but God was not in the earthquake. After the earthquake—fire, but God was not in the fire. And after the fire—a still, small voice. When Elijah heard this, he wrapped his cape about his face and stood at the mouth of the cave. "Why are you here, Elijah?" asked a voice.

"I have been zealous for God," Elijah answered, "because the Israelites have forsaken Your covenant, torn down Your altars, and killed Your prophets. I alone am left, and they seek my life."

"Go back the way you came and journey to the wilderness of Damascus. There anoint Hazael as king of Aram, Jehu as king of Israel, and Elisha to succeed you as prophet. Whoever escapes Hazael's sword will be killed by Jehu, and whoever escapes Jehu's sword will be killed by Elisha. I will leave in Israel only seven thousand—only the knees that have not knelt down to Baal and the mouths that have not kissed him."

He came to Elisha plowing with twelve oxen. Elijah threw his cape over him, and Elisha left the oxen and ran after Elijah. "Let me kiss my father and mother good-bye," he said, "and I will follow you."

"Go back," Elijah said to him. "What have I done to you?"

Elisha took the yoke of oxen and slaughtered them. He then took the wood of the yoke and boiled the meat, and gave it to the people. Then he followed after Elijah and became his attendant.

197

Naboth's Vineyard

AFTER ISRAEL DEFEATED THE ARAMEANS, KING AHAB CAME TO NABOTH THE JEZREELITE, WHO OWNED A VINEYARD ADJACENT TO THE KING'S PALACE. "GIVE ME YOUR VINEYARD," HE SAID TO NABOTH, "SO I CAN PLANT A VEGETABLE GARDEN, FOR IT IS RIGHT NEXT TO MY PALACE. I will give you an even better vineyard or pay you what it is worth."

"God forbid that I should hand over to you what I inherited from my fathers!" replied Naboth.

Ahab went home, depressed by Naboth's answer. He lay down in his bed and refused to eat. "Why won't you eat?" his wife Jezebel asked him.

"I asked Naboth to sell me his vineyard," answered Ahab, "but he would not."

"You must show that you are king over Israel!" Jezebel chided him. "Cheer up and eat. I will get Naboth's vineyard for you."

She wrote letters in the king's name, sealed them with the king's seal, and sent them to the elders and leaders who lived in Naboth's town. The letters commanded: "Declare a fast and seat Naboth in front of the people. Then let two rogues testify against him that he cursed God and the king and then stone him to death."

The elders and leaders of the town did just as Jezebel ordered, and then sent word to the queen that Naboth was dead. "Go and claim Naboth's vineyard," Jezebel said to Ahab, "for he is dead." So Ahab set out toward Naboth's vineyard.

Then God spoke to Elijah, saying, "Go to Samaria, to King Ahab, who has gone to claim Naboth's vineyard. Say to him, 'You murder and then take possession? In the very place where the dogs lapped up Naboth's blood,' says God, 'they will also lap up your blood.'"

Ahab said to Elijah, "So you have found me, my enemy!"

"So I have," answered Elijah. "And because you have done what is evil in God's eyes, I will bring evil upon you. I will cut off from Israel every one of your male descendants and will make your house like the House of Jeroboam, because you have led Israel to sin. And the dogs will devour Jezebel in the field of Jezreel. All of Ahab's descendants who die in the town shall be devoured by dogs; those who die in the field shall be devoured by birds of the sky."

Though there never was a king as evil as Ahab, who followed the evil counsel of his wife Jezebel and strayed after foreign gods, still he tore his clothes and put on sackcloth and fasted when he heard Elijah's words. And when God saw how Ahab had humbled himself, he told Elijah, "Because he has humbled himself before Me, I will not bring disaster upon him while he lives, but will visit it upon his son."

Ahab, king of Israel, and Jehoshaphat, king of Judah, made an alliance and sought to attack the Arameans. Ahab gathered the four hundred prophets of Israel and asked them, "Shall we march against Aram?"

"March," the prophets replied, "and God will deliver them into your hands!"

198

But there was one prophet, Micaiah, son of Imlah, who prophesied defeat for Israel, and Ahab imprisoned him until the armies of Israel and Judah should return victorious.

Ahab said to King Jehoshaphat, "I will go into battle in disguise, but you wear your robes."

The king of Aram commanded his charioteers, "Attack no one but the king of Israel." They came upon Jehoshaphat, king of Judah, and were about to attack him, but he cried out. When they realized that he was not the king of Israel, they turned away. Then one man drew his bow and wounded Ahab between the plates of his armor. And while the battle raged all day, Ahab remained propped up in his chariot, and his blood ran down. And at sunset he died. Then the men of Israel returned to their homes.

They buried Ahab in Samaria and washed out his chariot in the pool of Samaria. So the dogs lapped up his blood, and the whores bathed in it, as God had foretold.

Ahab's son Ahaziah became king of Israel, but he soon died when he fell through the lattice in the upper chamber of his house. Then his brother Jehoram became king, and he allied himself with Judah through marriage. Both kings did what was evil in God's sight, and they were vanquished by Jehu, who succeeded to the throne of Israel.

When Jezebel learned that Jehu was coming to Jezreel, she painted her eyes with kohl and put up her hair. When she saw Jehu at the gate, she called out the window, "Is all well, murderer of your master?"

He looked up and said, "Who is on my side?" Three eunuchs leaned out. Jehu said to them, "Throw her down." They threw her down, and her blood spattered on the wall and on the horses, and they trampled her.

Jehu went inside and ate and drank. Then he commanded, "Bury that cursed woman, for she was a king's daughter."

But when they went to bury her, all they found were the skull, the feet, and the hands. When they told Jehu, he said, "It is as Elijah foretold, 'The dogs shall devour her flesh, and the carcass of Jezebel shall be like dung on the ground, so that no one will be able to say: "'This was Jezebel!'"

Jezebel Advising King Ahab from the *Amiens Picture Bible* (Ms. 108, fol. 115), 1197. Amiens, Bibliothèque Municipale.

Elijah Ascends to Heaven
in a Fiery Chariot

WHEN GOD WAS READY TO TAKE ELIJAH UP TO HEAVEN, ELIJAH SET OUT WITH HIS DISCIPLE ELISHA TOWARD BETHEL.

"STAY HERE," ELIJAH SAID, "FOR GOD HAS SENT ME ON TO BETHEL."

"AS GOD LIVES AND YOU LIVE," REPLIED Elisha, "I will not leave you."

So they went to Bethel. The disciples of the prophets who lived there came out to meet Elisha and asked him, "Do you know that God will take your master away from you today?"

"I know," said Elisha. "Be still."

Then Elijah said to him, "Stay here, Elisha, for God has sent me on to Jericho."

"As God lives and you live," replied Elisha, "I will not leave you."

So they went on to Jericho. The disciples of the prophets who lived there came out to meet Elisha and asked him, "Do you know that God will take your master away from you today?"

"I know," said Elisha. "Be still."

Then Elijah said to him, "Stay here, Elisha, for God has sent me on to the Jordan."

"As God lives and you live," replied Elisha, "I will not leave you."

Fifty disciples of the prophets followed them and stood a distance apart from them as they stopped at the Jordan. Elijah removed his cloak, rolled it up, and struck the water with it, and

OPPOSITE: *Elijah on the Fire Chariot*, **Alessandro Franchi, 19th century. Duomo, Siena/ Scala/Art Resource, NY.**

it parted so that the two of them crossed over on dry land. As they were crossing, Elijah said to Elisha, "Tell me what I can do for you before I am taken away from you."

"Let a double portion of your spirit come to me," he replied.

"Your request is a difficult one," Elijah said. "If you see me as I am taken from you, your request will be fulfilled; if not, it will not."

As they were walking along, a fiery chariot drawn by fiery horses suddenly came between them, and Elijah went up to heaven in a whirlwind.

Seeing it, Elisha cried out, "O Father, Father! The chariots and horsemen of Israel!"

When he could no longer see Elijah, Elisha tore his clothes in two. He picked up Elijah's cloak, which had fallen from him. "Where is the God of Elijah?" he cried. Then he struck the water with the cloak, and it parted, and he crossed over. When the disciples of the prophets saw him coming, they declared, "The spirit of Elijah has come to rest on Elisha!" And they bowed low before him.

"You have fifty strong men in your service," they said to him. "Send them to look for your master. Perhaps God's spirit has carried him off and flung him on some mountain or into some valley."

"Do not send them," replied Elisha.

But they urged him until he said, "Send them."

So they sent out fifty men, who searched for three days, but did not find him. When they reported back to him in Jericho, he said to them, "I told you not to go."

2 *Kings* 2:19–25; 4:1–7, 38–44; 5:1–27

Elisha the Miracle-Worker

THE MEN OF JERICHO SAID TO ELISHA, "THIS TOWN IS A PLEASANT PLACE TO LIVE, BUT THE WATER IS BAD AND THE LAND CAUSES BARRENNESS."

"BRING ME A NEW DISH," ELISHA TOLD THEM, "AND PUT SALT IN IT."

THEY BROUGHT HIM THE DISH, AND HE WENT to the spring and threw salt in it.

"So declares God," Elisha said. "I heal this water, so that death and barrenness will no longer come from it!"

And the water has remained healthy to this day.

AS ELISHA WENT ON HIS WAY TO Bethel, some little boys came out of the town and mocked him. "Go away, baldie!" they jeered.

He turned around and cursed them in the name of God. Then two she-bears emerged from the woods and mangled forty-two of the children.

He then went to Mount Carmel, and from there he returned to Samaria.

ONCE THE WIFE OF ONE OF THE prophets' disciples cried out to Elisha, "My husband is dead, and you know that he was God-fearing. Now a creditor is coming to seize my two children as slaves!"

"What can I do for you?" asked Elisha.

OPPOSITE: *Elisha's Final Prophesy and Oath,* **Salvador Dali, 20th century. SuperStock, Inc. ©** **1999 Artists Rights Society (ARS), New York.**

"What do you have in the house?"

"I have nothing but one jug of oil," the woman replied.

"Go borrow vessels from your neighbors," Elisha told her, "empty ones, as many as you can get. Then go inside and shut the door behind you and your children. Pour the oil into all these vessels, and take away each one as it is filled."

The woman did as he instructed. Her children kept bringing her vessels, and she kept on pouring. Finally, she said, "Bring me another vessel."

"There are no more," her son told her. And the oil stopped. When she told Elisha what had happened, he said to her, "Sell the oil and pay your debt. Then you and your children can live on what remains."

ONCE THERE WAS A FAMINE IN the land. The disciples of the prophets came to sit before Elisha. "Put the pot on the fire," he said to his servant, "and cook a stew for the disciples of the prophets."

One of them went out into the fields to gather weeds. He came upon a wild vine and plucked from it gourds, as many as his garment would hold. He brought them back, sliced them into the pot, and served the dish for the men to eat. As they were eating it, they cried out, "O man of God, there is death in the pot!" And they could not eat it.

203

"Bring me some flour," Elisha told them. He threw it into the pot and said, "Serve it to them and let them eat."

And there was no longer anything harmful in the pot.

A MAN BROUGHT THE man of God some bread from the first harvest—twenty loaves of barley bread—and some fresh grain. Elisha said, "Give it to the people to eat."

"How can this feed a hundred?" the man asked.

"Give it to them to eat," repeated Elisha. "For God has said, 'They shall eat and have some left over.'"

He set it before them, and when they had finished eating, they had some left over, as God had said.

NAAMAN, COMMANDER OF THE ARMY OF THE king of Aram, was a great warrior and a favorite of the king's, but he was a leper. Once when the Arameans were out raiding, they captured a young Israelite girl, and she became a servant to Naaman's wife. "If only my master could go to the prophet in Samaria," she said to her mistress. "He would surely cure him."

Naaman told the king, who said to him, "Go to the king of Israel, and carry a letter from me."

Naaman set out with much silver and gold and clothing. He gave the letter to the king of Israel. It said, "I have sent my courtier Naaman to you, that you may cure him of leprosy."

The king of Israel tore his clothes and cried when he read the letter. "Am I God," he cried, "that I can dispense death or life? No, he is plotting something against me!"

When Elisha heard of this, he sent word to the king, "Send him to me, so that he will learn there is a prophet in Israel."

So Naaman came with his horses and chariots and stopped before Elisha's house. Elisha sent a messenger to him, who told him, "Go and bathe seven times in the Jordan, and your flesh shall be made whole, and you shall be clean."

But Naaman was angry and left. "I thought that he would certainly come out himself, invoke God's name, wave his hand over me, and cure the affected part. Are not the two rivers of Damascus better than all the waters of Israel? I can bathe in them and become clean!" And he stormed off in anger.

But his servants said to him, "If the prophet had told you to do something difficult, would you not do it? How much more so when he only told you, 'Bathe and become clean.'"

So Naaman went and immersed himself in the Jordan seven times, and his flesh became like a little boy's, and he was clean. He returned to Elisha with all his attendants and said, "Now I know that there is no God in the whole world except the God of Israel! Please accept a gift from me."

"As God lives, whom I serve," replied Elisha, "I will not accept any gifts."

"At least give me two mule-loads of earth," said Naaman, "for I will never again offer sacrifices to any god except the God of Israel. But please pardon me when I bow low in the temple in Rimmon, for my master the king leans on my arm so that I must bow low."

"Go in peace," Elisha said.

When Naaman had gone a short distance on his way, Elisha's attendant Gehazi thought to himself, "My master has let that Aramean go without accepting what he brought. I will run after him and get something from him."

204

When Naaman saw someone running after him, he got down from his chariot and said, "Is all well?"

"All is well," answered Gehazi. "My master has sent me to say to you that two disciples of the prophets have just come from the hill country of Ephraim. Please give them each a talent of silver and a set of clothes."

"Please take them," Naaman said. He placed the silver in two bags and gave them along with the clothes to two of his servants, who carried them ahead of him. Gehazi took the things from the servants when they reached the citadel and put them in the house. Then he dismissed the men, and they went on their way.

"Where have you been?" Elisha asked him.

"Nowhere," answered Gehazi.

"Did not my spirit go along with you," Elisha said to him, "when a man got down from his chariot to meet you? Is this a time to take money to buy clothing and olive groves and vineyards, sheep and oxen, male and female slaves? Surely, the leprosy of Naaman will cling to you and your household forever."

And as he left Elisha, Gehazi was snow-white with leprosy.

Multiple-nozzle lamp, 1st century C.E. **Collection Israel Museum, Jerusalem.**

THE DIVIDED KINGDOM

Elisha and the Shunamite Woman

ONE DAY THE PROPHET ELISHA VISITED THE TOWN OF SHUNEM. A RICH WOMAN LIVED THERE, AND SHE BEGGED HIM TO STAY FOR A MEAL. WHENEVER HE PASSED BY, HE WOULD STOP THERE TO EAT.

ONCE SHE SAID TO HER HUSBAND, "I AM SURE THIS IS A HOLY MAN OF GOD WHO ALWAYS COMES THIS WAY. LET US MAKE A SMALL ROOM FOR HIM UPSTAIRS WITH A BED, A TABLE, A CHAIR, AND A LAMP, SO HE CAN STAY HERE WHENEVER HE PASSES THROUGH."

One day he came, went upstairs, and lay down. He said to his servant Gehazi, "Call that Shunamite woman."

Soon she stood before him.

"Say to her," he told Gehazi, "'You have gone to all this trouble for us. What can we do for you? Can we speak on your behalf to the king or the commander of the army?'"

"The fact is," replied Gehazi, "that she has no son, and her husband is old."

"At this time next year," Elisha said to her, "you will be cradling a son."

"Please, my lord, man of God," she replied, "do not lie to me!"

One year later, the woman gave birth to a son, as Elisha had promised. When the child was grown, he went out one day to join his father among the reapers. Suddenly he cried out to his father, "Oh, my head, my head!"

His father called to a servant, "Carry him to his mother."

The servant picked him up and took him to his mother. The child sat on her lap until noon. Then he died. She picked him up, laid him on Elisha's bed, left him, and closed the door.

Then she called to her husband, "Please send me one of the servants and one of the donkeys, so I can hurry to call upon the man of God." When the donkey was saddled, she said to her servant, "Drive the beast on! See that I do not slow down unless I tell you."

At last she came to the man of God on Mount Carmel. When Elisha saw her in the distance, he said to his servant Gehazi, "There is that Shunamite woman. Run up to her and ask her, 'How are you? How is your husband? How is the child?'"

"We are well," she answered.

But when she came close to him on the mountain, she grabbed hold of his feet. Gehazi stepped forward to push her away, but Elisha said, "Leave her alone, for she is very distressed. God has hidden it from me and has not told me."

"Did I ask my lord for a son?" she cried. "Did I not say, 'Do not lie to me!'"

"Dress yourself for a journey," Elisha now told Gehazi, "take my staff in your hand, and go. If you meet anyone, do not greet him, and if anyone greets you, do not answer him. Place my staff on the face of the boy."

"As God lives and as you live," the boy's mother said. "I will not leave you!" So Elisha stood up and followed her.

Gehazi went on ahead and placed the staff on the

The Departure of the Shunamite Woman, Rembrandt Harmensz van Rijn, 1640.
Victoria & Albert Museum, London/Bridgeman Art Library, London/New York.

boy's face, but there was no response. He then turned back to meet Elisha and told him, "The boy has not awakened."

Elisha came into the house. There was the boy, laid out dead on his couch. He went in, shut the door behind the two of them, and prayed to God. Then he climbed onto the bed and placed himself over the child, putting his mouth on the boy's mouth, his eyes on his eyes, and his hands on his hands. The boy's body became warm. Elisha then stepped down, walked once up and down the room, then climbed up and bent over the boy. The boy sneezed seven times and opened his eyes.

Elisha called to Gehazi, "Call the Shunamite woman."

When she came to Elisha, he said, "Pick up your son."

She came and bowed low to the ground before Elisha. Then she picked up her son and went on her way.

The Fall of Jerusalem and the Destruction of the First Temple

When Pharaoh Necho, king of Egypt, went to war against Assyria, King Josiah of Judah marched out against him, and Pharaoh slew him at Megiddo. Josiah's servants brought him back to Jerusalem, where he was buried in his tomb. His son Jehoahaz became king for three months, until the pharaoh imprisoned him and brought him down to Egypt, where he died. Then Pharaoh appointed Jehoahaz's brother Jehoiakim king of Judah and imposed a heavy tribute on the land, which Jehoiakim made the people pay. Jehoiakim was twenty-five years old when he became king, and he did what was evil in God's eyes.

THEN KING NEBUCHADNEZZAR OF BABYLON MADE JEHOIAKIM HIS VASSAL FOR THREE YEARS, UNTIL JEHOIAKIM REBELLED AGAINST HIM. THEN GOD SENT RAIDING BANDS OF CHALDEANS, ARAMEANS, MOABITES, AND AMMONITES AGAINST JUDAH, AS HAD BEEN FORETOLD, because of the innocent blood that had been shed by Judah's kings.

When Jehoiakim died, his eighteen-year-old son Jehoiachin became king, and he too did what was displeasing in God's eyes. In the eighth year of Jehoiachin's reign, Nebuchadnezzar of Babylon marched against Jerusalem and besieged it. And Jehoiachin, together with his mother, Nehushta, and all his courtiers and officers, surrendered to the king of Babylon. Nebuchadnezzar took Jehoiachin captive and exiled him to Babylon along with his mother, his wives, his officers, and all the nobles of the land. He carried off all the treasures of the royal palace and of the House of God, including the golden decorations made by King Solomon. He exiled ten thousand men from Jerusalem, all the commanders and all the soldiers, as well as the craftsmen and smiths, leaving behind only the poorest people of the land. Nebuchadnezzar appointed Jehoiachin's twenty-one-year-old uncle Mattaniah king over Judah, changing his name to Zedekiah. And he too did what was displeasing in God's eyes.

In the ninth year of Zedekiah's reign, Nebuchadnezzar and his whole army marched against Jerusalem and built siege towers around it. They laid siege to the city for a year and a half, until famine became so acute that the common people had no food. Then the wall was breached. That night Zedekiah and his soldiers fled through the

OPPOSITE: *Solomon's Temple,* **David Sharir, 1987. Courtesy of David Sharir, Old Jaffa, Israel.**

213

VIII.
In Diaspora

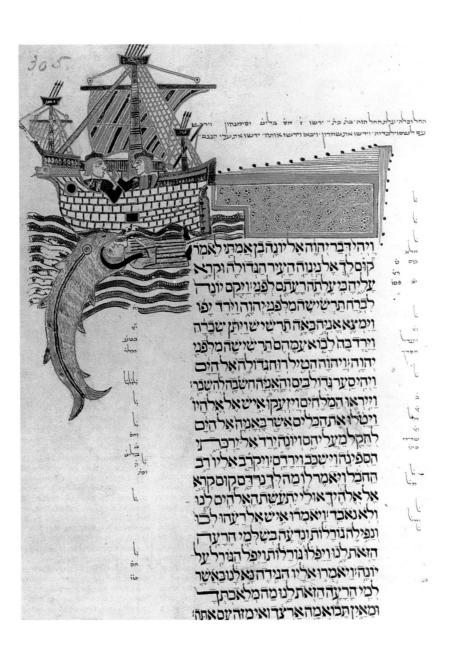

ONCE JERUSALEM AND THE TEMPLE lie in ruins, we enter the realm of our own time, though twenty centuries removed. After that pivotal destruction occurs, the history of the Jewish people assumes a pattern quite familiar to us: the story of a people in exile.

Dating the events in the Bible is difficult, especially in those books whose narrative structure so closely resembles that of folktales or legends. Such is the case with four of the five stories in this final section. In the Book of Jonah, we encounter a reluctant prophet whose flight from God lands him in the belly of a whale. In the Book of Daniel, set during the Persian diaspora, we meet four extraordinary Jewish exiles—Shadrach, Meshach, and Abednego, who walk unharmed through a fiery furnace; and Daniel, who survives untouched in a lions' den. And in the Book of Esther, also set in Persia, a young woman who keeps her Jewish identity secret saves her people from genocide and vanquishes the villain.

Are these stories historically accurate? Did a man named Jonah actually prophesy to the wicked citizens of Nineveh—and did they heed his warning and repent? Did the four Persian Jews condemned to death by fire and wild beasts really survive their ordeals? Did Esther truly infiltrate the Persian court and countermand the royal decree to kill all the Jews in the kingdom?

Though scholars have spent many hours debating the historical accuracy of these stories, most readers seem unconcerned about such questions—perhaps because these tales serve two purposes besides chronicling the events. They function beautifully as allegories or moral fables, demonstrating to readers the dramatic consequences of sin, repentance, and faith. And they also renew our faith amid the darkness of exile. How inspiring that a Jewish princess triumphs over a conniving anti-Semite! How thrilling that these Persian court Jews, condemned to death simply for their religious beliefs, escape the jaws of death while their persecutors get their just deserts! How heartening that not even a prophet can obstruct the course of repentance once it is set in motion by a compassionate God! Speaking in a language altogether different from sermons or laws, such stories convey powerful messages directly to the spirit of the reader.

The final tale in this section brings us full circle. Just as Adam and Eve once left the haven of Eden to venture out into the world, just as Abraham and Sarah set out from Ur to journey to a new homeland, just as the Israelites fled Egypt to return to their Promised Land, so the Bible ends with the Jewish people's return from exile. Though the Temple has been destroyed and the fields of Judea lie fallow, the people eagerly take up the task of rebuilding. And when the foundation for the new Temple has finally been laid, they shout for joy. But so loud is their cry, the Bible tells us, that "the people could not distinguish between the shouts of joy and the weeping."

OPPOSITE: *Jonah and the Whale* **from the** *Kennicott Bible* **(Ms. Kennicott 1, fol. 305r), 476. The Bodleian Library, University of Oxford.** OVERLEAF: *Scroll of Esther,* **late 18th century. Collection Israel Museum, Jerusalem.**

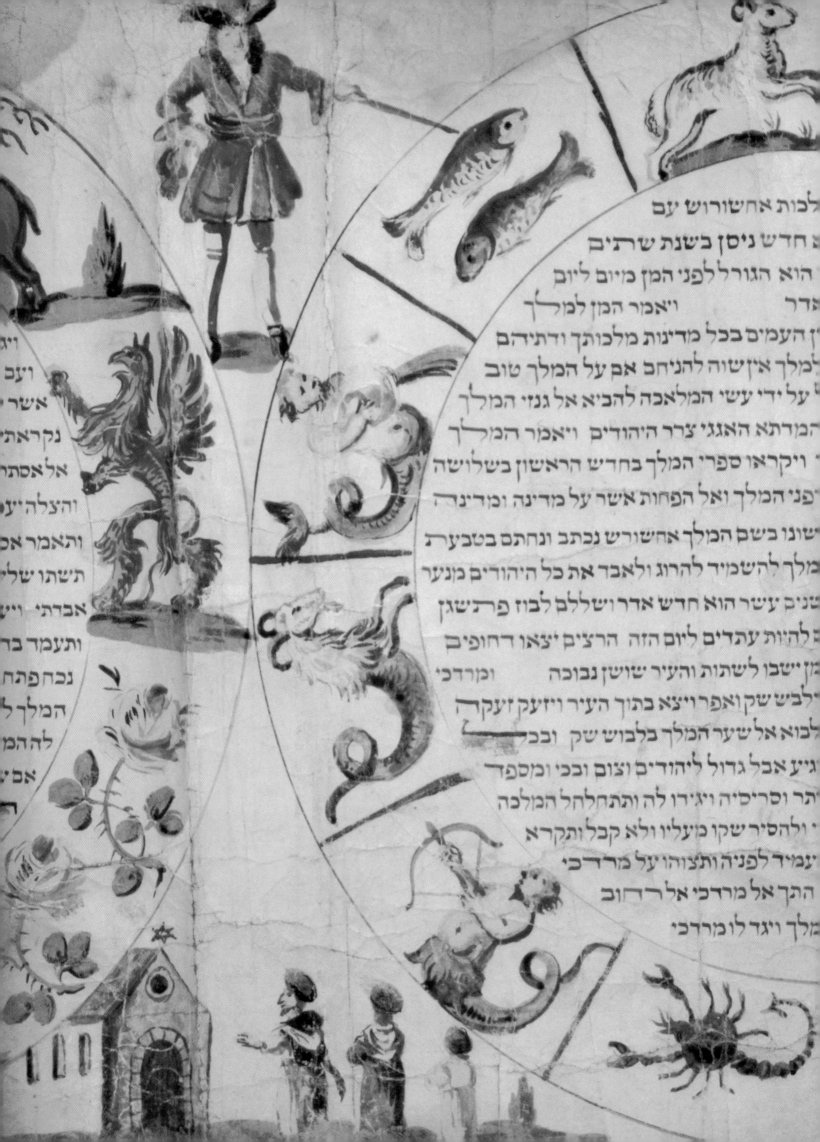

לכות אחשורוש עם

חדש ניסן בשנת שתים

הוא הגורל לפני המן מיום ליום

אדר ויאמר המן למלך

ן העמים בכל מדינות מלכותך ודתיהם

למלך אין שוה להניחם אם על המלך טוב

על ידי עשי המלאכה להביא אל גנזי המלך

המדתא האגגי צרר היהודים ויאמר המלך

ויקראו ספרי המלך בחדש הראשון בשלושה

פני המלך ואל הפחות אשר על מדינה ומדינה

נושו בשם המלך אחשורש נכתב ונחתם בטבעת

מלך להשמיד להרוג ולאבד את כל היהודים מנער

שנים עשר הוא חדש אדר ושללם לבוז פרשגן

להיות עתדים ליום הזה הרצים יצאו דחופים

מן ישבו לשתות והעיר שושן נבוכה ומרדכי

לבש שק ואפר ויצא בתוך העיר ויזעק זעקה

לבוא אל שער המלך בלבוש שק ובכל

גיע אבל גדול ליהודים וצום ובכי ומספד

תר וסריסיה ויגידו לה ותתחלחל המלכה

ולהסיר שקו מעליו ולא קבל ותקרא

עמיד לפניה ותצוהו על מרדכי

התך אל מרדכי אל רחוב

מלך ויגד לו מרדכי

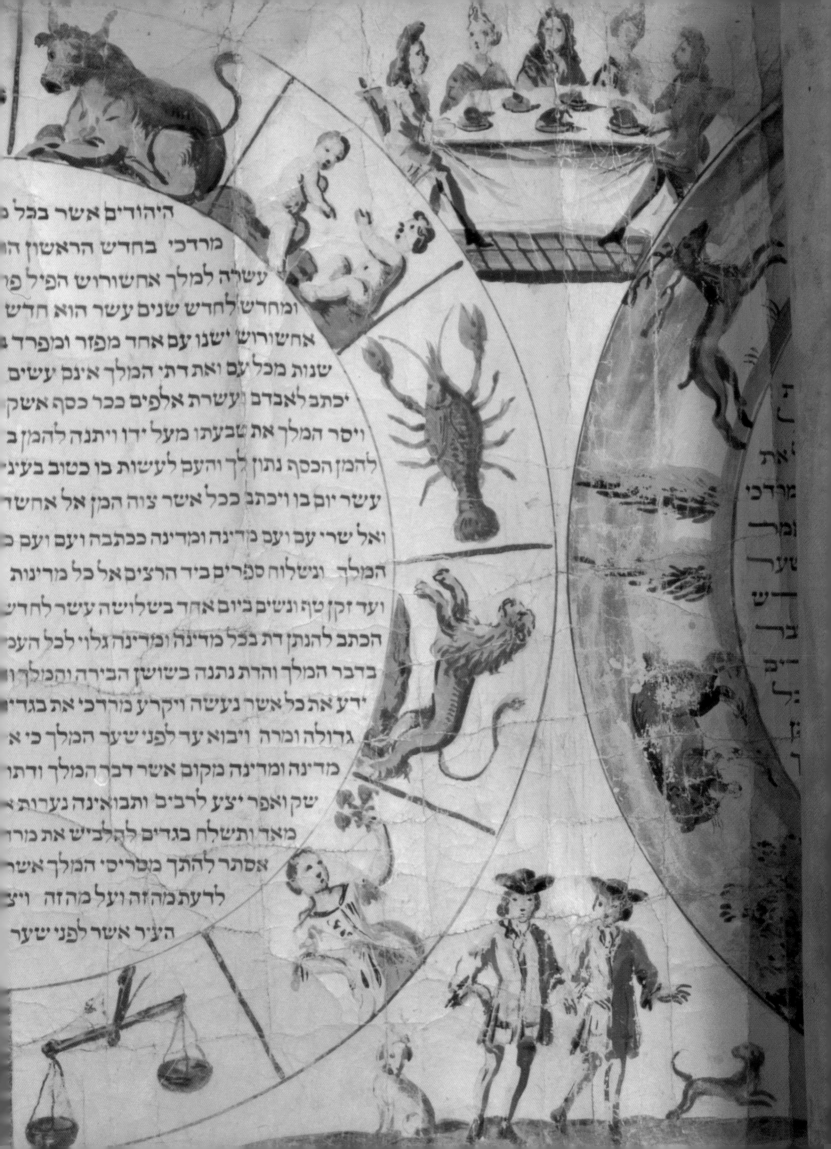

היהודים אשר בכל מ
מרדכי בחדש הראשון הו
עשרה למלך אחשורוש הפיל פו
ומחדש לחדש שנים עשר הוא חדש
אחשורוש ישנו עם אחד מפזר ומפרד ב
שנות מכל עם ואת דתי המלך אינם עשים
יכתב לאבד ועשרת אלפים ככר כסף אשק
ויסר המלך את טבעתו מעל ידו ויתנה להמן ב
להמן הכסף נתון לך והעם לעשות בו כטוב בעיני
עשר יום בו ויכתב ככל אשר צוה המן אל אחשד
ואל שרי עם ועם מדינה ומדינה ככתבה ועם ועם כ
המלך ונשלוח ספרים ביד הרצים אל כל מדינות
ועד זקן טף ונשים ביום אחד בשלושה עשר לחד
הכתב להנתן דת בכל מדינה ומדינה גלוי לכל העב
בדבר המלך והדת נתנה בשושן הבירה והמלך ו
ידע את כל אשר נעשה ויקרע מרדכי את בגדי
גדולה ומרה ויבוא עד לפני שער המלך כי א
מדינה ומדינה מקום אשר דבר המלך ודתו
שק ואפר יצע לרבים ותבואינה נערות א
מאד ותשלח בגדים להלביש את מרד
אסתר להתך מטריסי המלך אשר
לדעת מה זה ועל מה זה ויצ
העיר אשר לפני שער

את
מרדכי
ומר
שער
דש
בר
ב
ל
כ

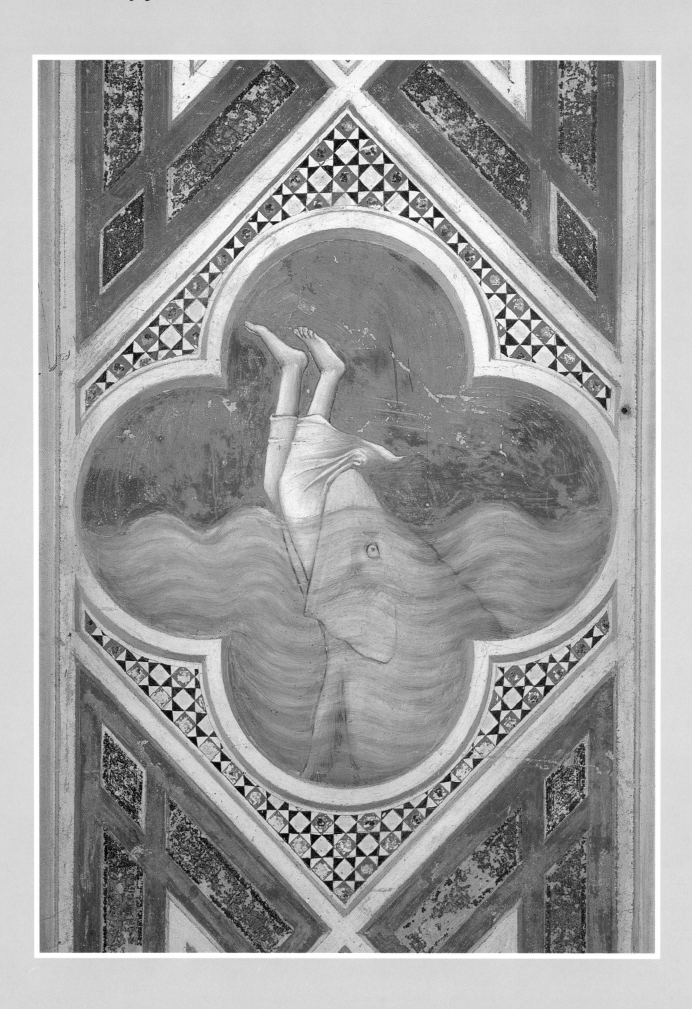

Jonah and the Whale

THE WORD OF GOD CAME TO JONAH, SON OF AMITTAI: "ARISE AND GO TO THE GREAT CITY OF NINEVEH, AND ANNOUNCE THAT ITS WICKEDNESS HAS COME BEFORE ME." JONAH AROSE TO FLEE FROM GOD. HE WENT DOWN TO YAFFA AND FOUND A BOAT THERE BOUND FOR TARSHISH. HE PAID HIS FARE AND WENT ABOARD.

Then God stirred up a great wind that churned the sea into a tempest, so that the boat threatened to founder. Terrified, the sailors cried out to their gods and threw the ship's cargo overboard to lighten its load. Jonah, however, went down into the bowels of the ship, lay down, and fell asleep. The captain called to him, "How can you sleep! Get up and call upon your god! Perhaps your god will take pity upon us so that we will not perish!"

"Let us cast lots to find out who is responsible for this evil that has befallen us," the sailors said to one another. So they cast lots, and the lot fell upon Jonah.

"Tell us, you who have brought this evil upon us, what is your business?" they asked him. "Where have you come from? What is your country, and who are your people?"

"I am a Hebrew," he replied, "and I worship the God of heaven who made the sea and the dry land."

The men were very frightened. "What have you done?" they asked him. And when they learned that he was fleeing from God, they said, "What should we do to you so that the sea will be appeased?" For the sea was growing increasingly more turbulent.

"Throw me overboard into the sea," he told them, "and it will be still, for now I know it is my fault that this great storm has come upon you."

The men tried to row ashore, but they could not, for the storm grew ever fiercer. So they cried out to God: "Please, God, let us not perish on account of this man, and do not hold us guilty of spilling innocent blood! For you, O God, have caused all this to happen." Then they lifted Jonah up and cast him overboard into the sea. And the sea became calm. And because the men feared God, they offered a sacrifice and swore vows.

Then God summoned a great fish to swallow Jonah. He remained in the belly of the whale for three days and three nights. Jonah prayed to God from the belly of the whale:

You cast me into the deep,
Into the heart of the sea.
I thought I was driven away out of
 Your sight:
Would I ever again gaze upon Your
 holy Temple?
When my life was waning,
I remembered God, and my prayer
 came before You,
Into Your holy Temple.

221

OPPOSITE: *Jonah and the Whale*, **Giotto di Bondone, ca. 1305. Scrovegni (Arena) Chapel, Padua/SuperStock, Inc.**

THEN GOD SPOKE TO THE fish, and it spit Jonah out upon dry land.

The word of God came to Jonah a second time: "Arise and go to the great city of Nineveh, and announce what I tell you to say."

So Jonah rose up and went to Nineveh as God had commanded him. Now Nineveh was a great city, a three days' walk from one end to the other. Jonah walked through the city for one whole day, declaring, "In forty days, Nineveh will be overturned!"

Then the people of Nineveh acknowledged God. They declared a fast and tore their clothes, young and old alike. When word reached the king of Nineveh, he arose from his throne and took off his royal robes. He donned sackcloth and sat down in ashes. He issued a decree that was proclaimed throughout Nineveh: "By order of the king and his court, no person or beast shall eat or drink, but they shall all cover themselves with sackcloth and cry out to God. Let all turn back from their evil ways! Perhaps God will repent and turn back from wrath so that we may not perish."

When God saw what they did, that they indeed were turning back from their evil ways, God repented of the plan to destroy them.

But when Jonah saw this, he was incensed. He prayed to God: "Did I not foretell this when I was still in my own country? That is why I fled toward Tarshish, for I knew that you were a compassionate and merciful God, slow to anger and full of lovingkindness, and that you would repent your decision. Please, God, take my life, for it is better now to die than to live!"

"Are you so bitter?" God asked him.

Then Jonah went out of the city until he came to a place toward the east, where he built a booth and rested there under its shade, to watch what would happen to the city. And God summoned a gourd plant to grow up over Jonah, providing shade for him so that he would be sheltered from harm. Jonah rejoiced over the gourd. But early the next morning God summoned a worm to attack the gourd, and it shriveled up. And when the sun rose, God summoned a hot east wind. The sun beat down on Jonah's head, and he became so faint that he wished to die. For he said, "It is better for me to die than to live!"

"Are you so bitter about the gourd?" God asked Jonah.

"Yes," answered Jonah, "so much so that I would rather die!"

"You cared about the gourd, which you neither toiled over nor tended, that grew up overnight and perished overnight. Should I not then care about the great city of Nineveh, which contains more than one hundred twenty thousand people who do not know their left from their right, as well as a great many cattle?"

OPPOSITE: *Jonah Under the Gourd,* **David Sharir, 1968. Courtesy of David Sharir, Old Jaffa, Israel.**

been assembled in the royal harem were pampered with oil, perfumes, and cosmetics. Then, one by one, they were brought before the king. When it was Esther's turn to appear before Ahasuerus, she pleased him more than all the others. So he set a royal diadem upon her head and made her queen in place of Vashti. Then he made a special banquet in her honor for all his officials and distributed gifts throughout his kingdom.

Yet Esther still did not reveal her identity, as Mordechai had instructed her.

At this time, Mordechai uncovered a plot by two of the king's eunuchs to assassinate the king. Mordechai reported the plot to Queen Esther, who told the king in Mordechai's name. When the matter was investigated and confirmed, the two plotters were impaled on stakes. And it was all recorded in the annals of the king.

Some time after this, King Ahasuerus elevated Haman the Agagite to be chief of his courtiers. All the other courtiers in the palace gate bowed before him, as the king had decreed, but Mordechai would not kneel or bow before him. The other courtiers challenged Mordechai, but he would not relent. So they told Haman about Mordechai, for Mordechai had told them that he was a Jew, and they wished to test his faith.

When Haman saw for himself that Mordechai would not bow before him, he was furious. But he resolved to punish not only Mordechai but all his people, the Jews throughout Ahasuerus's realm. And so in the month of Nisan, lots—that is, *purim*—were cast before Haman to determine when his revenge would take place. The lot fell on the twelfth month of Adar.

Haman then went before the king. "There is a certain people, dispersed among all the other peoples in your realm," he told the king, "whose laws are different from those of any other people and who do not obey the king's laws. Therefore, let a royal decree be issued ordering their destruction. And I will pay ten thousand talents of silver to the royal treasury."

The king gave his signet ring to Haman and said, "The money and the people are yours to do with as you will."

And so a decree was issued, and sealed with the king's ring, that on a single day in Adar, all the Jews in Ahasuerus's kingdom— young and old, men, women, and children— were to be exterminated, and their possessions plundered. At once messengers were dispatched to every province to proclaim this decree. Then the king and Haman sat down to celebrate, but the city of Shushan was amazed.

When Mordechai learned of this, he tore his clothing and put on sackcloth and ashes. He went through the city, weeping bitterly, until he came to the palace gate, which he could not enter wearing mourning clothes. So too throughout the provinces, the Jews fasted, wept, and mourned, donning sackcloth and ashes.

When Esther's maids told her what had happened, she was greatly distressed. She sent clothing to Mordechai, so that he could enter the palace, but he refused to put it on. So she sent one of her eunuchs to speak to him outside the palace gate. Mordechai told him all that had happened and gave him the decree to show to the queen. Then he gave instructions that Esther was to appear before the king and plead for her people.

When Esther received Mordechai's message, she sent back her reply: "Know that anyone who enters the king's presence without being summoned shall be put to death. Only if the king extends his golden

226

scepter will he be spared. But I have not been summoned at all for the last thirty days."

Mordechai sent a message back to Esther: "Do not think that you, a Jew, will escape death by being in the king's palace. No, if you keep silent, deliverance will come to the Jews from another place, and you and your father's house will be lost. Indeed, who knows whether you have attained the crown precisely for such a time as this."

Esther sent back her reply: "Gather together all the Jews of Shushan and have them fast on my behalf. For three days and nights, do not eat or drink. My maidens and I will observe the same fast. Then I shall go before the king, though I defy the law. And if I am to perish, then I shall perish!"

And Mordechai did as Esther had commanded him.

On the third day, Esther dressed in her royal robes and stood outside the throne room, where the king sat upon his throne. As soon as he saw her, he extended his golden scepter to her, and she entered and touched its tip.

"What troubles you, Queen Esther?" he asked. "And what is your wish? Even if it is half of my kingdom, it shall be yours."

"If it please Your Majesty," she replied, "let Your Highness and Haman come today to a feast I have prepared."

"Tell Haman to hurry and do the queen's bidding," the king commanded. And they came to the feast that Esther had prepared.

When they sat feasting before her, the king asked again, "What is your wish? Even

if it is half of my kingdom, it is yours."

"If Your Majesty will do me the favor," she replied, "let Your Highness and Haman come to another feast I will prepare for them."

Haman left the palace happy. But when he saw Mordechai sitting in the palace gate, he was enraged, for the man did not rise when he passed by. But he restrained himself and went on his way.

When Haman returned home, he told his wife Zeresh and his friends about his good fortune, especially about the feast the queen had made for him and the second feast she was preparing for the following day.

"Yet all this means nothing to me," he told them, "when I see that Jew Mordechai sitting in the palace gate."

"Erect a stake seventy-five feet high," Zeresh and his friends advised him, "and tomorrow morning ask the king to impale Mordechai upon it. Then you can go to the feast with a glad heart."

Their proposal pleased Haman, and the stake was erected.

THAT NIGHT THE KING COULD NOT SLEEP, AND he ordered that the royal annals be read to him. It so happened that what was read to him concerned the eunuchs' assassination plot against the king and Mordechai's role in denouncing them.

"What honor was done for this Mordechai?" asked the king.

"Nothing at all," his servants replied.

"Who is waiting in the outer court?" asked the king.

It so happened that Haman had just entered the outer court to ask the king to impale Mordechai on the stake prepared for him.

"It is Haman," the servants told the king.

"Let him enter," said the king, and Haman came before the king.

"What should be done to the man whom the king wishes to honor?" the king asked Haman.

Thinking the king was talking about him, Haman replied, "Let him be dressed in

227

the king's robes and crowned with the king's crown, seated upon the king's horse, and paraded throughout the city by a royal courtier, crying, 'This is what is done for the man whom the king wishes to honor.'"

"Quick, get the robes and the horse," said the king, "and do this to Mordechai the Jew, who sits in the palace gate!"

So Haman dressed Mordechai in royal robes and crowned him, and paraded him throughout the city, proclaiming, "This is what is done for the man whom the king wishes to honor!"

When he had finished, Haman hurried home, his head hung in mourning. When he told Zeresh and his friends what had happened, they said to him, "If you have already begun to fall before Mordechai the Jew, you will surely fall before him to your ruin."

Just then, the king's eunuchs arrived to summon Haman to Esther's banquet.

At the feast, the king again asked Esther, "What is your wish? Even if it is half of my kingdom, it is yours."

"If Your Majesty will do me the favor," she replied, "let my life and the lives of my people be granted as my wish. For my people and I have been sold, to be exterminated. Had we only been sold as slaves, I would have kept silent."

"Who dared to do this?" demanded the king.

"The enemy is Haman!" replied Esther.

In terror, Haman shrank back before the king and queen. Furious, the king stormed out into the garden while Haman fell face down upon Esther's couch to plead for his life, because he realized that the king was bent on killing him. When the king came back into the room and saw Haman lying prostrate beside his queen, he cried, "So he dares to violate the queen in my own palace!"

"Not only that," added one of the king's eunuchs, "he has built a stake, seventy-five feet high, on which to impale Mordechai, whose words once saved the king's life!"

"Impale him on it instead!" ordered the king.

And so they impaled Haman upon the stake meant for Mordechai, and the king's anger cooled.

That day, King Ahasuerus gave Haman's property to Esther. And when she revealed that Mordechai was her kin, the king gave him his signet ring, which he had taken back from Haman. And Esther put Mordechai in charge of Haman's property.

Then Esther fell down before the king, weeping, pleading with him to annul the evil plot that Haman had set into motion against the Jews.

"If it please Your Majesty," she said when he had lowered his golden scepter to her, permitting her to rise and speak, "let the king send messengers throughout the kingdom rescinding Haman's decree to exterminate the Jews. For how can I bear to witness the destruction of my people!"

"I have impaled Haman upon the stake for scheming against the Jews, and given his property to Esther," the king said, "but whatever has been decreed in the king's name and sealed with his seal cannot be rescinded. Therefore, write your own decree in my name and seal it with my seal, as you see fit."

So Mordechai dictated letters in the king's name and sealed them with the king's seal, and messengers, riding swiftly on royal steeds, carried the letters to the Jews and the governors in all one hundred twenty-seven provinces from India to Ethiopia. The decree, written to the Jews in their language and script, and to every other

228

Haman from *The Five Scrolls*, Leonard Baskin, 1980. HUC Skirball Cultural Center, Museum. Collection, Los Angeles. (Museum purchase with funds provided by the Gerald M. and Carolyn Z. Bronstein Acquisition Fund for Project Americana).

229

people in its own language and script, proclaimed: "The king permits the Jews in every city and in the capital city of Shushan to gather together and fight for their lives!"

Mordechai departed from the king's presence wearing a golden crown, royal robes of blue and white, and a cape of fine linen and purple wool. That day, the city of Shushan rejoiced. And throughout the realm, the Jews enjoyed light and joy, gladness and fortune. Everywhere, there was feasting and celebration. And many in the land claimed to be Jews, for fear of the Jews had fallen upon them.

And so on the thirteenth day of Adar, when the Jews were to have been exterminated, just the opposite happened: Throughout the kingdom, Jews attacked those who were bent on their destruction, and none could prevail against them. Indeed, the governors and officials in all the provinces yielded before the Jews, so humbled were they by the fear of Mordechai. For Mordechai had become a rising power in the palace, and his fame was spreading through the kingdom. Jews throughout the realm destroyed their enemies by the sword, but they did not plunder. And the next day, they celebrated a holiday, feasting and making merry.

In Shushan that day, the Jews killed five hundred men, and they also struck down the ten sons of Haman, but they did not plunder.

When the king heard of all this, he said to Esther, "What now is your wish? Ask, and it shall be granted."

"If it please Your Majesty," she replied, "let the Jews of Shushan fight again tomorrow, and let Haman's sons be impaled upon stakes." And so it was done the next day, on the fourteenth day of Adar.

Then Mordechai and Queen Esther decreed that from that day on, Jews throughout the kingdom were to celebrate the holiday of Purim with feasting and joy, sending gifts to one another and to the poor. And so these days are remembered and observed by every family in every generation.

Shadrach, Meshach, and Abednego in the Fiery Furnace

MONG THE EXILES OF JUDAH THAT KING NEBUCHADNEZZAR BROUGHT TO BABYLON WERE SEVERAL HANDSOME YOUNG MEN OF ROYAL AND NOBLE DESCENT, PROFICIENT IN KNOWLEDGE AND WISDOM. NEBUCHADNEZZAR ORDERED THAT THEY BE TAUGHT THE CHALDEAN language, provisioned from the king's food, and educated for three years, after which they were to enter the king's service. Among these men were Daniel, Hananiah, Mishael, and Azariah, whom the king's chief officer gave Chaldean names: Daniel became Belteshazzar; Hananiah, Shadrach; Mishael, Meshach; and Azariah, Abednego. But being Israelites, they refused to defile themselves with the king's food or drink; to the chief officer's surprise, they flourished on legumes and water. And at the end of three years, they entered the king's service.

Impressed by Daniel's ability to interpret dreams, the king appointed him chief governor over the province of Babylon and head of all the wise men and brought him into the royal court. At Daniel's request, Shadrach, Meshach, and Abednego were appointed ministers of the province.

King Nebuchadnezzar ordered that a ninety-foot golden statue of himself be set up on the plain of Dura, and he summoned all the governors, officials, and judges to celebrate the dedication of the statue. The royal herald proclaimed: "Whoever does not bow down and worship the golden statue of Nebuchadnezzar shall be thrown into a fiery furnace!" To the music of horn, pipe, and lyre, all peoples of every language and nation worshipped the golden statue of the king.

Some Babylonians came forward to slander the Jews. "O King," they said to him, "there are certain Jews—Shadrach, Meshach, and Abednego, whom you appointed as ministers—who do not serve your god or worship your golden statue."

Furious, Nebuchadnezzar ordered the three Israelites brought before him. "Is it true," he asked them, "that you refuse to serve my god or worship my golden statue? If it is not so, well and good; but if it is true, you shall be thrown this instant into a fiery furnace! And what god can save you from my power then?"

"We need not answer you, O King," they replied, "for our God will save us from the fiery furnace and will save us from your power. But even if we are not saved, we will not serve your god or worship your golden statue."

His face contorted by rage, Nebuchadnezzar ordered the furnace heated to seven times its usual heat, and he commanded some of his strongest soldiers to bind Shadrach, Meshach, and Abednego and throw them into the furnace. Fully clothed in shirts,

230

Shadrach, Meshach and Abednego in the Fiery Furnace, Simeon Solomon, 1863. Mallett & Son Antiques Ltd., London/Bridgeman Art Library London/New York.

231

trousers, hats, and other garments, the three men were bound and thrown into the flames. So hot was the furnace and so urgent the king's order that a tongue of flame instantly killed the soldiers carrying the three men, so that the Israelites were dropped, bound, into the furnace.

How astonished was the king to look into the mouth of the fiery furnace and see four men walking, unharmed and unbound, amid the fire.

"Did I not order you to bind three men and throw them into the fire?" asked Nebuchadnezzar. "Why then do I see a fourth, with the appearance of a divine being, and the three others walking unbound?" The king came close to the mouth of the furnace and shouted, "Shadrach, Meshach, and Abednego, servants of the most high God, come out!"

When they emerged, the governors, officials, and royal attendants were astounded to see that their bodies showed no sign of fire: Their hair was not singed, their clothing did not even bear the odor of smoke.

Then Nebuchadnezzar declared: "Blessed be the God of Shadrach, Meshach, and Abednego, who sent an angel to save the lives of those who refused to worship any but their own God. I hereby decree that anyone who blasphemes the name of this God shall be torn limb from limb and lose his house, for this God alone can save in this way."

Then the king elevated Shadrach, Meshach, and Abednego to administer the province of Babylon.

Daniel in the Lions' Den

אֱלָהִי שְׁלַח מַלְאָכֵהּ
וּסְגַר פֻּם אַרְיָוָתָא

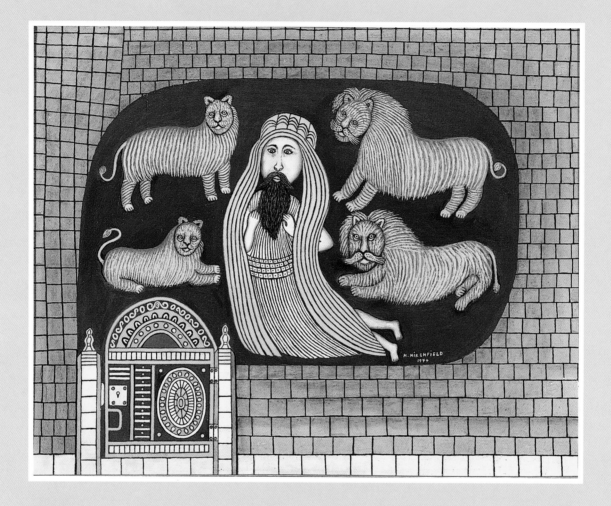

S OON AFTER THE CHALDEAN KING BELSHAZZAR ELEVATED DANIEL TO RULE AS ONE OF THREE IN THE KINGDOM, BELSHAZZAR WAS KILLED, AND OLD DARIUS THE MEDE BECAME KING. DARIUS APPOINTED Daniel and two other ministers to rule over the one hundred twenty governors in charge of the kingdom, but Daniel possessed such an extraordinary spirit that Darius planned to place him over all the governors and ministers in the kingdom.

Daniel in the Lions' Den, Morris Hirshfield, 1944. Courtesy Sidney Janis Gallery, New York. © Estate of Morris Hirshfield/Licensed by VAGA, New York.

The ministers and governors sought to discredit Daniel, but they could find no fault with him, for he was trustworthy and above corruption. So they said, "We will not be able to discredit this Daniel unless

we find something against him having to do with the laws of his God."

They went to the king and said, "O King Darius, may you live forever! All the ministers and governors in your kingdom agree that you should issue a decree under oath banning all your subjects from petitioning anyone, human or divine, besides you. Anyone who violates this ban over the next thirty days shall be thrown into a lion's den. Put it in writing, O King, so that it may not be annulled."

When Daniel heard the decree, he went to the upper chamber of his house, where he had made windows facing Jerusalem, and he knelt down three times, prayed, and confessed to God, as was his usual practice. The plotters came in and found Daniel petitioning his God. They told the king: "Did you not write a ban against petitioning anyone besides you, O King, over the next thirty days?"

"The decree stands as a law of the Medes and Persians," agreed the king, "and may not be annulled."

"Daniel, one of the exiles of Judah, has flaunted your ban!" they told the king. "Three times a day he petitions his God."

When he heard this, the king was greatly distressed. He set his heart upon saving Daniel and made every effort to rescue him. But when the sun set, the plotters came to Darius and said, "O King, it is a law of the Medes and the Persians that a royal ban sanctioned under oath cannot be changed."

So the king ordered Daniel thrown into the lions' den. The king said to Daniel, "Your God whom you serve so faithfully will surely deliver you." Then a rock was rolled over the mouth of the den, and the king sealed it with his signet ring so that nothing could be reversed concerning Daniel.

The king then went to his palace and fasted all night. He enjoyed no entertainments and could not sleep. At the first light of dawn, he rushed to the lions' den. Approaching the den, he cried out in a voice filled with sorrow, "Daniel, servant of the living God, did the God whom you have served so faithfully deliver you from the lions?"

"O King, may you live forever!" Daniel replied. "My God sent an angel who shut up the lions' mouths so that they did not harm me. For I am guiltless before God and have not done my king any harm."

The king rejoiced and ordered Daniel released from the den. He was found free of any mark, for he had trusted in God. Then the king ordered the plotters who had slandered Daniel, together with their wives and children, thrown into the lions' den. As soon as they reached the bottom of the den, the lions pounced upon them and crushed all their bones.

Then King Darius issued a proclamation in writing to all peoples of every language on earth: "Peace be with you! I hereby order that within my royal domain all my subjects must tremble in fear before the God of Daniel, the living God who abides forever, whose kingdom endures until the end of time. God delivers and saves, performing miracles and wonders in heaven and on earth. For God delivered Daniel from the power of the lions."

Thus Daniel prospered during the reign of Darius and during the reign of Cyrus the Persian.

233

Return from Exile

After the exiles from Judah had been in Babylon for fifty years, King Cyrus of Persia conquered that kingdom and permitted the Jews to return to Jerusalem. Those who left—some fifty thousand from the tribes of Judah and Benjamin, as well as priests, Levites, male and female singers, and servants of the Temple—brought back with them many of the gold and silver vessels that Nebuchadnezzar had taken from God's House. And they settled in their towns and began to rebuild Jerusalem.

IN THE SEVENTH MONTH, THE ENTIRE PEOPLE GATHERED TOGETHER IN JERUSALEM TO OFFER SACRIFICES ON THE REBUILT ALTAR, ACCORDING TO THE TORAH OF MOSES, THE MAN OF GOD. TOGETHER THEY celebrated the festival of Sukkot. They hired craftsmen to bring cedarwood from Lebanon, and they relaid the foundations of the Temple. When the foundations were finished, the priests blew upon trumpets, and the Levites sang songs of praise to God. The people raised a great shout. And the old men who had seen the first House of God wept loudly to see the new House in its place. All the others shouted for joy at the top of their voices. The people could not distinguish between the shouts of joy and the weeping, for the sound was so loud that it could be heard from a great distance.

After many years, when the work was at last completed and the Temple once again stood in Jerusalem, the people dedicated God's House with great joy. Soon afterward,

OPPOSITE: **Levites Playing Music in the Temple, Shalom of Safed, 1972. The Jewish Museum, NY/Art Resource, NY.**

they celebrated the Passover, eating the Passover offering and observing the Festival of Unleavened Bread.

THUS WAS FULFILLED THE SONG of the psalmist:

> When God restores the fortunes
> of Zion
> —we see it as in a dream—
> our mouths shall be filled
> with laughter,
> our tongues, with songs of joy.
> Then shall they say among
> the nations:
> "God has done great things
> for them!"
> God has indeed done great
> things for us,
> and we shall rejoice.
>
> Restore our fortunes, O God,
> like watercourses in the desert.
> They who sow in tears
> shall reap with songs of joy.
> Though he goes along weeping,
> carrying the seed-bag,
> he shall come back with songs of joy,
> carrying his sheaves.

235

The Books of the Hebrew Bible

Index of selected stories

Torah

GENESIS
In the Beginning
The Creation of Adam and Eve
The Serpent in the Garden
The Story of the First Murder
The Great Flood
The Tower of Babel
Abram and Sarai Leave Their
 Native Land
The Birth of Ishmael
The Visit of the Three Angels
Sodom and Gomorrah
The Birth of Isaac and the
 Banishment of Hagar and Ishmael
The Binding of Isaac
Eliezer Seeks a Wife for Isaac
Jacob Steals the Birthright
Jacob's Dream of the Ladder
Jacob Marries Leah and Rachel
Jacob Wrestles with the Angel
The Rape of Dinah
The Death of Rachel
Joseph and His Brothers
Judah and Tamar
Joseph in Egypt

EXODUS
Pharaoh and the Midwives
The Birth of Moses
Moses Kills an Egyptian Taskmaster
 and Flees to Midian
The Burning Bush
The Ten Plagues and the
 First Passover
The Splitting of the Sea of Reeds
Gifts of Manna and Quail

The Giving of the Ten
 Commandments
The Golden Calf
Moses Encounters God in the
 Cleft of the Rock

LEVITICUS
Nadav and Avihu Offer Strange Fire

NUMBERS
Miriam and Aaron Challenge Moses
The Twelve Spies
The Rebellion of Korakh
Moses Strikes the Rock at Meribah
Balaam and the Talking Ass
The Daughters of Zelophehad

DEUTERONOMY
Moses Bids Farewell

Prophets

JOSHUA
Joshua and the Battle of Jericho

JUDGES
Deborah
Gideon
Yotam's Parable
Jephthah's Daughter
Samson

SAMUEL 1 & 2
Hannah and the Birth of Samuel
Samuel Appoints Saul King
Saul Loses His Kingdom
David and Goliath
The Struggle Between Saul and David

TO ROB AND RUTH GOLDSTON, two old friends who knew me when and know me now. Their abounding love of Jewish music, family, community, celebration, and learning has always inspired me and given me faith in the Jewish future.

Acknowledgments

HOW HUTZPADIK IT IS TO RETELL THE STORIES OF THE BIBLE, EVEN IF only with modest changes! What allowed me to undertake this daunting task was my faith that the Bible would survive my well-intentioned tampering, just as it has survived other efforts by translators, editors, commentators, and bowdlerizers to improve upon its words. Fortunately, it is an incorruptible document, well-tempered by centuries of hard use.

Putting together this volume has been a joy from start to finish, in large part due to the professional competence and genial spirit of the Fair Street/Welcome staff. As with my previous book, *The Jewish Spirit*, they smoothed any obstacles in my path, and listened most generously to my suggestions. Most of all, I am indebted to my editor, collaborator, and champion, Susan Wechsler, whose good cheer, level head, and refreshing whimsy always lifted my spirits and spurred me on. How eagerly I opened her many e-mails and FedEx surprise packages! I am also immensely grateful to Gregory Wakabayashi at Welcome for his elegant and loving design, and his creative problem-solving. Thanks also to Clark Wakabayashi for helping us all navigate the chancy shoals of commerce. And I would like to thank Elizabeth Kessler, Joanne Polster, Rebecca Wolff, and all the staff members at Fair Street, Welcome, and Photosearch, whose inexhaustible care, energy, and expertise produced such a luscious volume!

Two people in particular helped me conceptualize this project at an early stage, both of them magical storytellers in their own right—Chaim Potok, who years ago encouraged me to hazard this daunting task, and Esther Hautzig, who urged me to give it my "own heart and soul, and use words which are true to the text, yet direct and simple." I hope I have not disappointed them. I was also inspired by several English translations of the Bible, notably the 1985 translation by The Jewish Publication Society, as well as Everett Fox's translation. I am indebted to JPS for permission to adapt passages from the JPS TANAKH. A special thanks to Barbara Breitman, who asked incisive questions at a critical juncture in the book's development.

As always, I am deeply grateful to my family—Herb, Sarah, and Les—for their steadfast support and forebearance, especially when my job responsibilities unexpectedly doubled in the middle of this project. Without a doubt, they now have impressive accommodations reserved for them in the World-To-Come. Herb was particularly helpful in guiding me and the Fair Street staff in selecting suitable art.

—ELLEN FRANKEL

OPPOSITE: *Torah Ark Curtain*, Jacob Koppel Gans, 1772–3.
The Jewish Museum. NY/Art Resource, NY.